RECORDING # 1
From : Green Glass
To : FEDERAL EXPRESS

RECORDING # 2
From : Container
To : DON'T WALK

RECORDING # 3
From : Cap in Car
To : ATLAS

RECORDING # 4
From : Dog Shit
To : IRMA VEP

RECORDING # 5
From : Flat Tyre
To : AIRPLANE

From Green Glass to Airplane documents Gabriel Orozco –
Recordings & Drawings, a project shown in the Stedelijk Museum
Amsterdam from 1 November to 14 December 1997. The project
centred around five digital video films Orozco had shot in the
autumn of 1997 in New York and Amsterdam. These were pre-
sented in the Stedelijk Museum together with drawings and
objects chosen by the artist. This book contains stills of the five
video films made by the curator of the exhibition, Martijn van
Nieuwenhuyzen, and subsequently authorized by the artist.

RECORDINGS & DRAWINGS

Stedelijk Museum
AMSTERDAM

What I'm after is the liquidity of things, how one thing leads you on to the next. These films take place in very ordinary urban settings. I'm not concerned with spectacular events or frantic rhythms. The works are about concentration, intention, and paths of thought: the flow of totality in our perception, the fragmentation of the 'river of phenomena'.[1]

Recordings & Drawings

Back in the viewing room to look at Gabriel Orozco's <u>Recordings</u>, almost four years after the five digital video films containing images of city life in New York and Amsterdam were first shown in the Stedelijk Museum. Through the loudspeakers come the sounds of bicycle bells, car horns, snatches of conversation, aircraft passing overhead and other urban noises. Once again the feeling of being swept along by a trance-inducing stream of images and the sense of wonder at how perfectly ordinary objects and situations from everyday reality coalesce in visual patterns that bear the unmistakable 'Orozco' signature. In Orozco's cinematographic recordings, the visual clamour of life in the city is translated into webs of circles, spirals, reflections and duplications; into patterns that are not only apparent when you take the time to surrender yourself to the flow of images. Even when you allow the films only a few moments to sink in, unexpected connections become visible in the seemingly chaotic urban scenes. Orozco manages to structure the film images so that they appear as a continuum. Plastic bags swinging at the end of arms link up with rucksacks bobbing along on backs, to form waves that surge and eddy through the city streets. Headlamps, traffic lights, reflections of the sun in the lens create patterns of light that weave their way through the video films. One of Orozco's favourite devices for suggesting connections between objects, situations and phenomena that are widely separated in time and space is the circle: beer mats scattered across an Amsterdam pub table connect with the circular pictograms of the New York subway system, with the company logo on the rotating drum of a concrete mixer or with the big, round shape on the Bagel Buffet awning. And there are other synchronicities for those who are alert to Orozco's perception. Vapour trails of aircraft high up in the heavens merge with white paint tracks on the earthly asphalt. The ladders of Dutch window cleaners and American maintenance men make the same acute angle with the facades of city buildings. Even the plastic bags that the inhabitants of Amsterdam and New York put over their bicycle saddles to protect them from the rain seem to have forged an aesthetic alliance. Orozco's films are driven by the tension of the moment, by the unexpected as opposed to the planned, and by a view of reality in which situations that appear irredeemably dull, one-dimensional

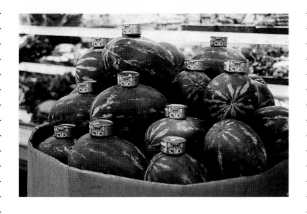

and meaningless turn into exciting and significant chains of images that stimulate the viewer's imagination.

Recordings is Orozco's impersonal designation for these video films. The titles of the five tapes, all lasting between forty minutes and an hour, are equally dry and factual. The title of each tape refers, inventory-style, to the first and last image: From Green Glass to Federal Express, From Container to Don't Walk, From Cap in Car to Atlas, From Dog Shit to Irma Vep, From Flat Tyre to Airplane. The suite of videos, with the overall title From Green Glass to Airplane, constitutes a unique group within Orozco's oeuvre; on only one previous occasion had he worked with moving images. In 1993 he made a one-hour VHS tape – Before the Waiting Dog – for Gavin Brown's Real Time exhibition at the ICA in London.[2] It was shown on a monitor placed informally on the floor of the ICA lobby and accompanied by various interventions in the entrance area and the bookshop (such as a melon balanced on the edge of a bookcase). The video work – according to Orozco not a true video film but a 'backdrop' that would be only fleetingly observed by people as they passed through the lobby – was an unedited film made in the Tesco supermarket at Covent Garden.[3] With the ICA's video camera strapped to his back, Orozco moved around the store shifting items about. His juxtapositions of totally unrelated products yielded arresting images in the manner of his Cats and Watermelons photograph of 1992. While he was busy photographing these rearrangements, the video camera recorded what was going on behind his back. Before the Waiting Dog consequently consists of a jerky succession of impressions of piled-up merchandise, jostling shopping trolleys and the groping hands and eyes of shoppers. With apparent aimlessness, the camera moves back and forth along the supermarket aisles to a muted accompaniment of checkout bleeps and fractious children. The video ends with a separate segment of about three minutes in which a black dog with a brown, mask-like face, is shown lying in front of the automatic doors to the supermarket, waiting for its owner. The dog has stretched itself uncompromisingly before the entrance to the store and is gazing anxiously through the reflecting glass of the opening and closing doors. People step over it, but none of the passers-by pays any attention to the animal. For its part, the dog is not the slightest bit interested in what is going on around it.

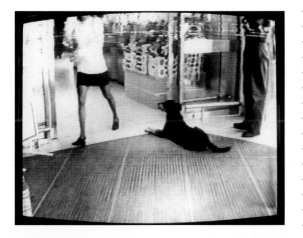

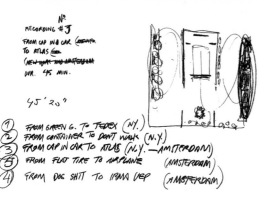

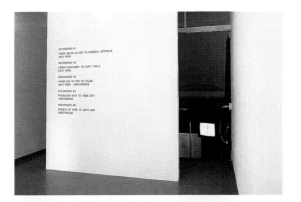

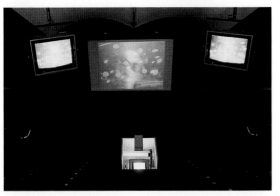

As soon as it spots its owner's figure, it jumps up and in a flash has disappeared out of frame. In contrast to the preceding hour of random images, this is a concentrated fragment that retains the viewer's attention for the full three minutes of its duration. Thus the film concludes with a 'plot' that has its own tension and meaning. Because of that final sequence, the film becomes, in retrospect, a statement about perception. Against the aimless, undirected 'looking' of the earlier section, Orozco places the concentrated attention of a dog waiting for its owner and its instantaneous reaction to the latter's reappearance. The dog's intent gaze, the very antithesis of automatic registration, becomes a metaphor for a more specific way of 'looking' and for the ability to discern connections and meanings in visible reality. In the five Recordings made for the Stedelijk this insight has become normative and it is Orozco's eye for the latent connections between images from everyday reality that is on show here.

Orozco's New York/Amsterdam video project was a response to the Stedelijk Museum's proposal to mount an exhibition of his work at the end of 1997. It was an open invitation, the details of which were to be worked out after an initial visit to Amsterdam by the artist in the late summer of 1997 to inspect the museum spaces. Although the museum favoured a new, site- and context-specific presentation, the choice between this and an exhibition of existing work was to be resolved in discussions with the artist. After various ideas had been batted back and forth across the Atlantic, a message arrived from New York in October 1997 that Orozco had purchased a digital camera and had gone out into the streets to film. 'I got something,' he announced on the phone. He also said that he had decided against the classic, white exhibition galleries we had reserved for him after his visit. Instead, he expressed interest in the more hybrid, multi-functional space below and beside the central stair. Beneath this monumental museum staircase is a dark, tiered, alcove-like space known as the 'video steps' where visitors can view works from the museum's video collection. The space is flanked by two passageways connecting the lobby to the museum cafeteria. Set into the walls of these passages are display cases that usually contain small objects from the applied art collection. Orozco proposed to use these transit zones, where various modes of museum presentation rub shoulders and visitor flows converge (a public area as complex

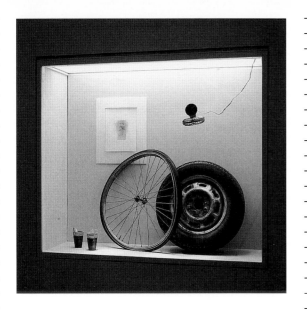

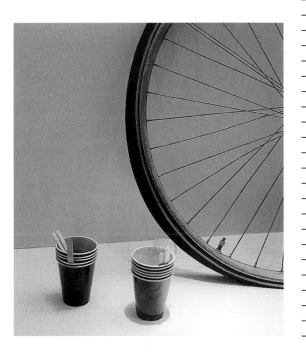

and dynamic as the lobby of the ICA three years earlier), to stage an exhibition centred around video films he would record on the streets of New York and Amsterdam. In the display cases and on the walls around the video steps he would exhibit objects related to the video images, together with drawings made in his New York apartment during the past year. Orozco dubbed his project for the Stedelijk Museum Recordings & Drawings.

To produce the five tapes (two-and-a-half shot in New York and two-and-a-half in Amsterdam) Orozco took to the streets with his camera in October 1997, spending several days making each tape. He set out in the morning, started walking and waited to see what caught his attention: natural phenomena like light and reflections, the unlooked-for beauty of prosaic objects, the actions of human beings and animals. He filmed still lifes of lipstick-smeared cigarette butts, arrangements of coffee cups on a café table, the shadows of gulls on a wall in the yellow light of the evening sun, buildings reflected in water and in the gleaming paintwork of parked cars. The efforts of a New York fire crew trying to put out a fire in an apartment were filmed at length, as were the weary motions of a group of Amsterdam students endlessly lugging chairs from one house to another. Pictures of attractively displayed products in shop windows alternated with a frenzied cinematographic pursuit of spiralling autumn leaves. In some parts in the city, Orozco's camera remained in its bag; others were the scene of lengthy filming sessions. His camera style is whimsically erratic, changing from prolonged fixed shots, to a lot of nervous zooming in and out such that the image sometimes disintegrates into rayed-looking digital patterns. Panning shots of the city skyline that suggest the relaxed style of the professional film maker alternate with the jerky pursuit of a woman with a small rucksack reminiscent of the hand-held camera work of cinema vérité. Often he will freeze the image in 'stills' that recall the ephemeral situations and interventions he records in his photoworks. In his flaneuristic 'stream of consciousness' Orozco shows how tension and concentration rise and fall, how connections are made and then demolished again. This does not involve any manipulation of the film material; Orozco is at pains to keep the relationship between film and reality as direct as possible by recording and playing the images in the order in which they appeared to him. Nor is there any post-production: no images are excised, there

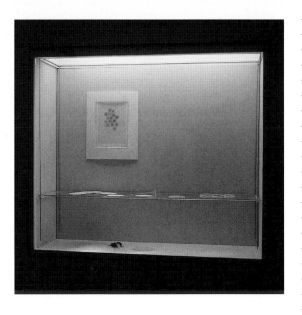

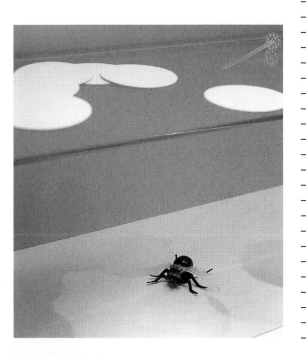

is no editing or reshuffling. Orozco started filming without any pre-conceived idea of how long each segment would last, allowing this to depend on his assessment of the incidents he encountered along his way. Whenever the recording was in danger of becoming too dull or too vague, he would stop filming. Sometimes reality took a turn that completely upset his plans. Orozco: 'I trace certain intentions with the camera, and then suddenly the tension between my intentions and reality becomes too great and the whole thing breaks down.'[4] In only a few cases did he decide – upon inspecting the results on the tiny screen of the camera in a café or restaurant – to rewind the tape and record over a too long sequence or a slack image. Decisions about choice of subject, segment length, mise en scène, structure and rhythm were made on-the-job and were guided by 'the things of the day'. Orozco: 'It's this "being next to each other" that appeals to me. In the films things are related, but through proximity rather than narrative.'[5]

In his show at the Stedelijk Museum, Orozco ran the five Recordings in a continuous programme lasting four-and-a-half hours (almost an entire museum day) on a video beam in the video steps area. The large projected picture was flanked by two monitors showing exactly the same picture. The titles and the length of the films were announced in a plain typography of black letters on a white wall placed at the entrance to the video steps, thereby creating an intimate, screened-off viewing area. Suspended from the ceiling in front of the steps, at the end of a long piece of wire, was a yellow cushion chrysanthemum in a white plastic bucket, like the ones Orozco had seen on numerous balconies during his walks around Amsterdam. By the simple expedient of introducing this 'everyday' element, Orozco managed to subvert the mechanisms and codes of the museum visit and to put the viewer in a new state of visual alertness. An even more obvious act aimed at mixing the undifferentiated 'outdoors' with the highly regulated indoor space of the museum and so honing the viewer's gaze, was achieved by filling the display cases in the walls on either side of the video steps with all sorts of everyday objects he had collected on his walks through Amsterdam and which also featured in Recordings. A setting usually reserved for rare and collectible items, suddenly found itself playing host to a flattened soft drink can, the plastic ring-holder from a six pack of

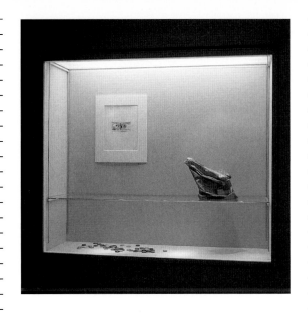

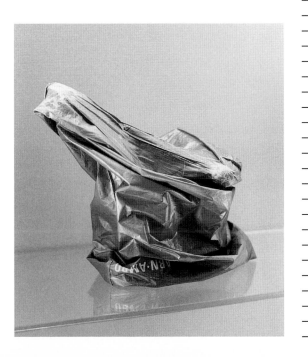

beer and the model of a KLM plane. In the cases on the left side of the video steps, circular objects predominated: coffee cups and crown corks the artist had plucked from the tables of the adjoining cafeteria, paper doylies, glass ashtrays, cardboard beer mats, up to and including a complete car tyre and a bicycle wheel. Objects from perfectly ordinary surroundings assumed the status of meticulously arranged artefacts. One of the finest specimens, an object with genuine sculptural pretensions, was a metallic green plastic bag still bearing the ghostly imprint of the bicycle saddle it had once embraced. The day before the exhibition opened, Orozco had 'liberated' the object from a bicycle parked in front of the museum and, being careful to keep its delicate form intact, placed it in the display case.

Arrayed in solitary splendour in each of the four right-hand cases, were miniature plastic 'ultra action figures' of the bizarre-looking seventies pop group KISS. The outlandishly made-up faces of Gene Simmons, Peter Criss, Ace Frehley and Paul Stanley grimaced ineffectually at the visitor from their meticulously lit glass cases. The same grotesque visages stared out of a couple Recordings segments where Orozco had filmed KISS posters in the windows of New York and Amsterdam toy shops.

On display between the objects in the five left-hand cases and on the wall opposite the four right-hand cases, was a total of fourteen passepartout-mounted drawings from 1996 and 1997. The drawings, graphite on computer prints, with their cluster patterns of circles on squares or vice versa, call to mind agglomerations of microbes seen through a microscope. They are part of Orozco's ongoing Puddle series that also includes a photo of a puddle on asphalt in which the artist has described circular patterns with his bicycle, and another of a puddle in which he has laid circles of plastic wrap as the fixed reflections of sunlight in water. Interspersed with the Puddle drawings were others with titles like Bank Polski, Cupon de Equipaje, Korean Air and Dangerous Articles, incorporating the airline tickets, boarding passes and foreign bank notes Orozco accumulates on his travels. These works, which consisted of collages of this commercial printed matter overlaid with circles and segments of circles drawn in paint, ink and graphite, combined the functional design of an airline ticket or a boarding pass with the formal abstraction of the circle, which in turn linked them to the tangible circular objects in the display cases.

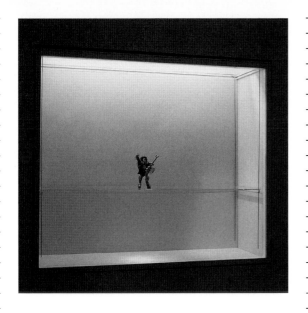

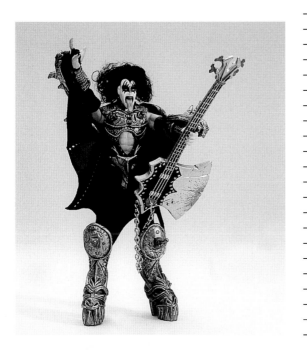

The exhibition <u>Recordings & Drawings</u> was, in all its modesty, exemplary for Orozco's artistic practice. In the catalogue to his <u>Clinton is Innocent</u> exhibition in the Musée Nationale d'Art Moderne de la Ville de Paris in 1998, Benjamin Buchloh published a long conversation with Orozco in which they discuss various aspects of the artist's work.[6] Buchloh notes that Orozco's practice cannot be approached in terms of specific media in that his work is a conglomerate of objects, ready mades, sculpture, language, photography, film, actions, installations and interventions. Together they make up the intricate tissue of his artistic activity. In <u>Recordings & Drawings</u> several of these techniques coincided in a project that brilliantly conveyed Orozco's ability to establish allusive connections between a wide variety of objects, situations and everyday phenomena and also to awaken the viewer to the possibility of their existence. In the Stedelijk Museum he turned the transit zone around the video steps into a hybrid, layered and associative space in which films of scenes from big city life (complete with street noises that echoed through the museum corridors) were linked up with prosaic objects laid out in display cases, and with drawings incorporating mundane printed matter hung on the walls. Through Orozco's intervention, the serendipitous outdoors was able to infiltrate the normally rigidly organized institutional space. By playing different kinds of viewing off against one another – the roving eye of the urban pedestrian and the concentrated scrutiny of the museum visitor – the artist challenged the self-evidence of museum rituals and conventions. A key talking point in the interview with Buchloh was Orozco's notion of 'activating space' which he regards as the basis of all his artistic activity. Orozco: 'I mean [to] activate the space between the sign and the spectator or a third person who is perceiving that space. ...That's "the" question that I'm asking somehow.'[7] Orozco's interpretation of that 'space', as he demonstrates in <u>Recordings & Drawings</u>, is wide-ranging. Space can be defined in social, political, psychological, physical and concrete terms and all these definitions apply to Orozco's work, usually several definitions at the same time. In examining the nature and functions of a particular place outside of its specific conditions, in playing with and intermixing different contexts, Orozco opens up new possibilities for himself and, by extension, for the viewer. His ambition is to 'sensitize' the viewer's gaze to the connectedness of things, with the ultimate aim of transforming their view of

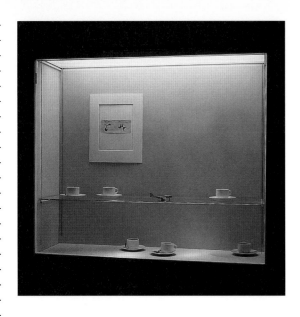

reality. All this became quite clear to anyone who spent some time absorbing Orozco's <u>Recordings & Drawings</u> project in the Stedelijk. The objects in the display cases struck up visual relationships with the drawings and the film images and films in turn breathed life into the drawings and objects. The whole was so unmistakably derived from and related to everyday reality that visitors leaving the museum after seeing the exhibition found themselves starting to view the world Orozco-fashion. A plastic cup being blown along the pavement by the wind ceased to be a meaningless piece of litter and became instead the catalyst for a string of visual associations. Orozco: '...what is most important is not so much what people see in the gallery or the museum, but what people see after looking at these things, how they confront reality again.'[8]

Martijn van Nieuwenhuyzen

The author would like to thank Jan van Adrichem for his willingness to act as a sounding board during the writing of this text, Xander Karskens for his assistence during both the mounting of the exhibition and the making of the film stills, Robyn de Jong-Dalziel for her inventive suggestions regarding the translation and, not least, Gabriel Orozco for a highly pleasurable collaboration in Amsterdam, almost four years ago.

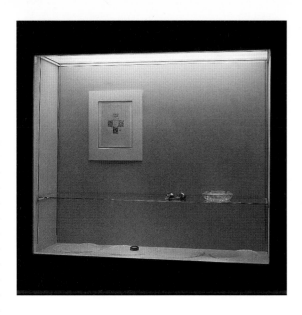

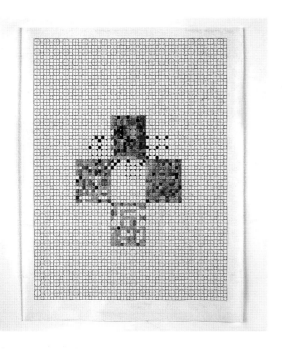

Notes

1. Daniel Birnbaum, 'A Thousand Words: Gabriel Orozco talks about his recent films', Artforum, vol. 36, no. 10, Summer 1998, p. 115.

2. Real Time, Institute of Contemporary Arts, London, 19 June to 19 July 1993. Gabriel Orozco, Rirkrit Tiravanija, Lincoln Tobier and Andrea Zittel created special works for this exhibition focusing on 'interaction and participation between artist, artworks, audiences and the institution' (cat. p. 2). There was an echo of the 1997 Recordings in the video Desde manos con Maiz hasta Calzon con Bicho (From Hands with Corn to Boxer Shorts with Insect) that Orozco showed as part of his Chacahua exhibition in Portikus, Frankfurt in 1999. The video was made in Mexico and showed pictures from a walk along the Mexican beach landscape. See exh. cat. Gabriel Orozco, Chacahua, Portikus, Frankfurt, 1999.

3. E-mail from artist to author, 2-2-2001.

4. Ibid., note 1.

5. Ibid., note 1.

6. 'Benjamin Buchloh interviews Gabriel Orozco in New York', exh. cat. Clinton is Innocent, Musée d'Art Moderne de la Ville de Paris (ARC), Paris, 1998, pp. 26-165.

7. Ibid., p. 43.

8. Ibid., p. 59.

RECORDING #1 59'00"

From

To

Green Glass
FEDERAL
EXPRESS

New York

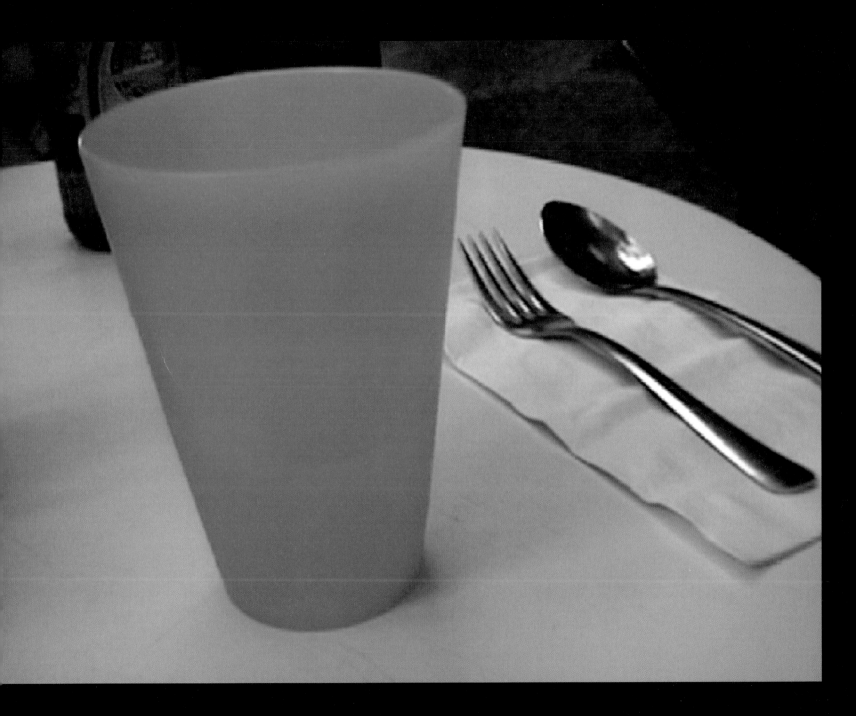

From GREEN GLASS

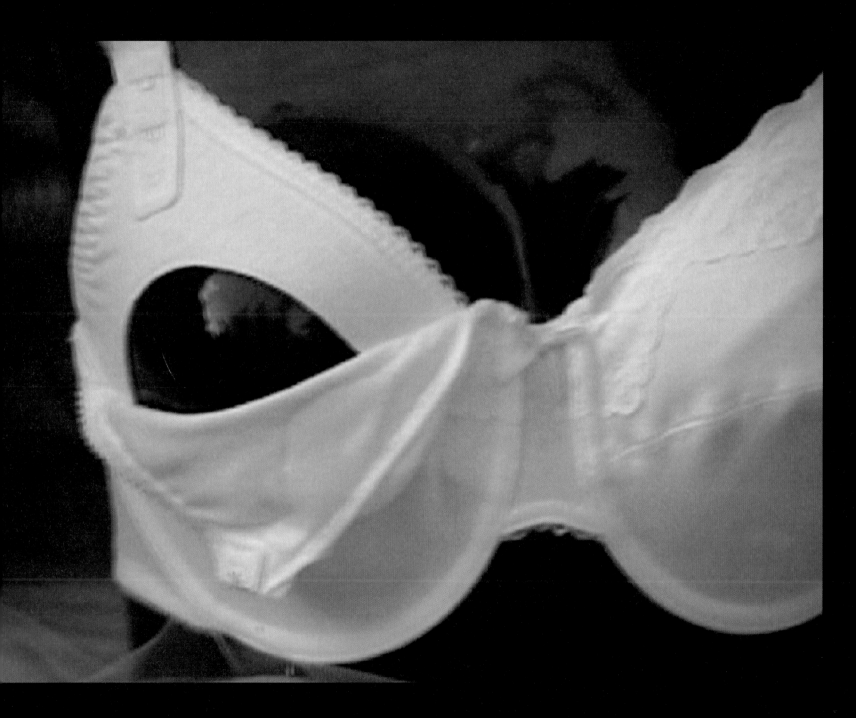

From GREEN GLASS

From GREEN GLASS

To FED EX

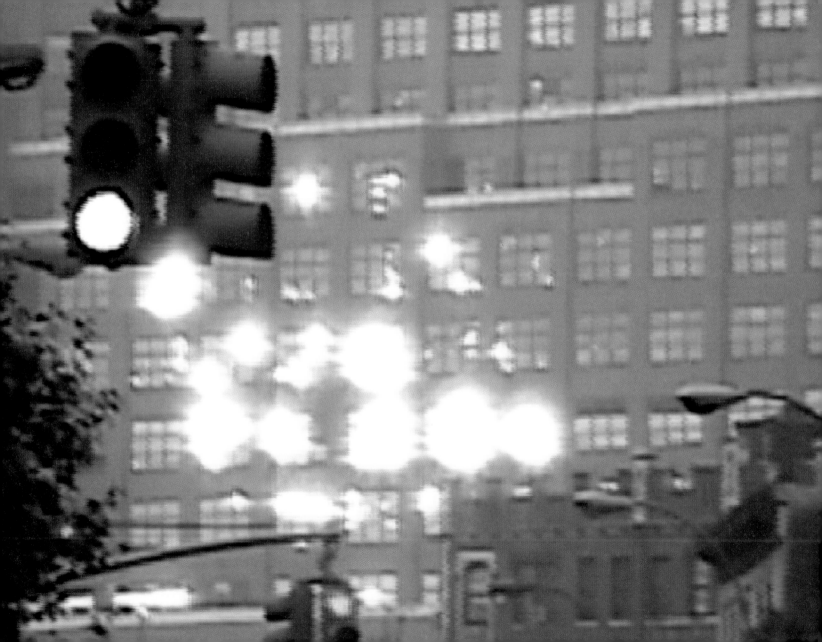

From GREEN GLASS

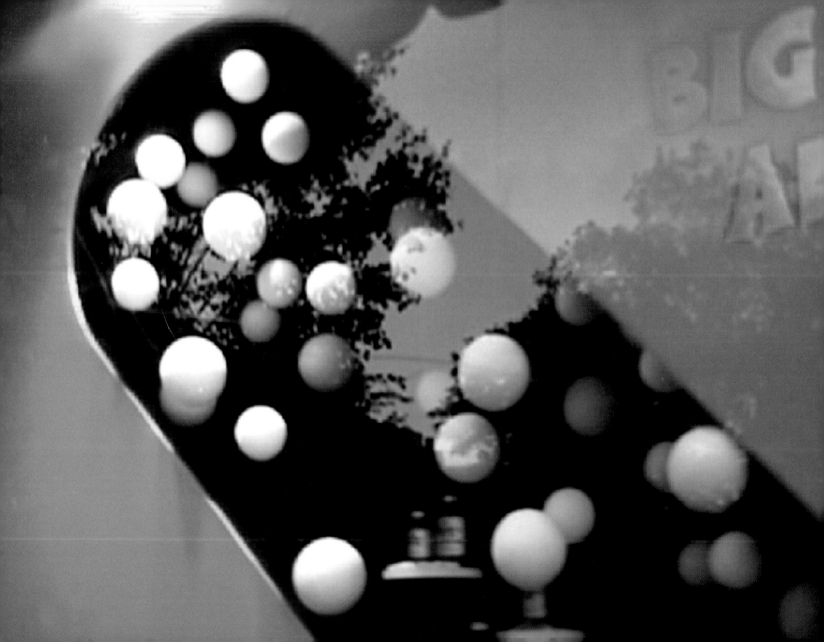

From GREEN GLASS

To FED EX

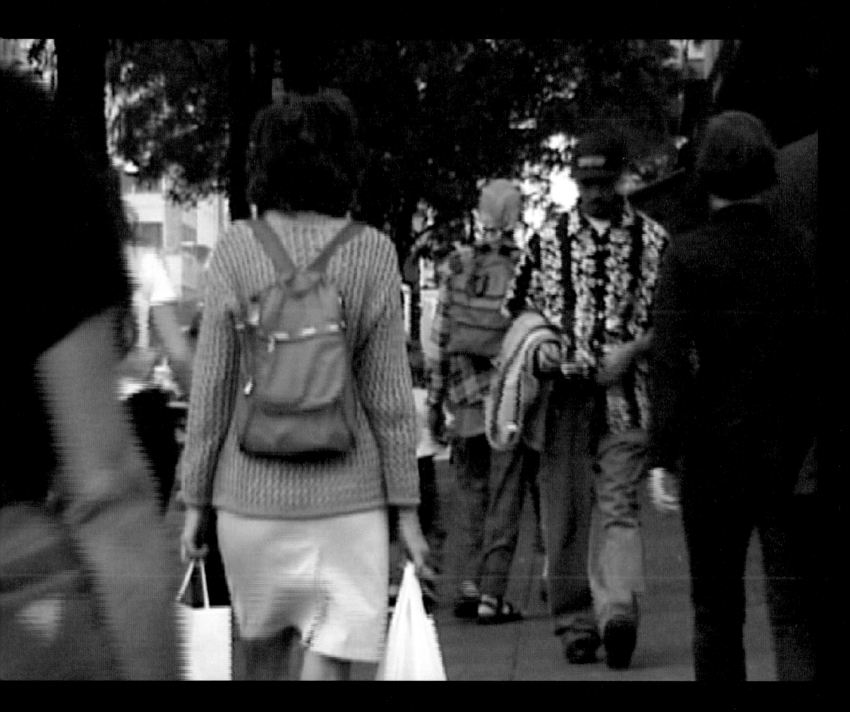

From GREEN GLASS

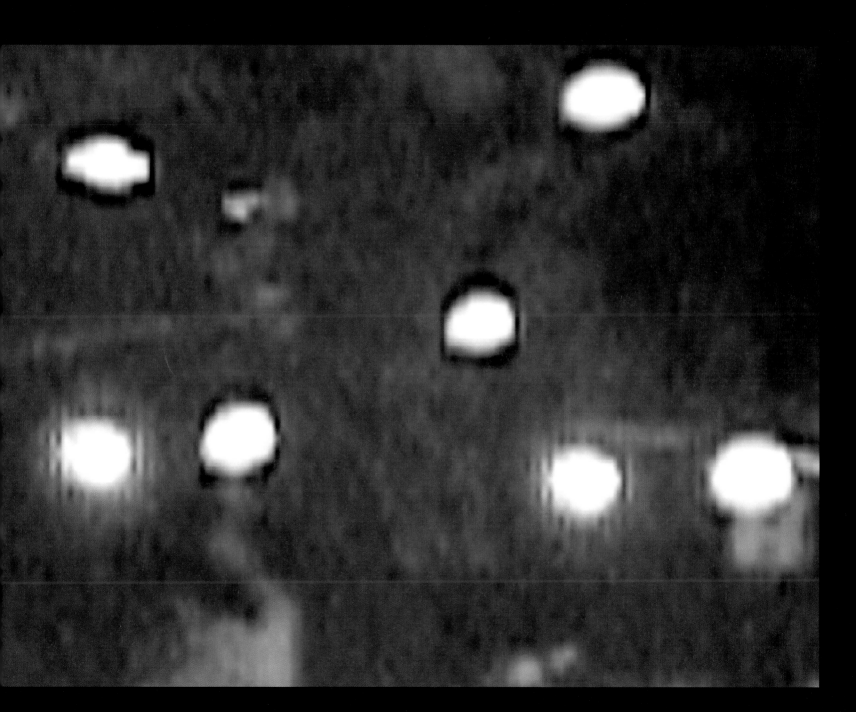

From GREEN GLASS

Art **Center** **College** of Design
Library
1700 Lida Street
Pasadena, Calif. 91103

To FED EX

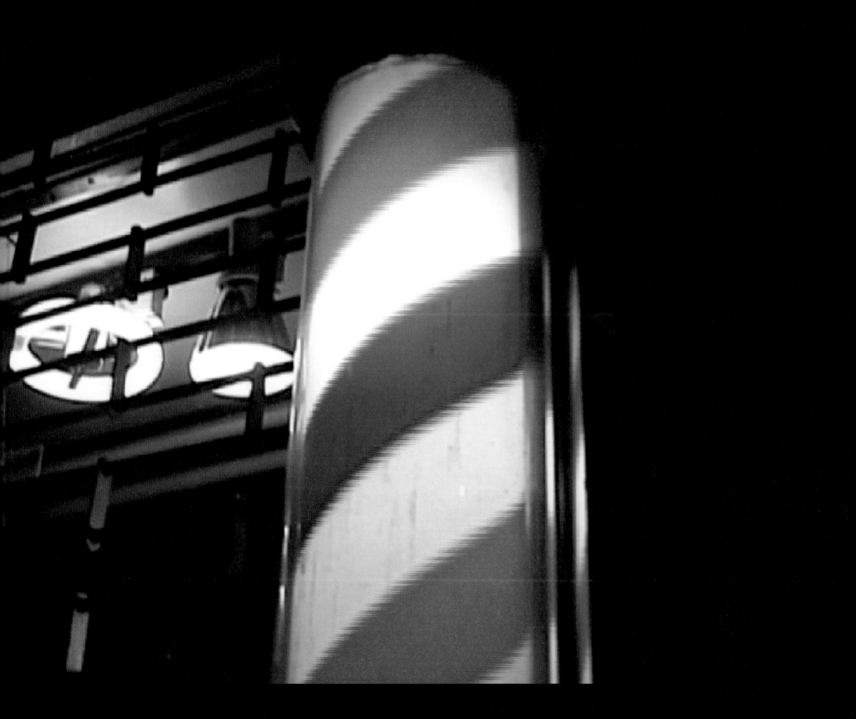

From GREEN GLASS

To FED EX

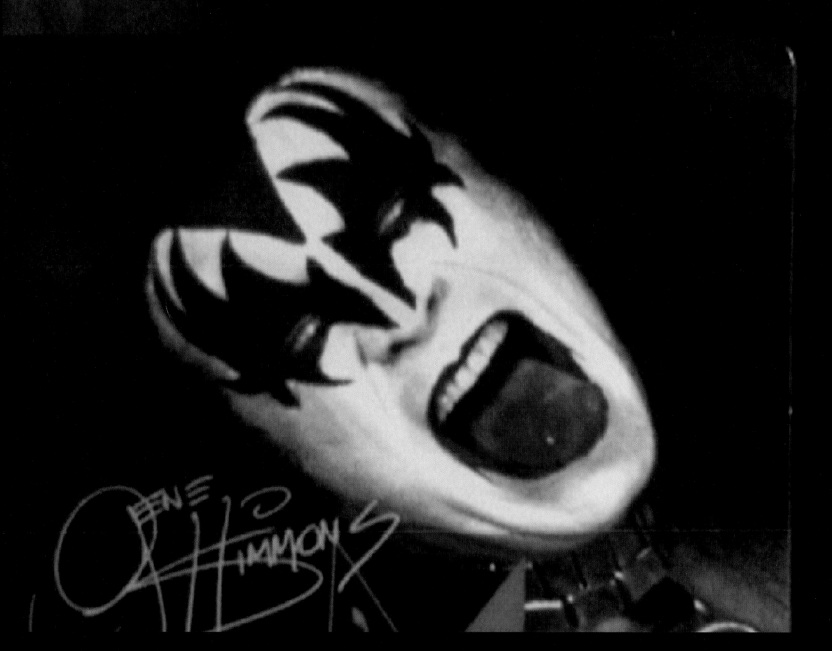

From GREEN GLASS

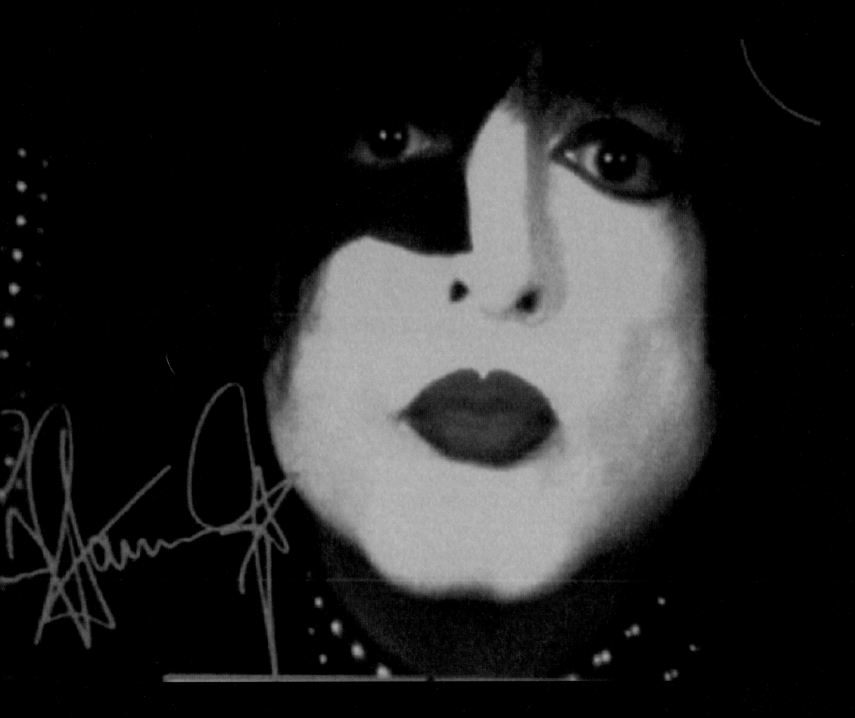

From GREEN GLASS

To FED EX

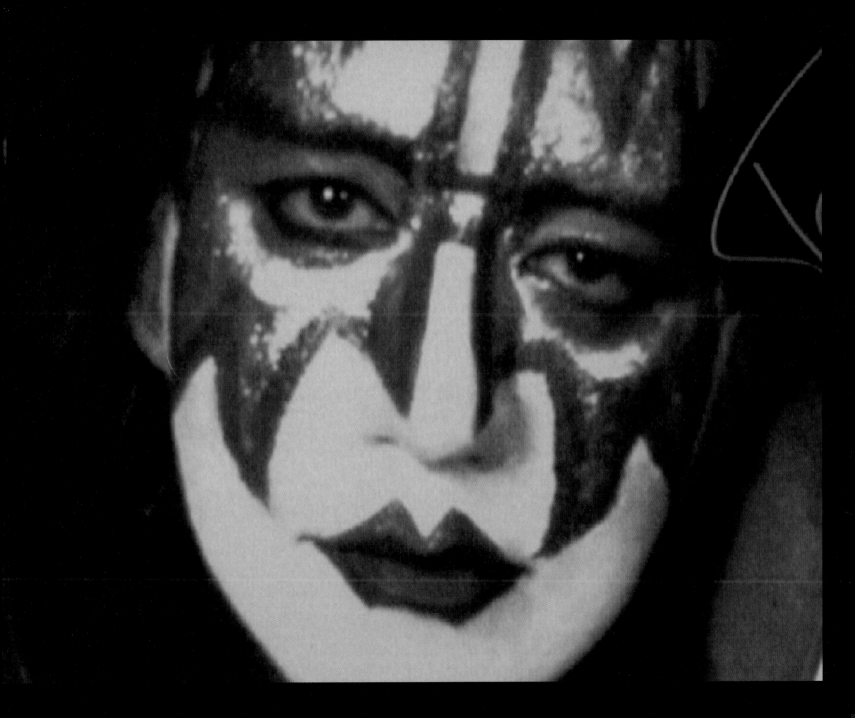

From GREEN GLASS

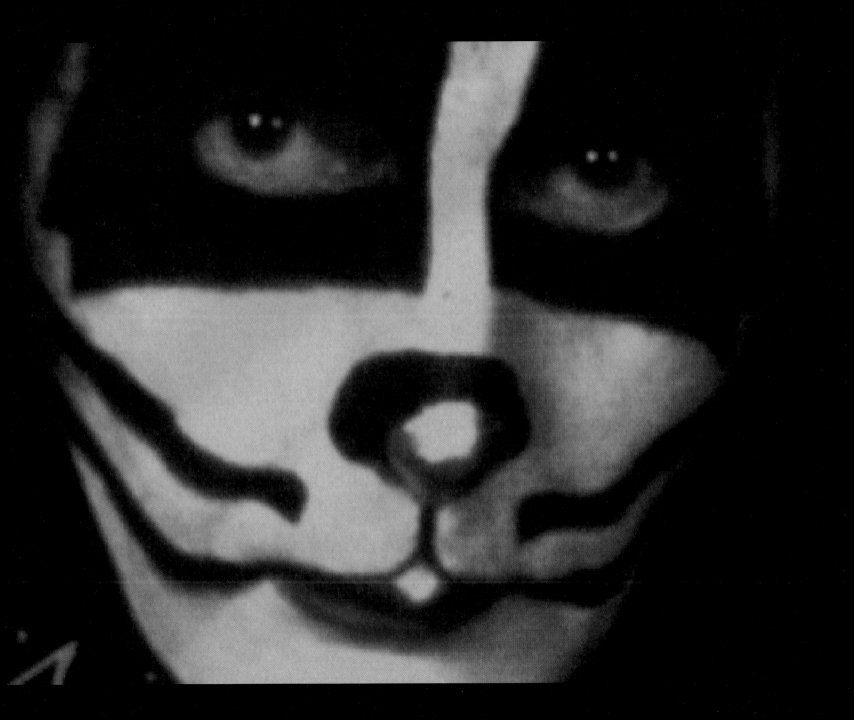

From GREEN GLASS

From GREEN GLASS

To FED EX

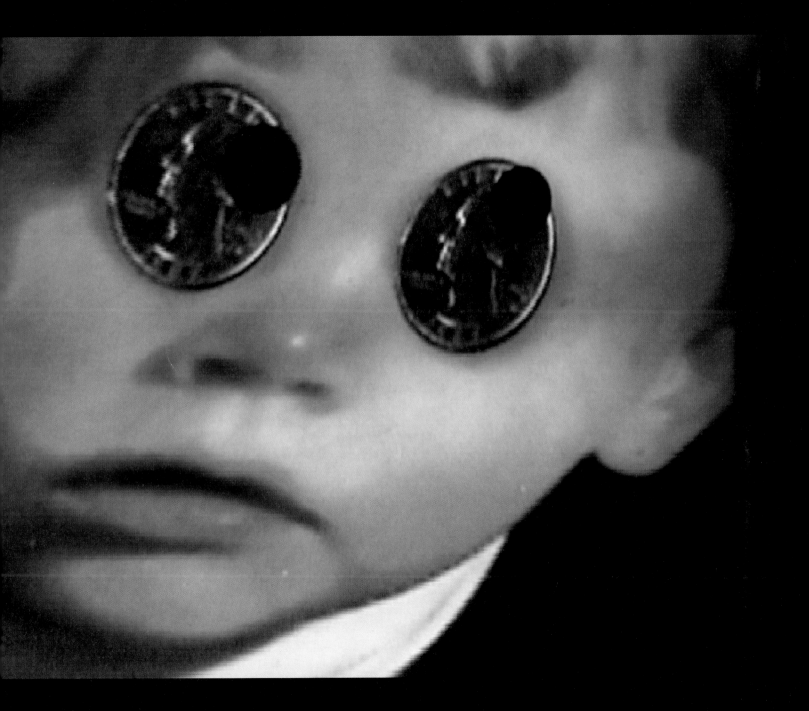

From GREEN GLASS

To FED EX

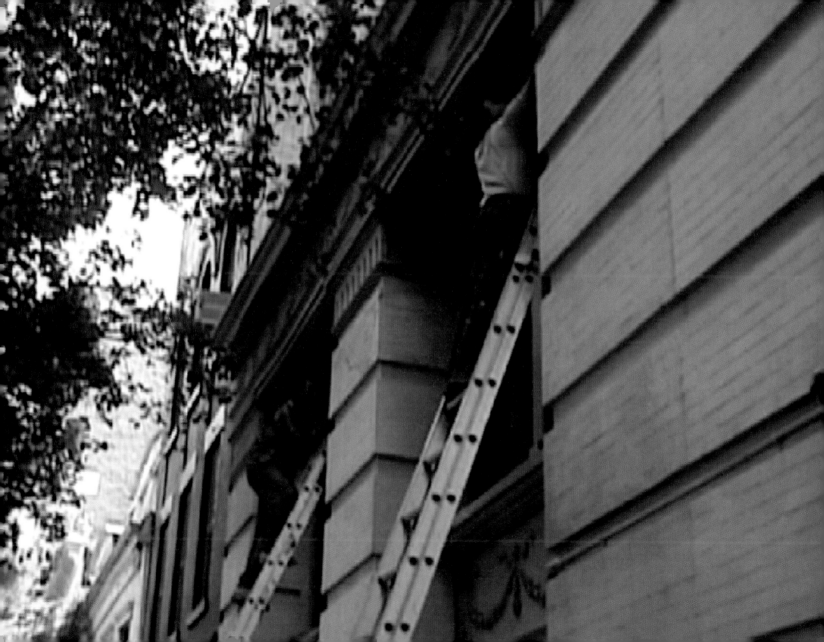

From GREEN GLASS

To FED EX

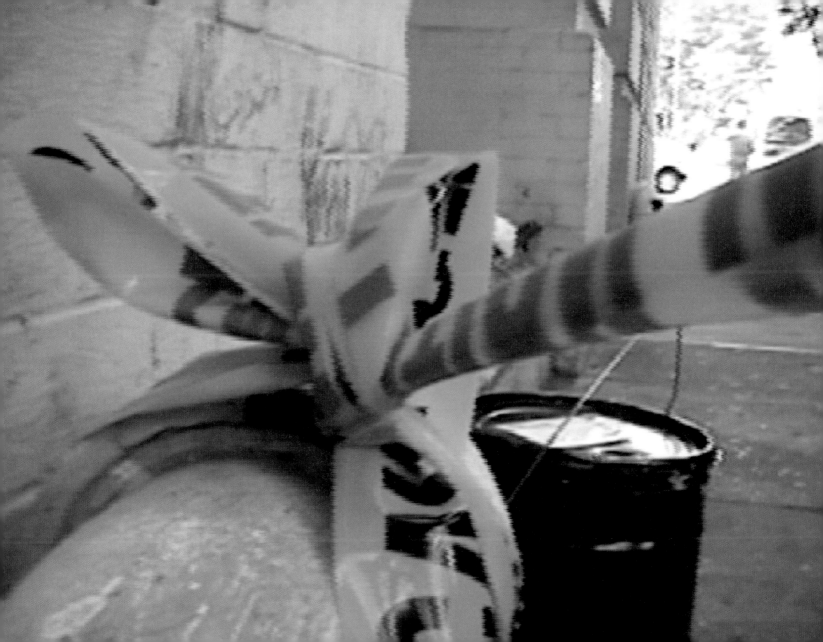

From GREEN GLASS

To FED EX

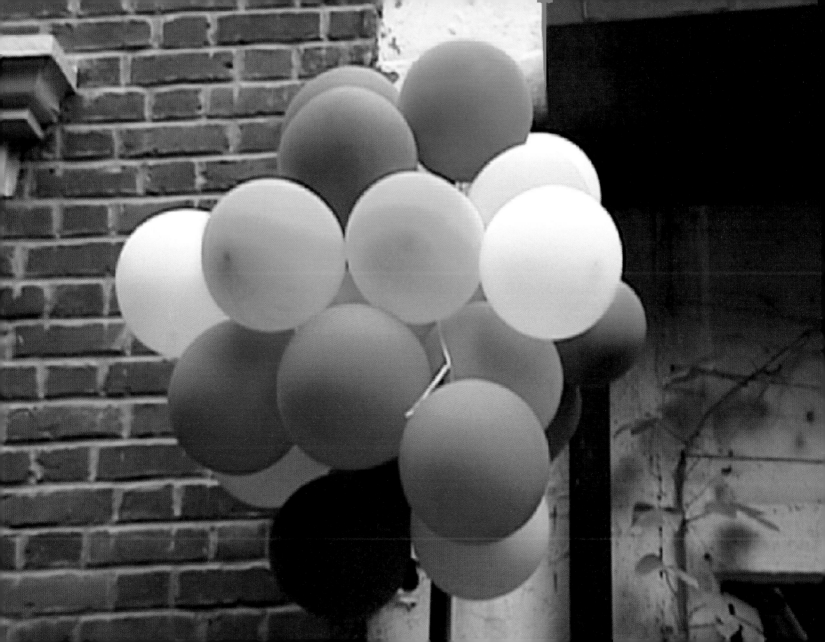

From GREEN GLASS

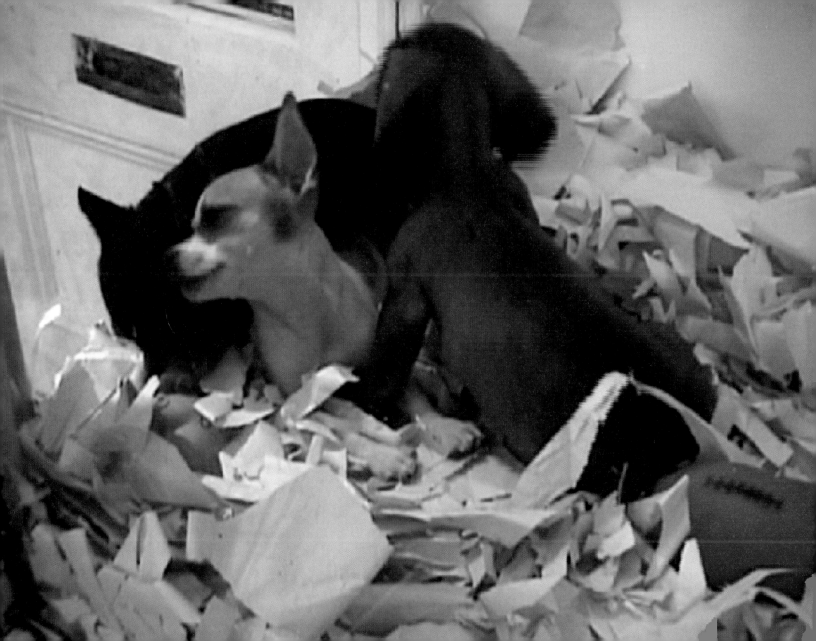

From GREEN GLASS

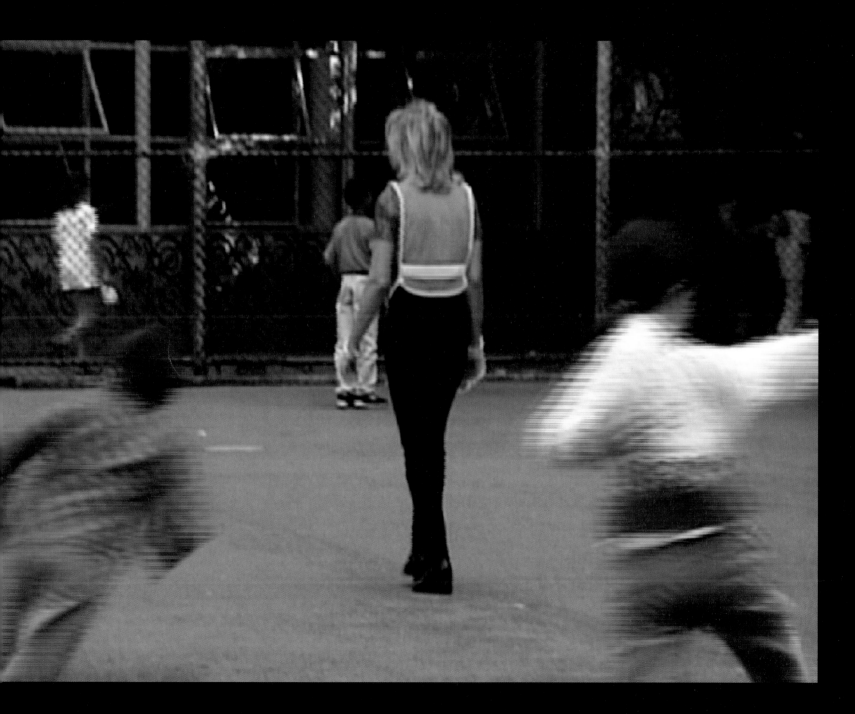

From GREEN GLASS

From GREEN GLASS

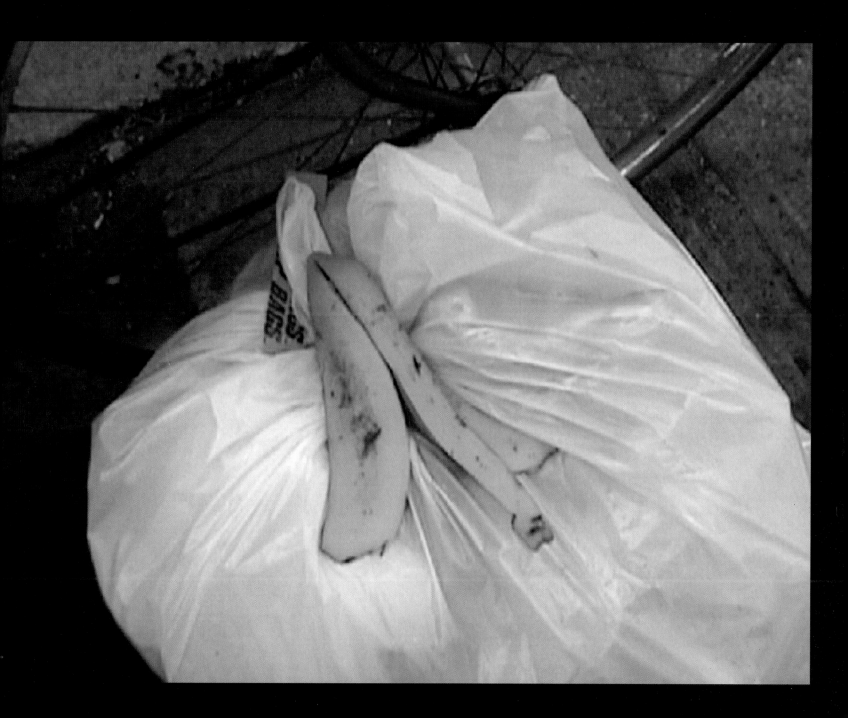

From GREEN GLASS

LINDA HAS LOST -- ARE YOU READY
FOR THIS?
SHE HAS LOST 100 POUNDS SINCE

From GREEN GLASS

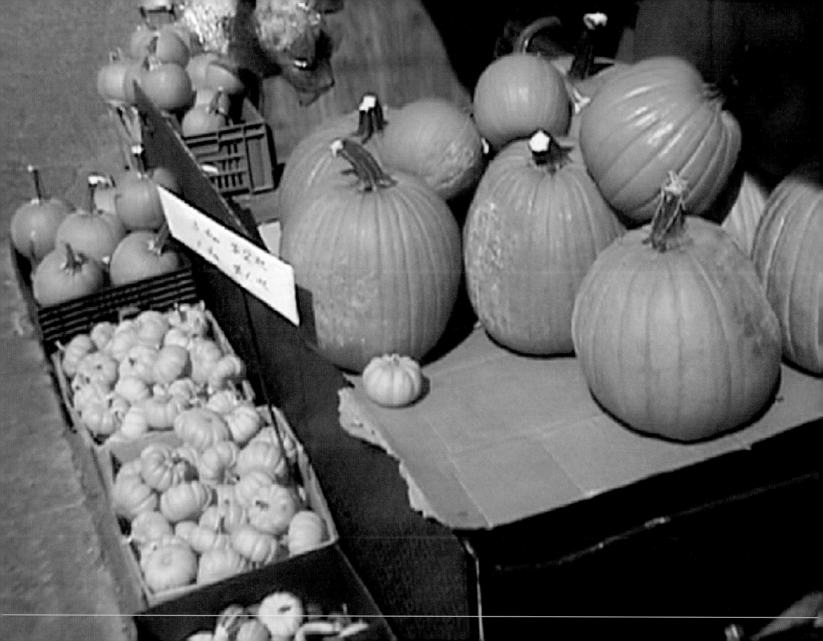

From GREEN GLASS

To FED EX

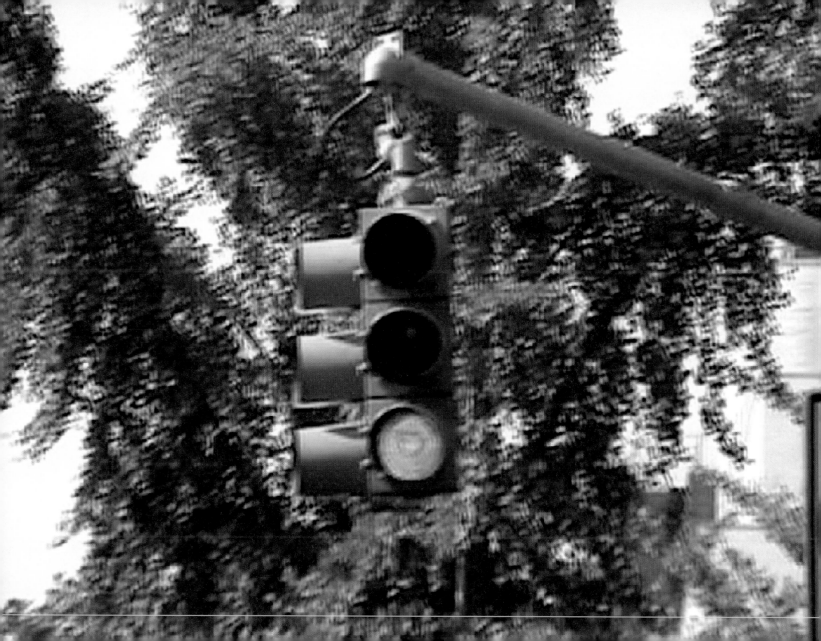

From GREEN GLASS

To FED EX

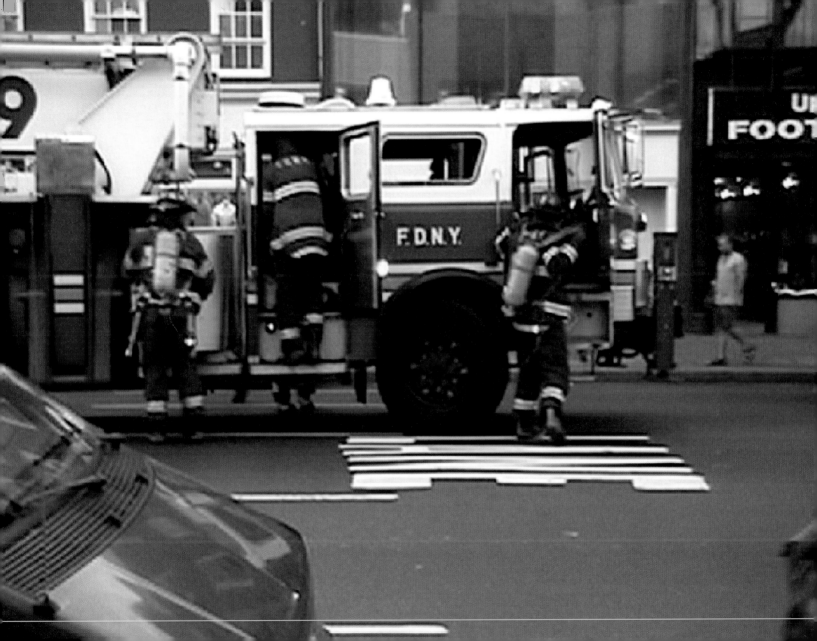

From GREEN GLASS

To FED EX

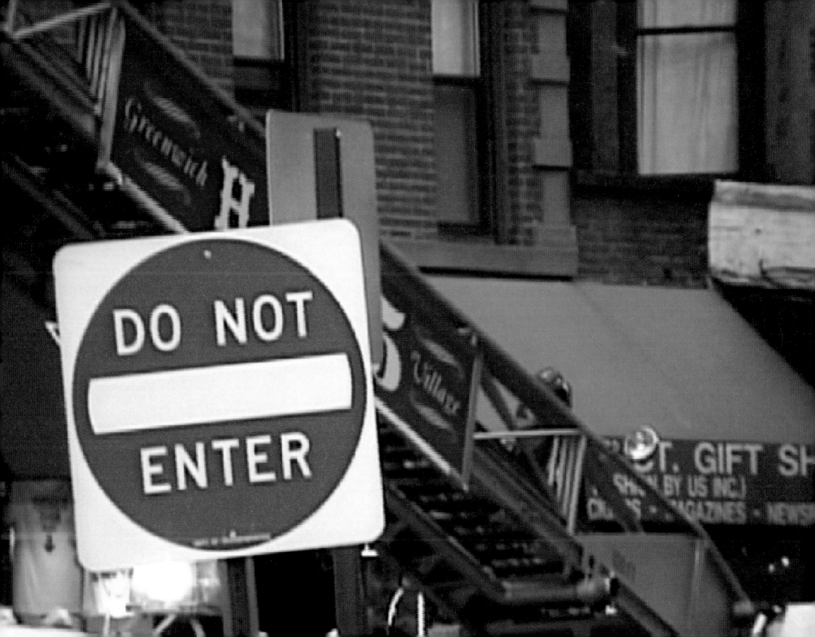

From GREEN GLASS

To FED EX

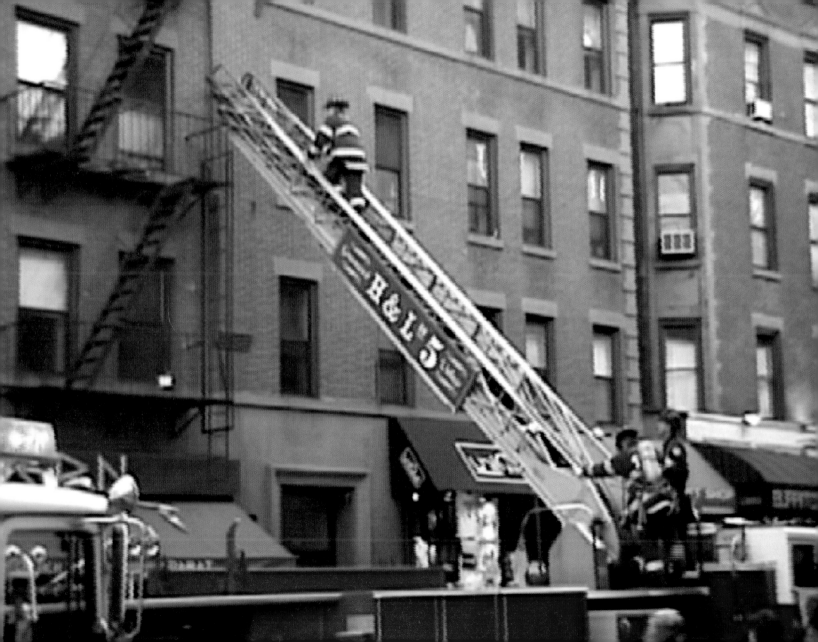

From GREEN GLASS

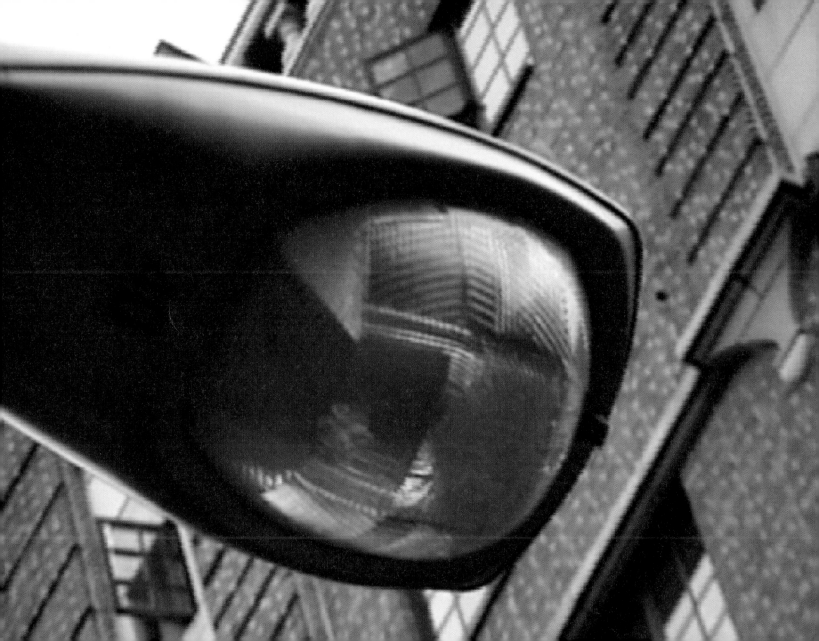

From GREEN GLASS

From GREEN GLASS

To FED EX

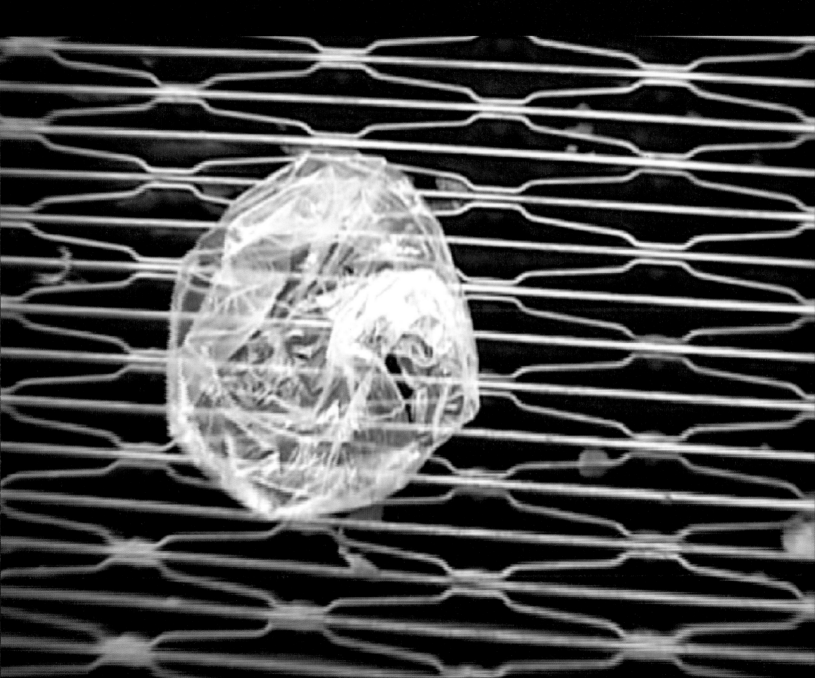

From GREEN GLASS

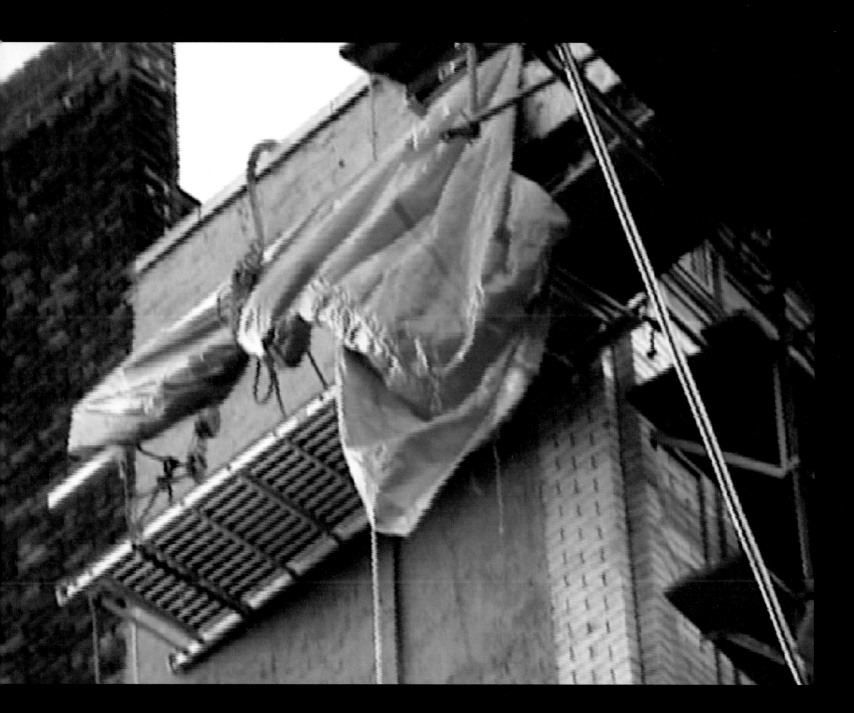

From GREEN GLASS

To FED EX

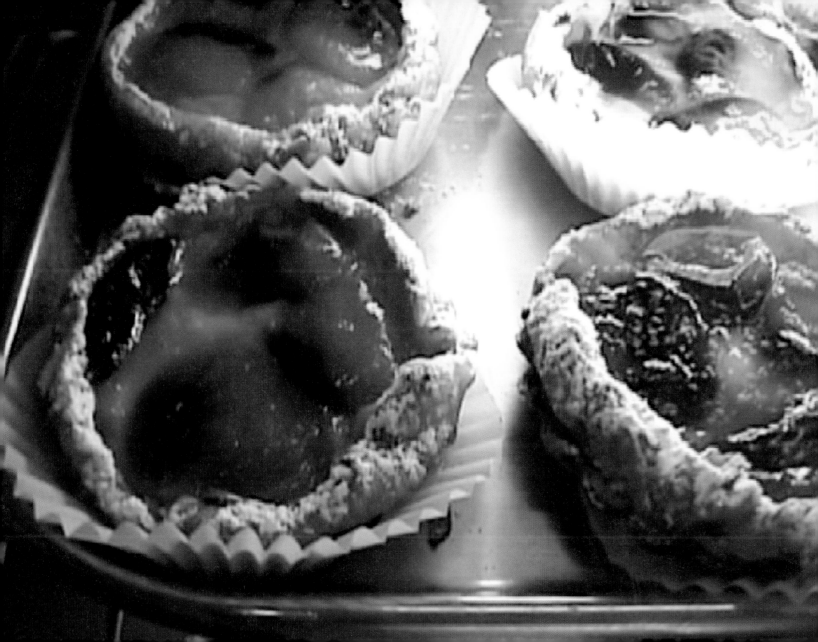

From GREEN GLASS

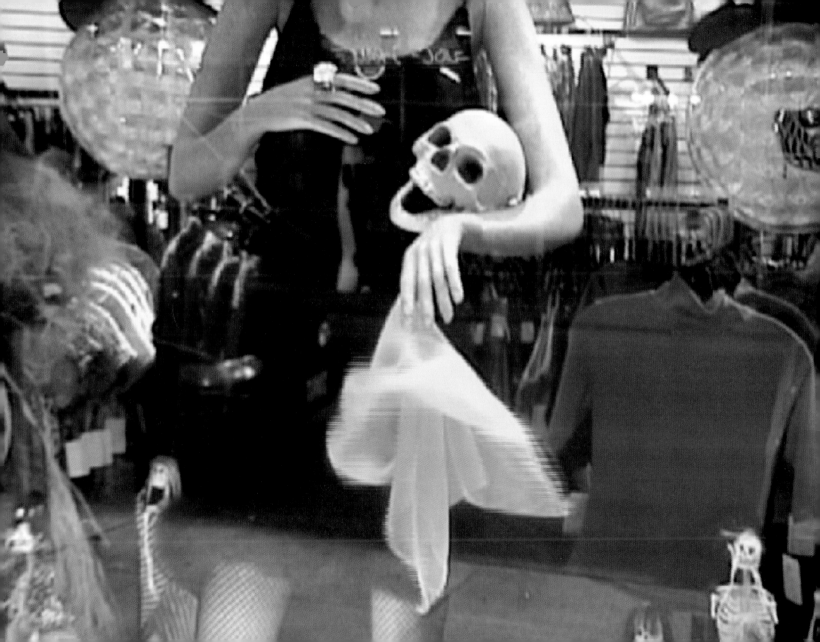

From GREEN GLASS

To FED EX

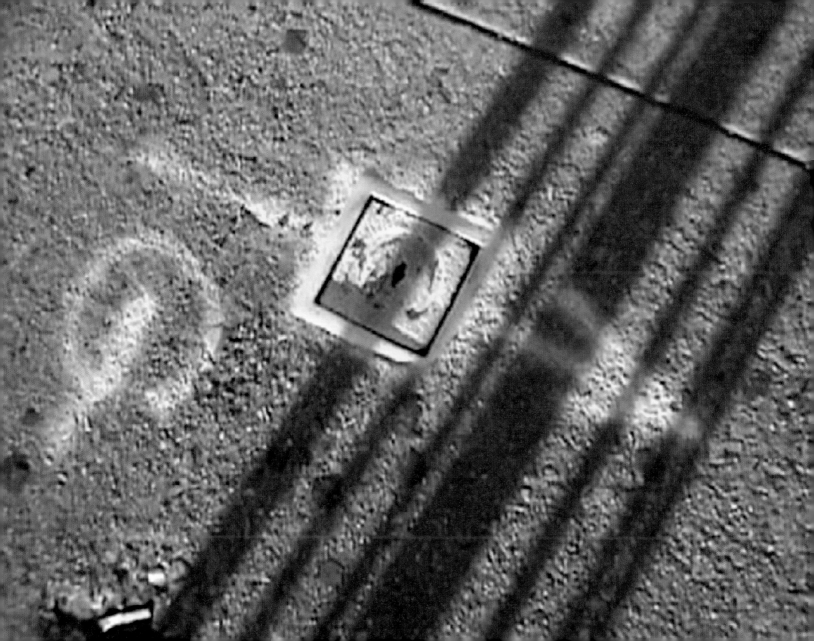

From GREEN GLASS

To FED EX

From GREEN GLASS

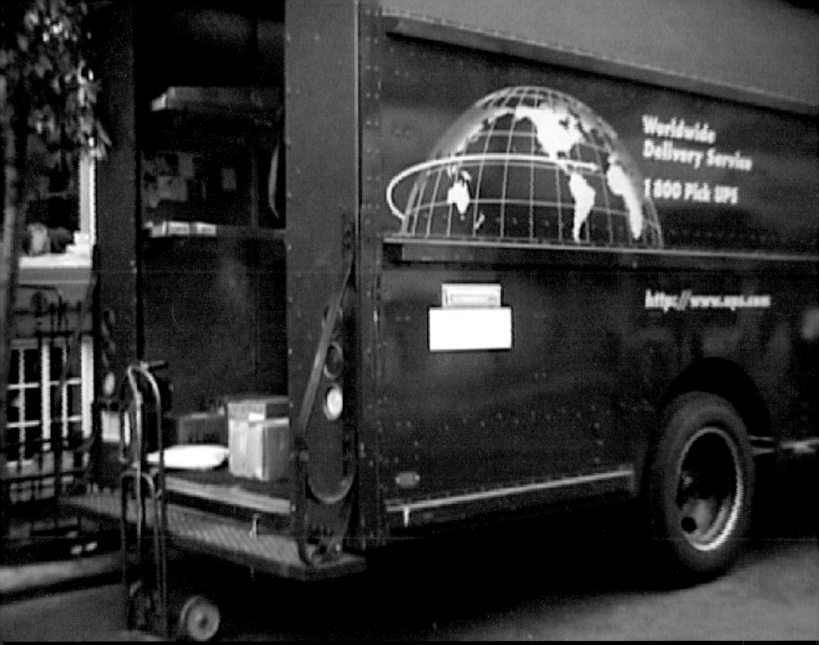

Worldwide
Delivery Service

1 800 Pick UPS

http://www.ups.com

From GREEN GLASS

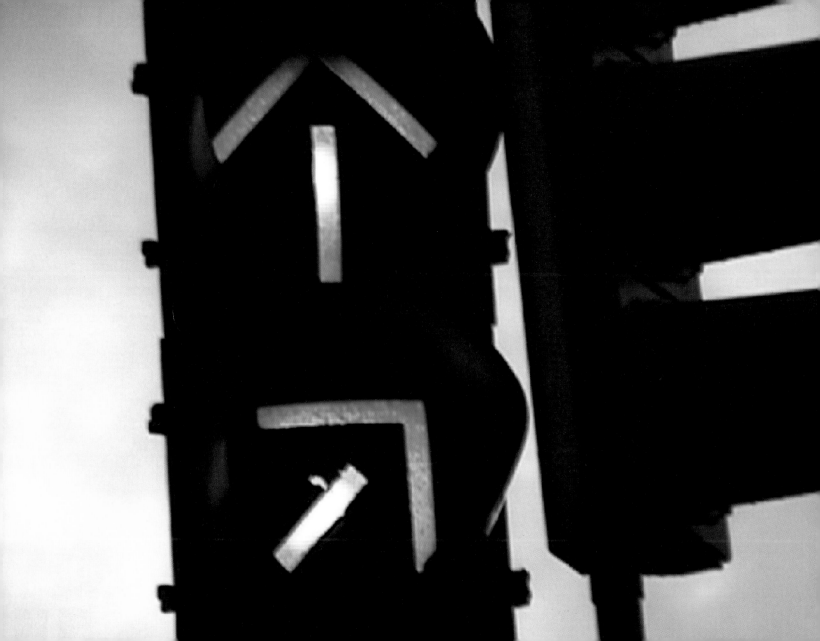

From GREEN GLASS

From GREEN GLASS

To FED EX

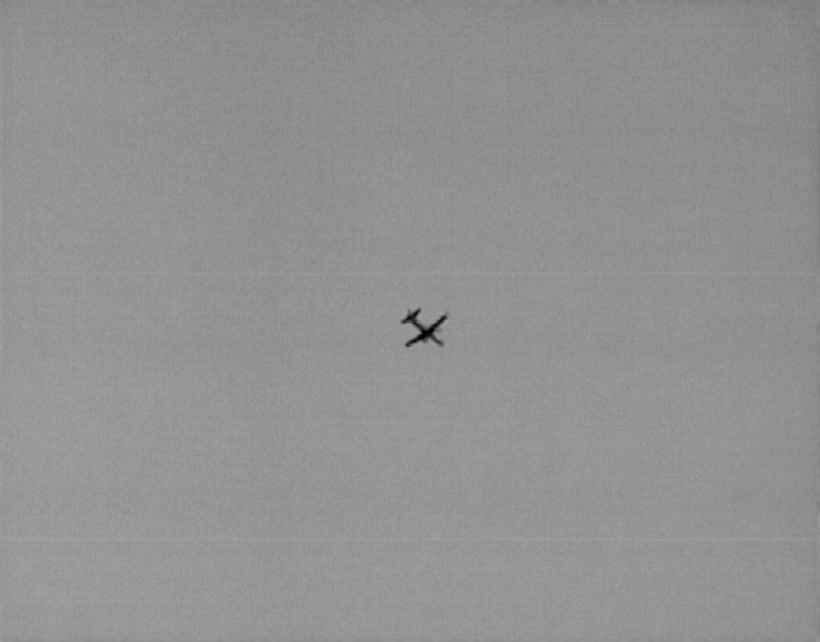

From GREEN GLASS

To FED EX

From GREEN GLASS

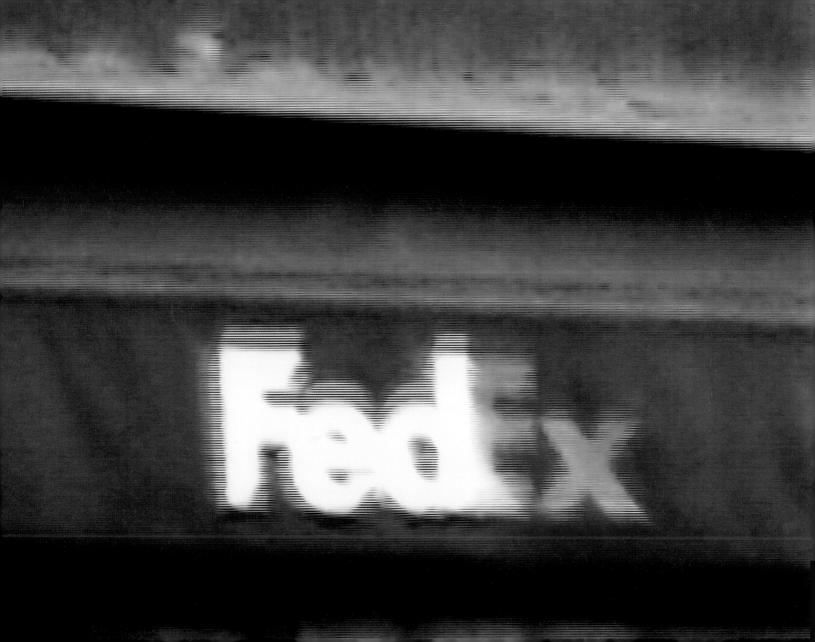

From GREEN GLASS

To FED EX

RECORDING #2 57"00"
From Container
To DON'T WALK

New York

From CONTAINER

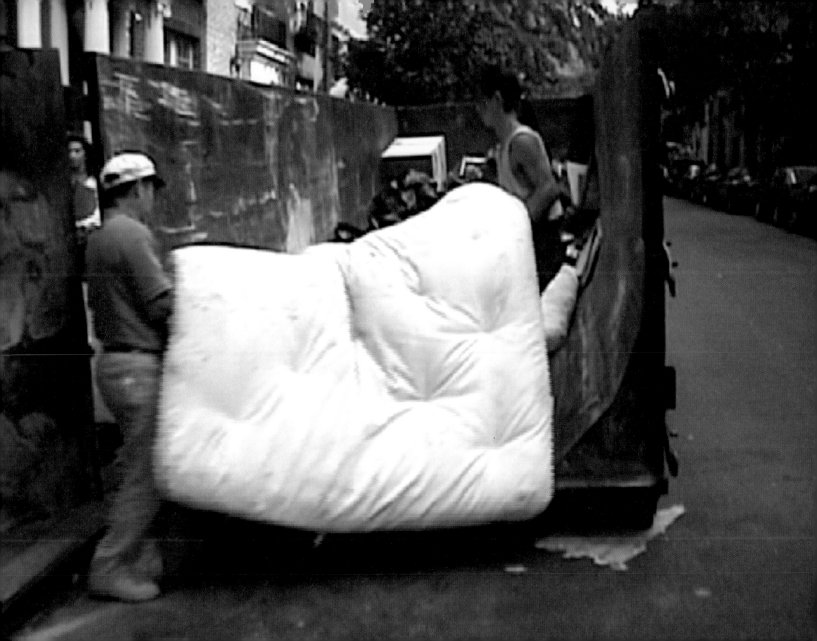

From CONTAINER

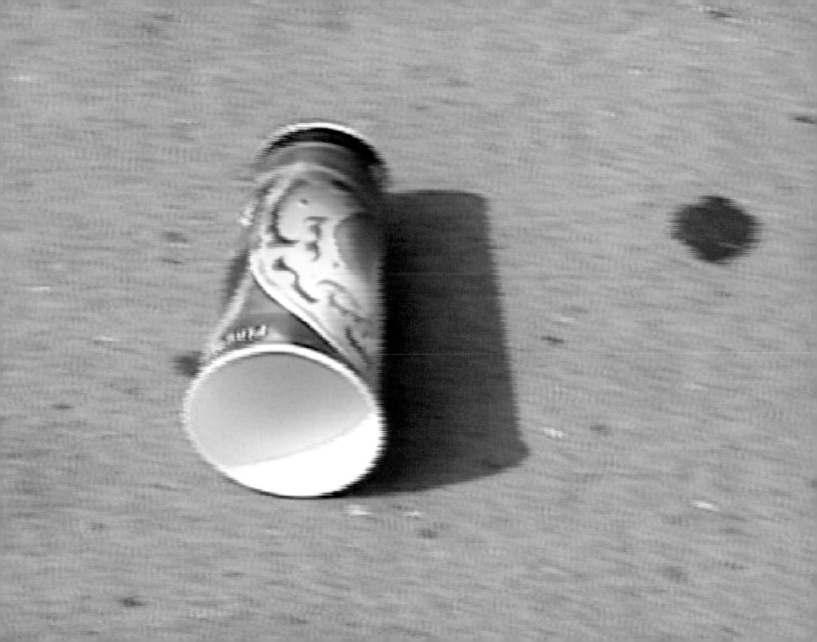

From CONTAINER

To DON'T WALK

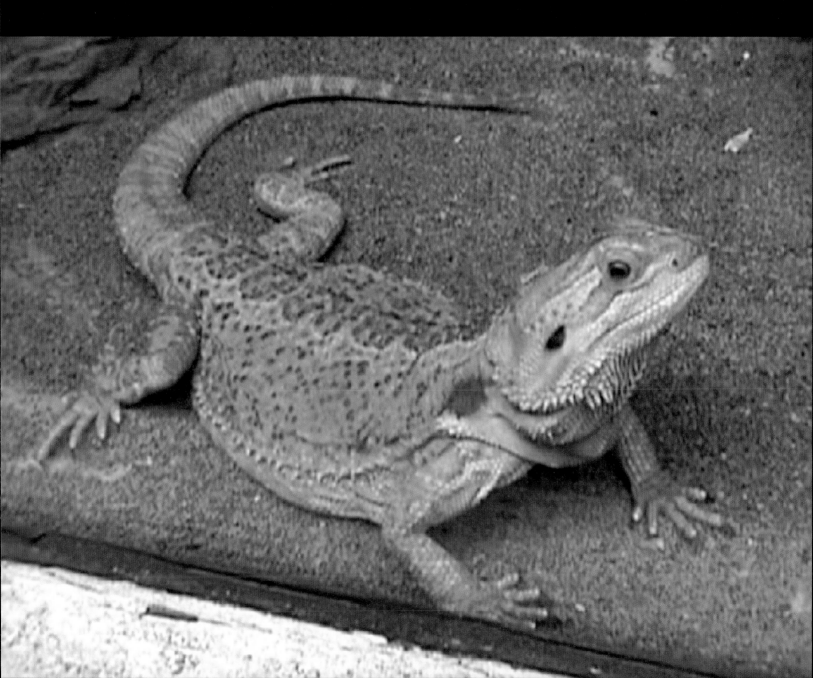

From CONTAINER

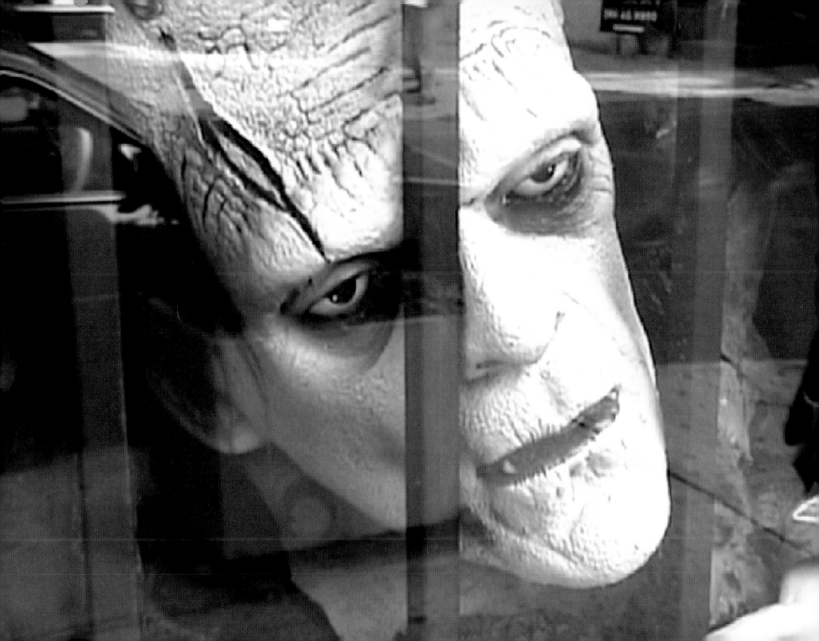

From CONTAINER

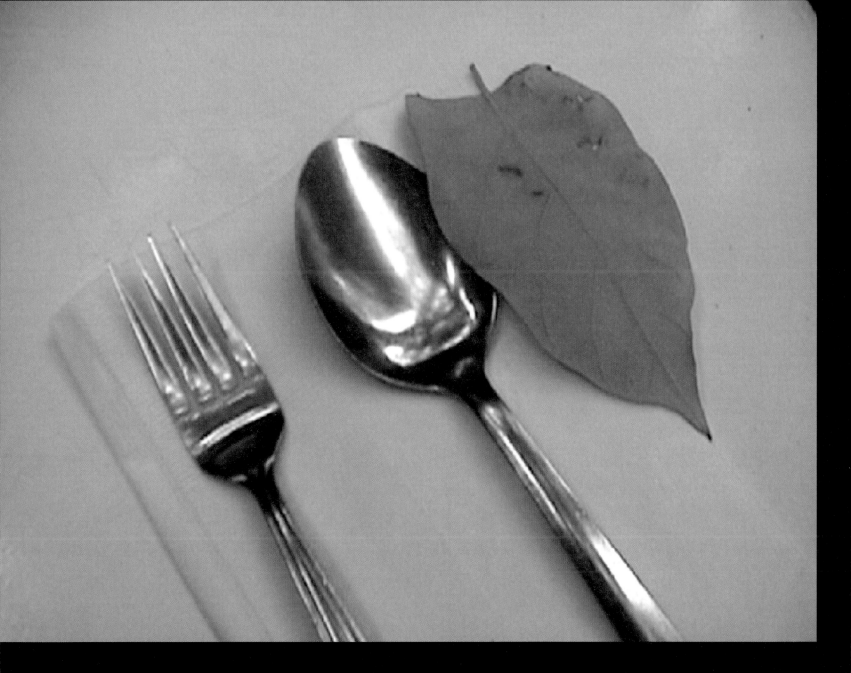

From CONTAINER

To DON'T WALK

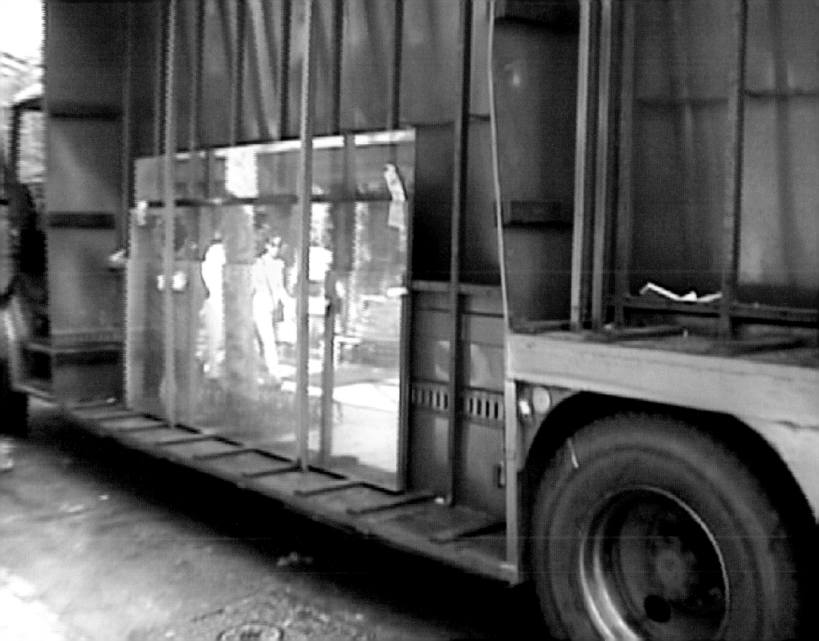

From CONTAINER

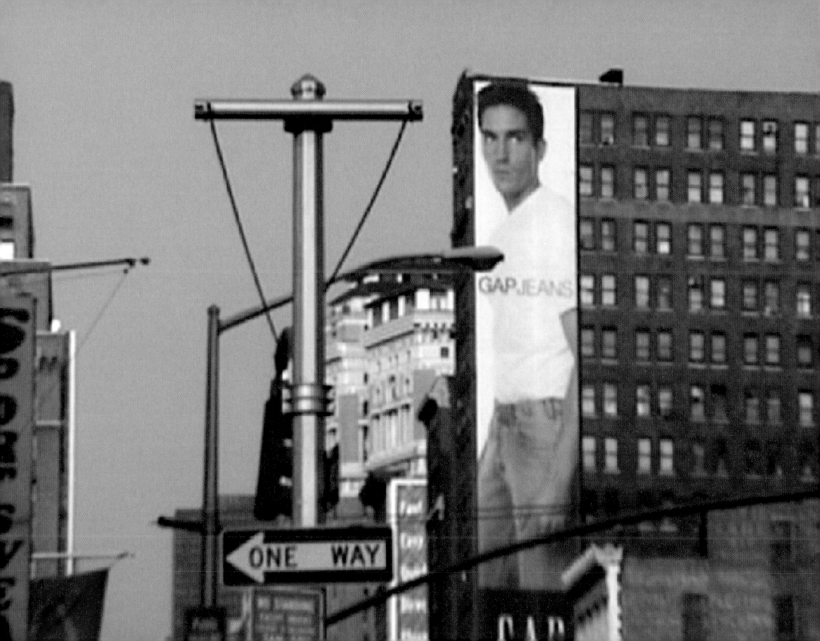

From CONTAINER

To DON'T WALK

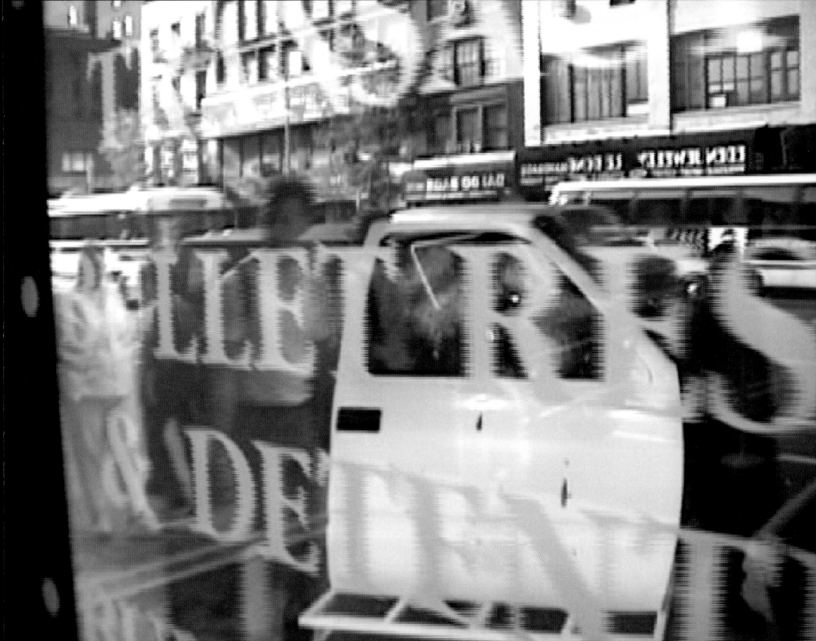

From CONTAINER

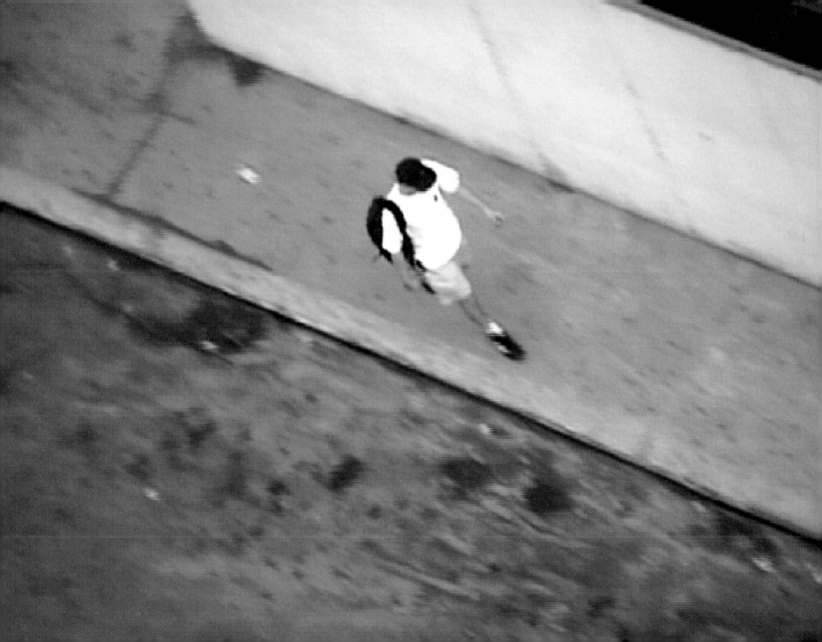

From CONTAINER

To DON'T WALK

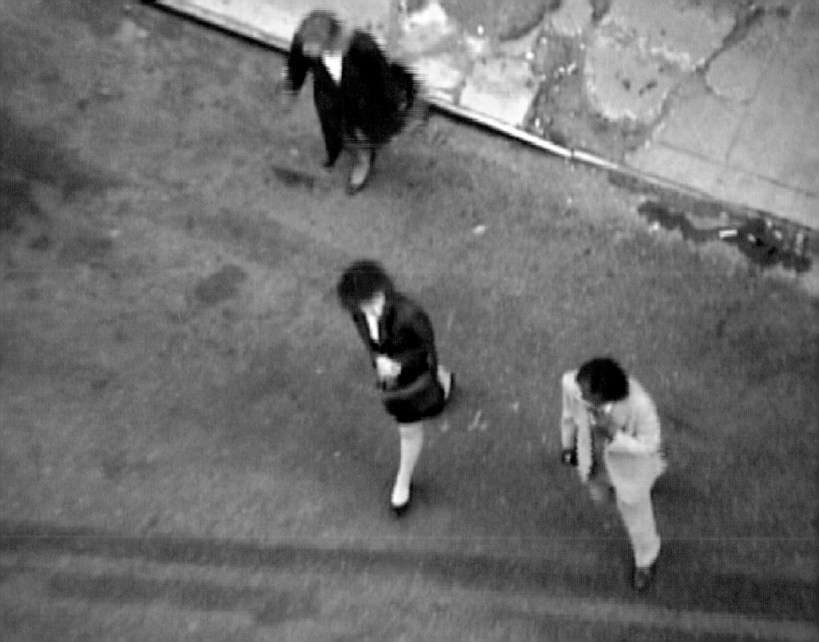

From CONTAINER

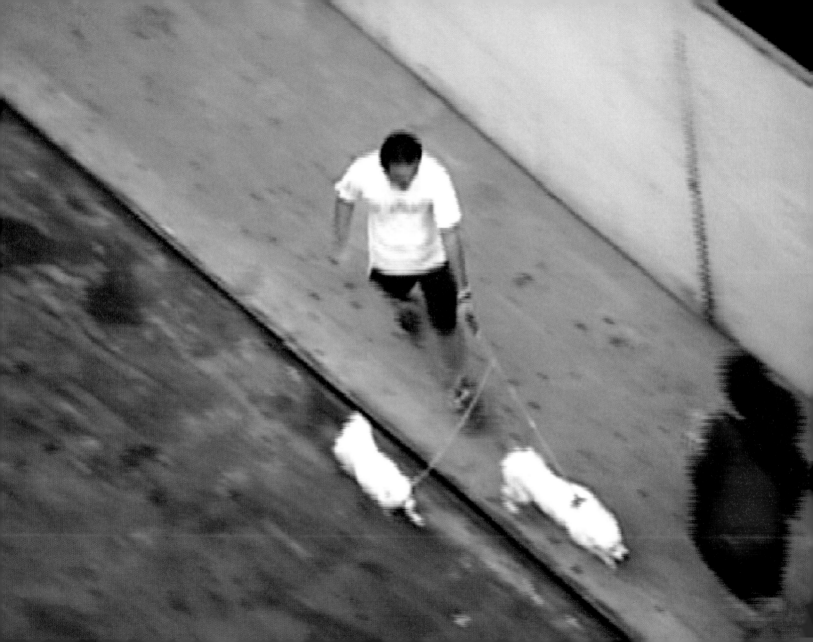

From CONTAINER

To DON'T WALK

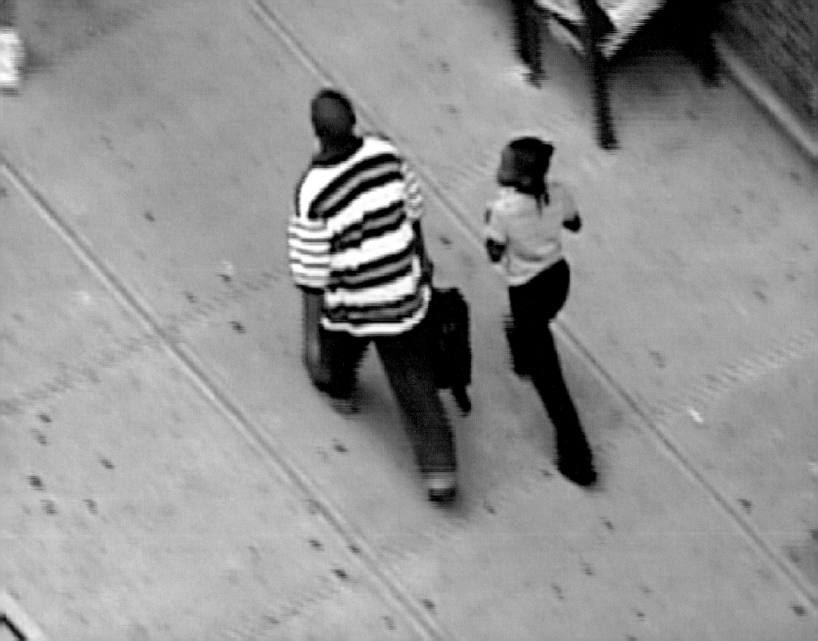

From CONTAINER

To DON'T WALK

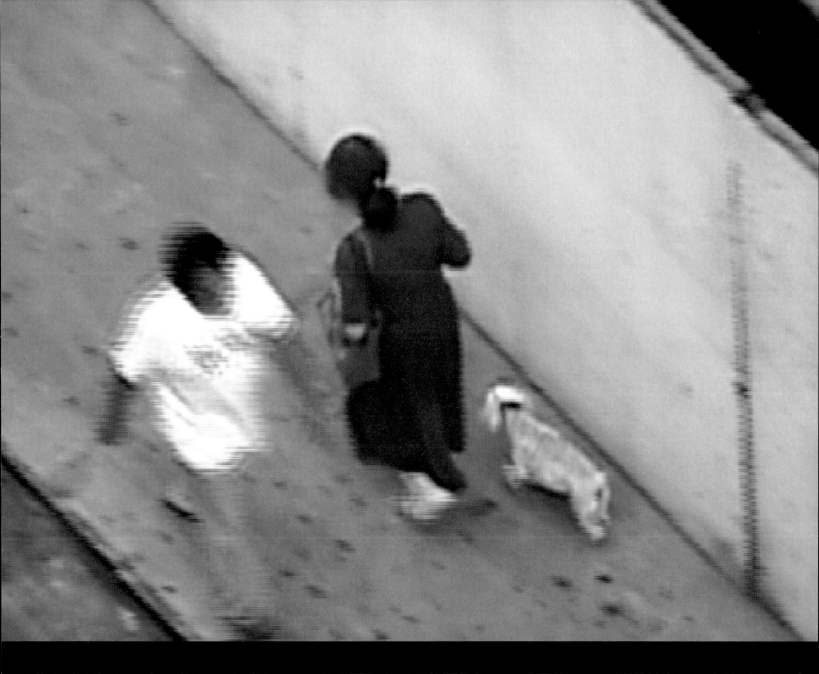

From CONTAINER

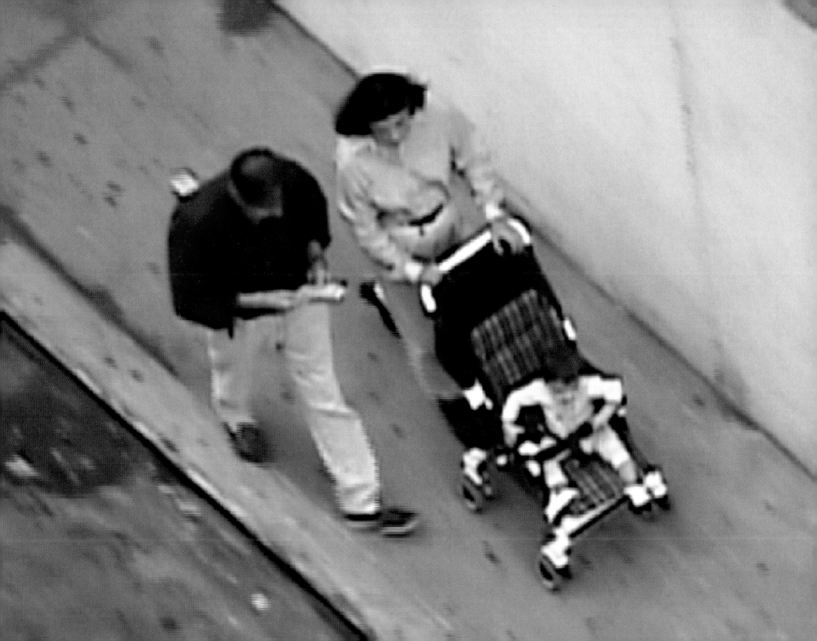

From CONTAINER

To DON'T WALK

From CONTAINER

From CONTAINER

To DON'T WALK

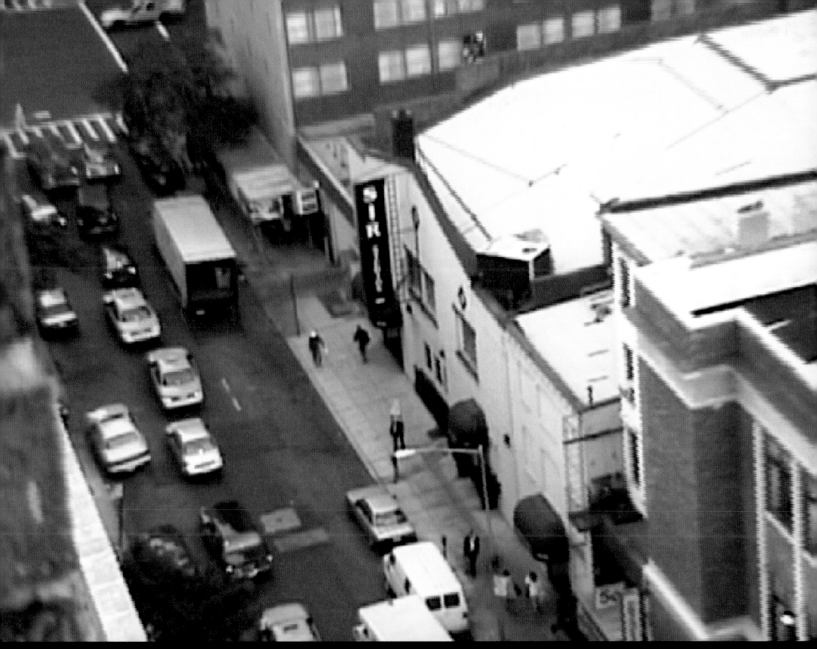

From CONTAINER

To DON'T WALK

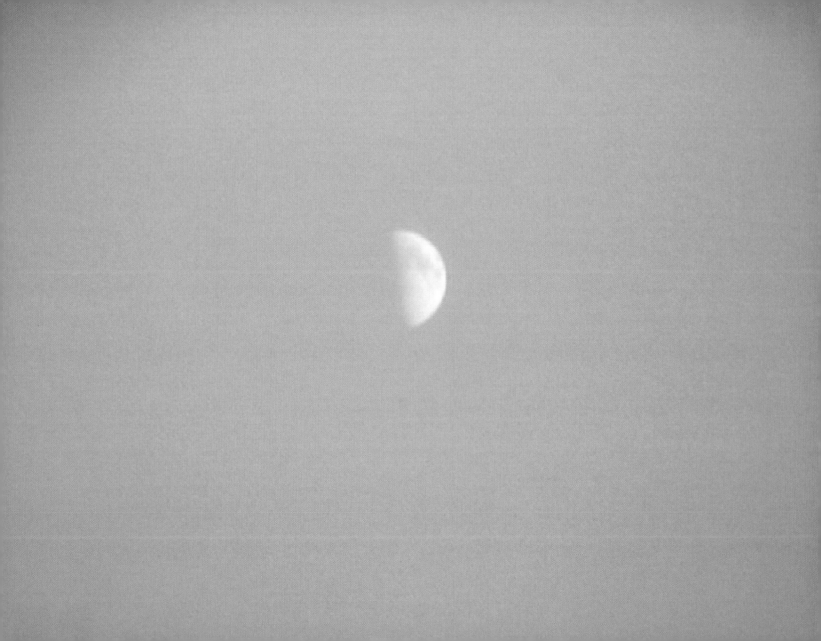

From CONTAINER

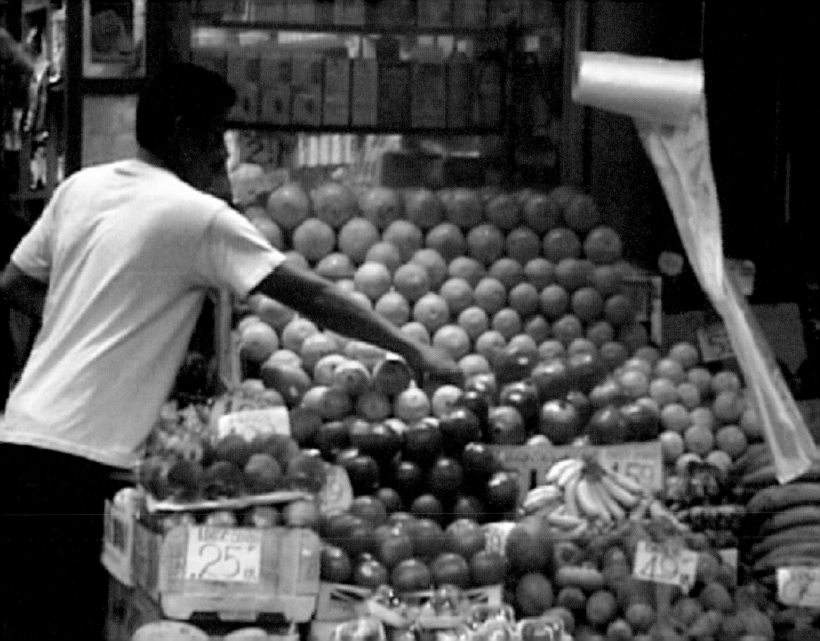

From CONTAINER

To DON'T WALK

From CONTAINER

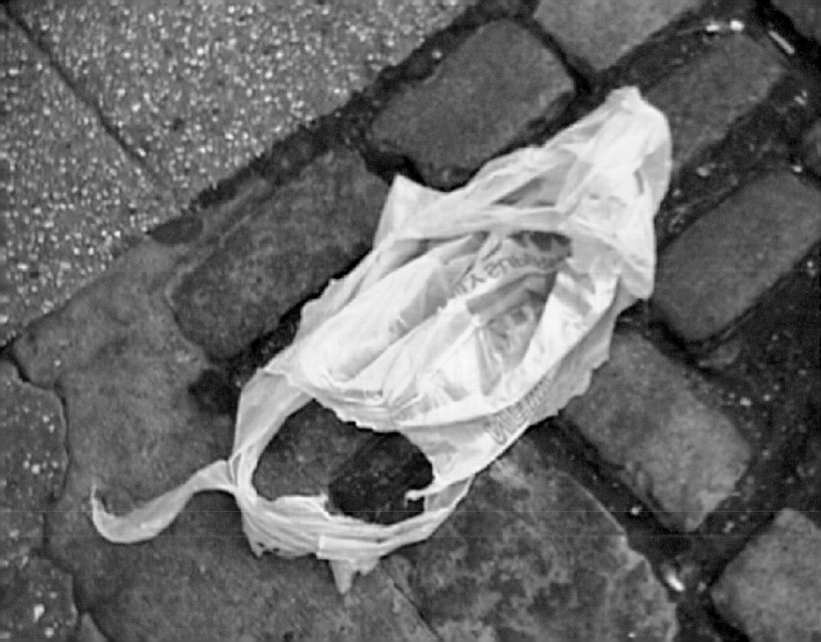

From CONTAINER

To DON'T WALK

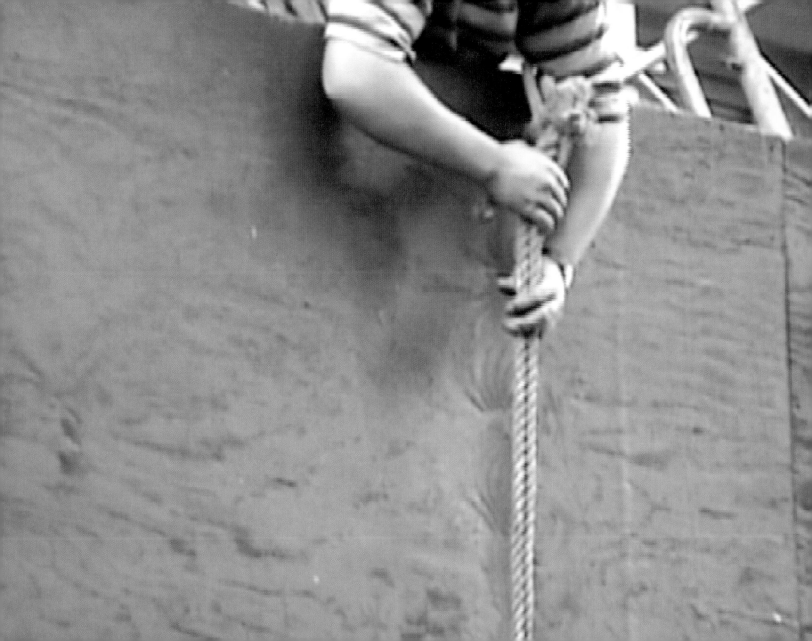

From CONTAINER

Art Center College of Design
Library
1700 Lida Street
Pasadena, Calif. 91103

To DON'T WALK

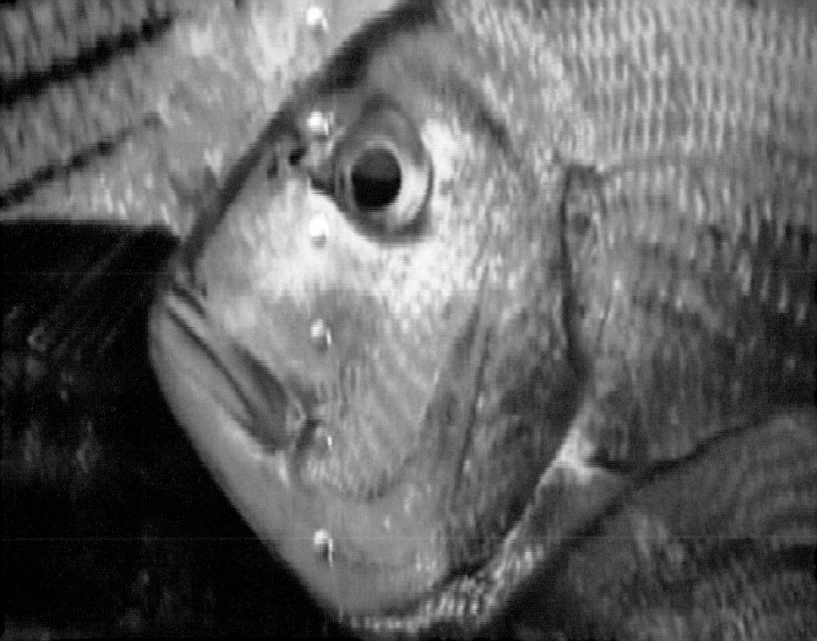

From CONTAINER

To DON'T WALK

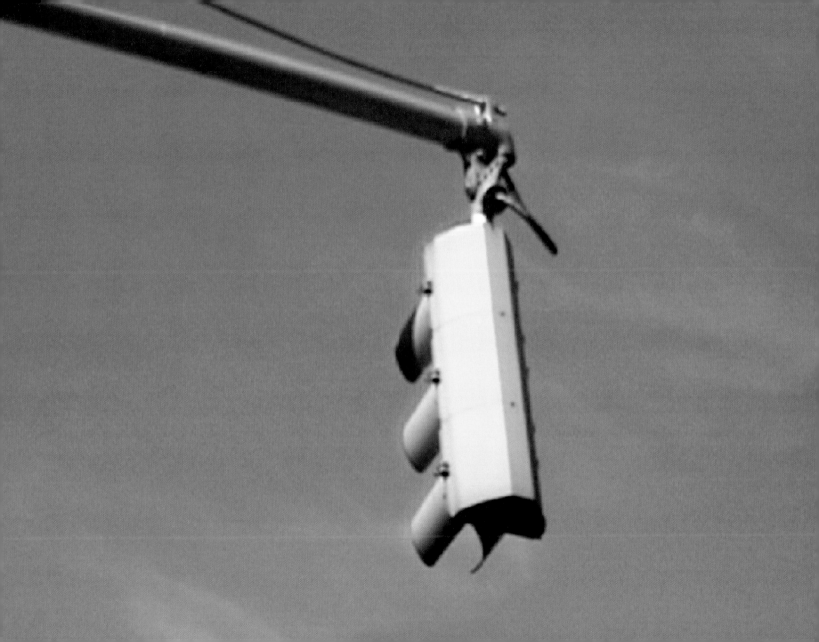

From CONTAINER

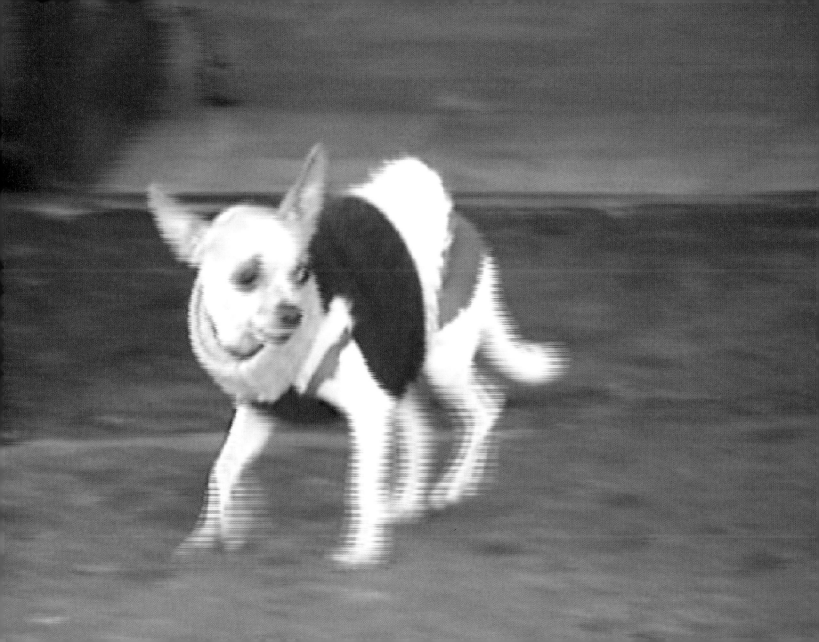

From CONTAINER

From CONTAINER

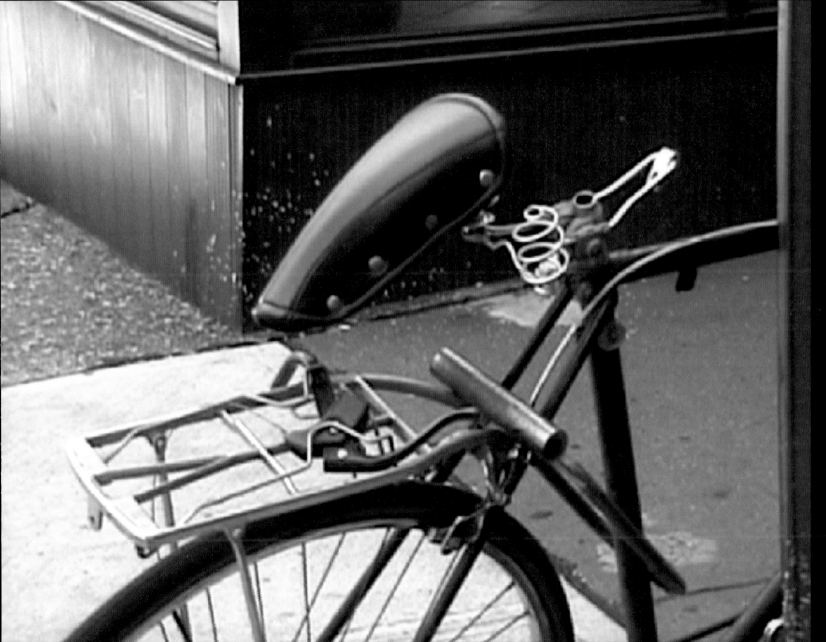

From CONTAINER

To DON'T WALK

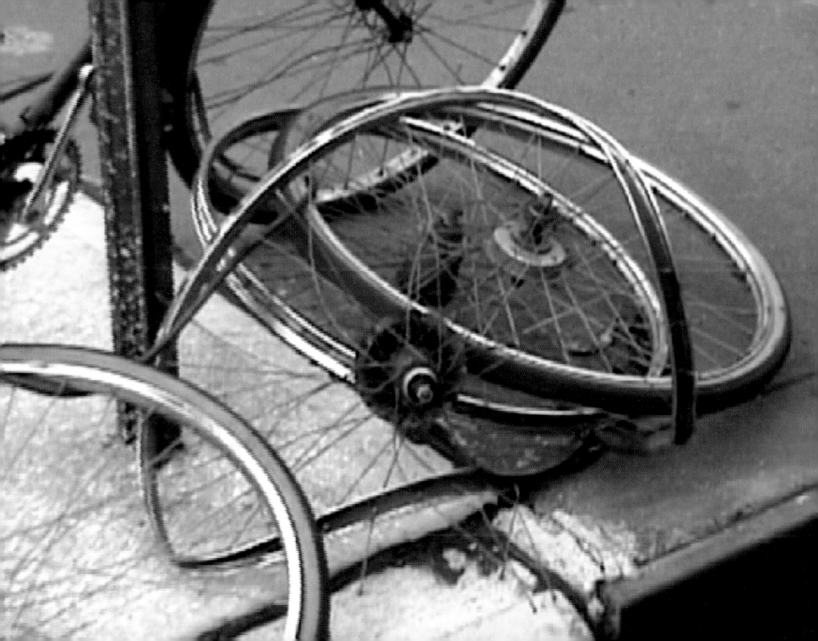

From CONTAINER

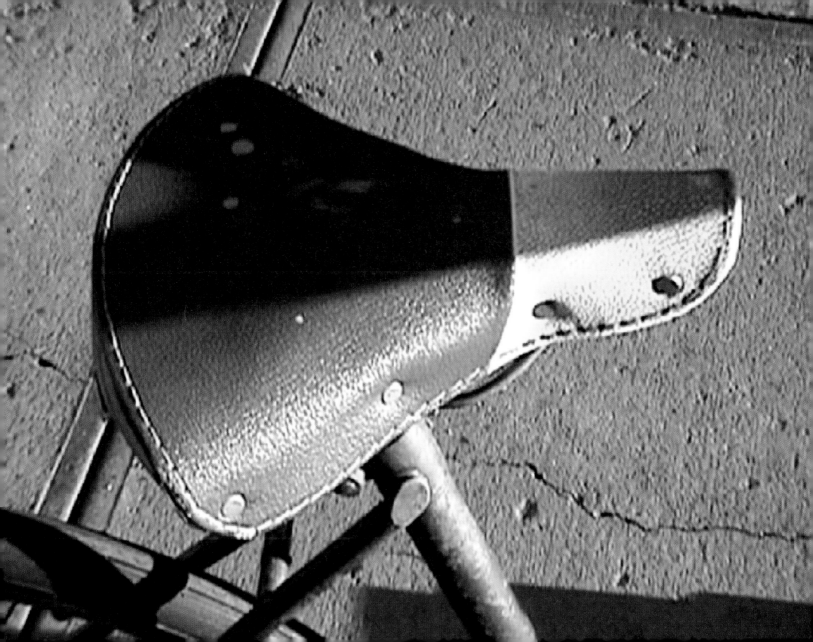

From CONTAINER

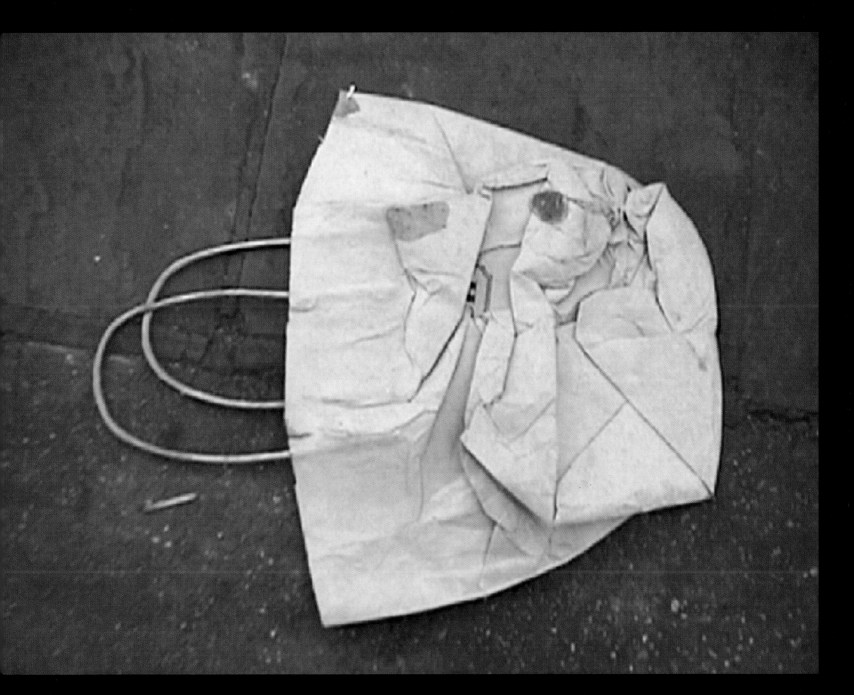

From CONTAINER

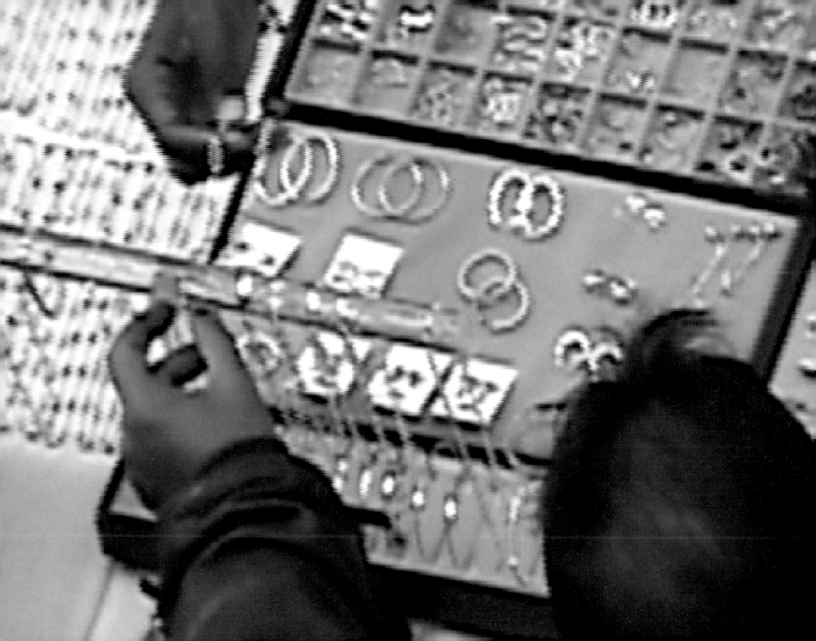

From CONTAINER

To DON'T WALK

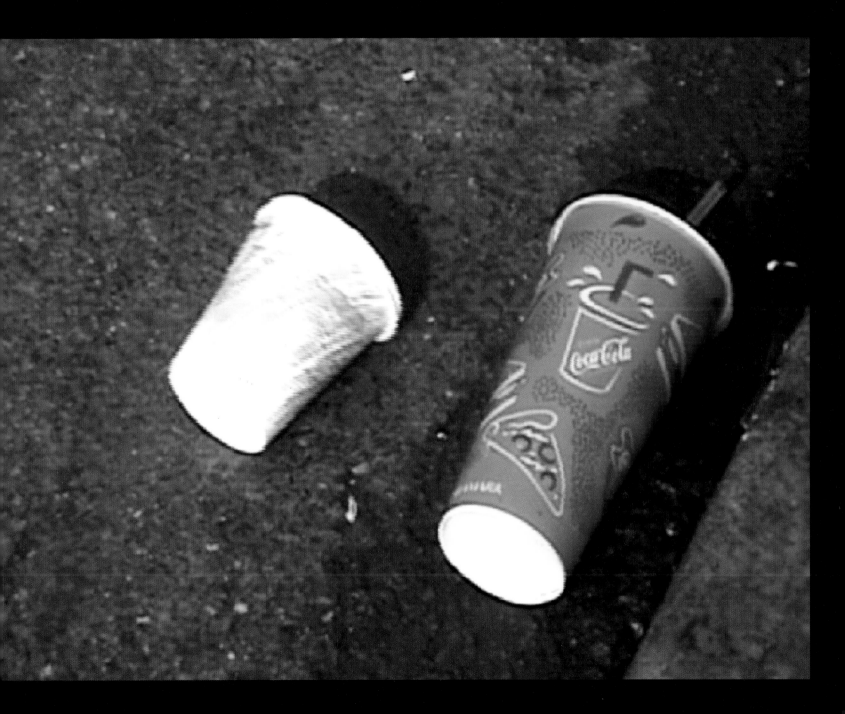

From CONTAINER

To DON'T WALK

From CONTAINER

To DON'T WALK

From CONTAINER

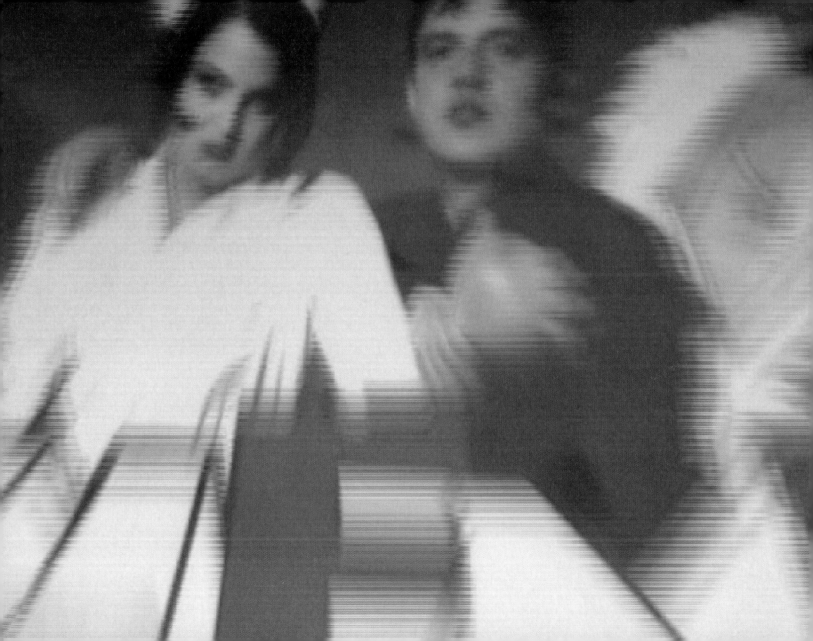

From CONTAINER

To DON'T WALK

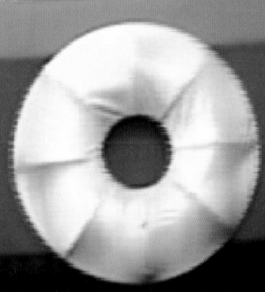

COOKIES · MUFFIN

AGEL

E DELIVER

C.O. BIGELOW

D

ALL BAKING D

BUF

(212) 477

From CONTAINER

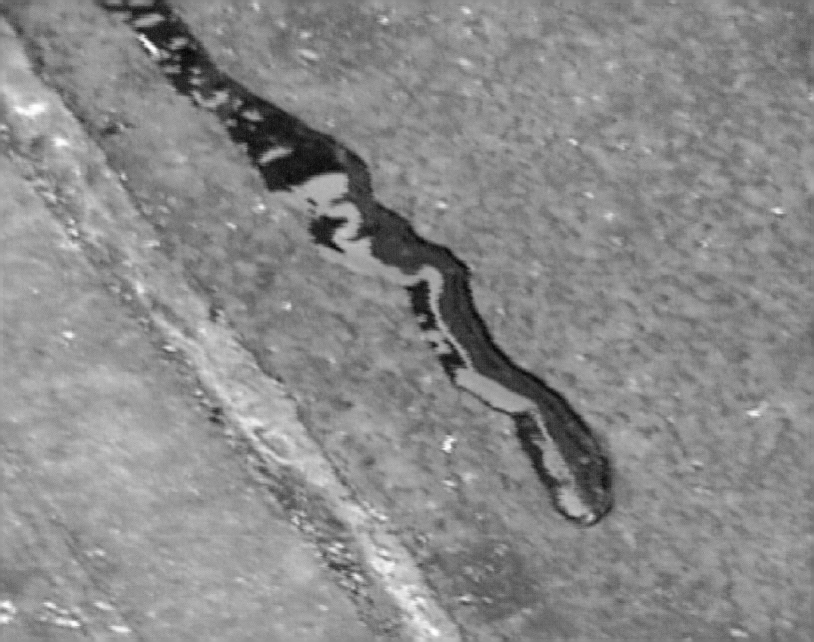

From CONTAINER

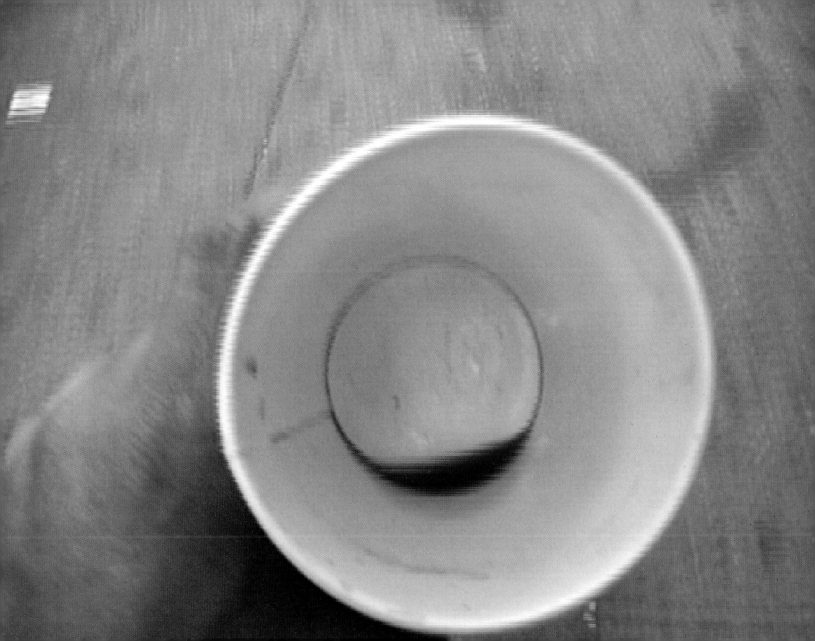

From CONTAINER

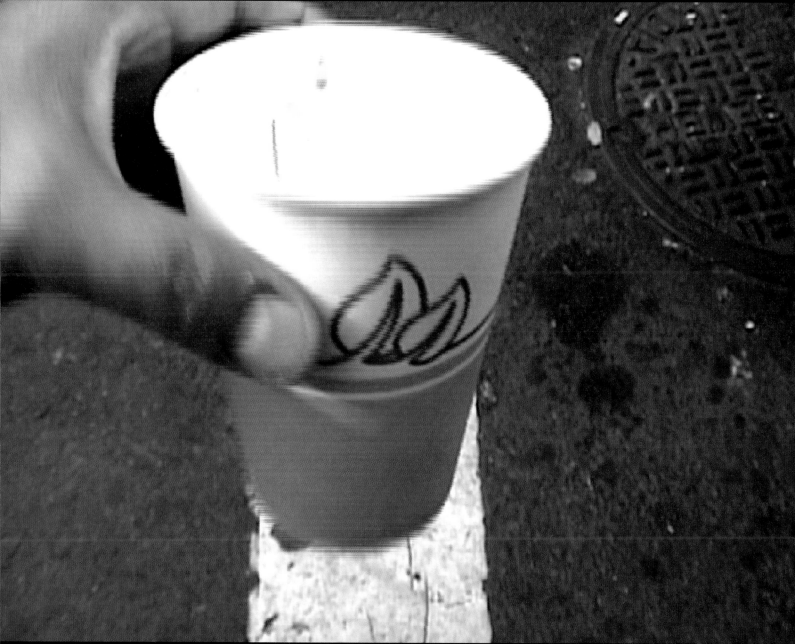

From CONTAINER

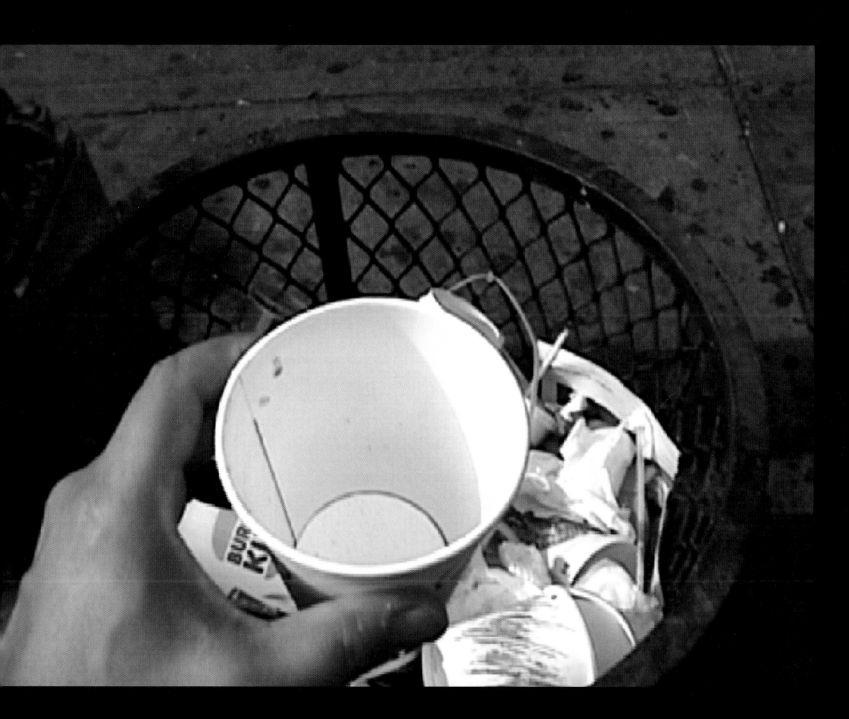

From CONTAINER

To DON'T WALK

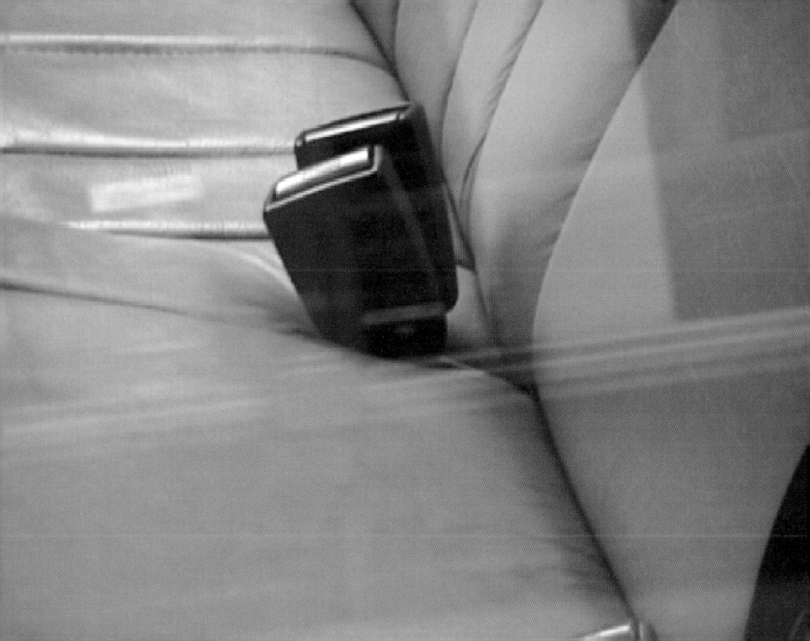

From CONTAINER

To DON'T WALK

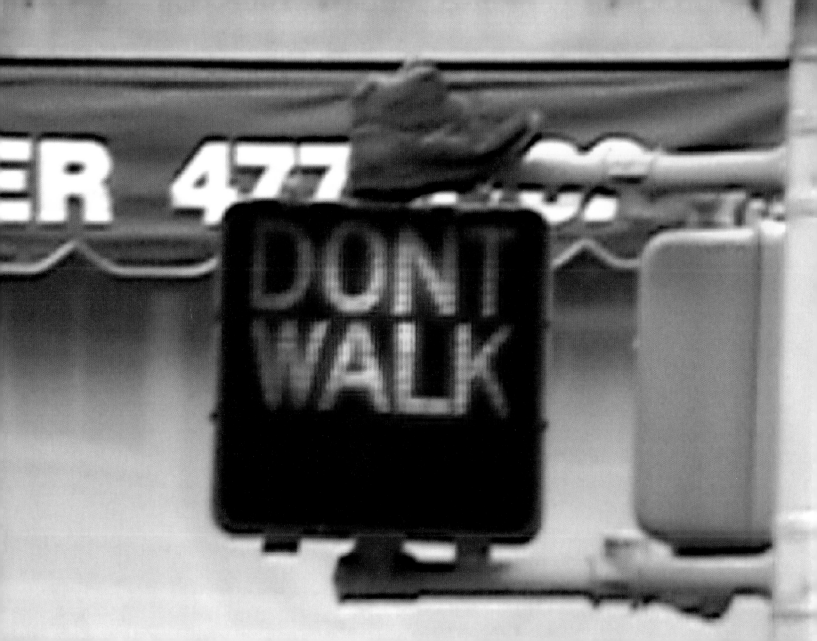

From CONTAINER

RECORDING #3 61'00"
From
Cap in Car
To
ATLAS

New York - Amsterdam

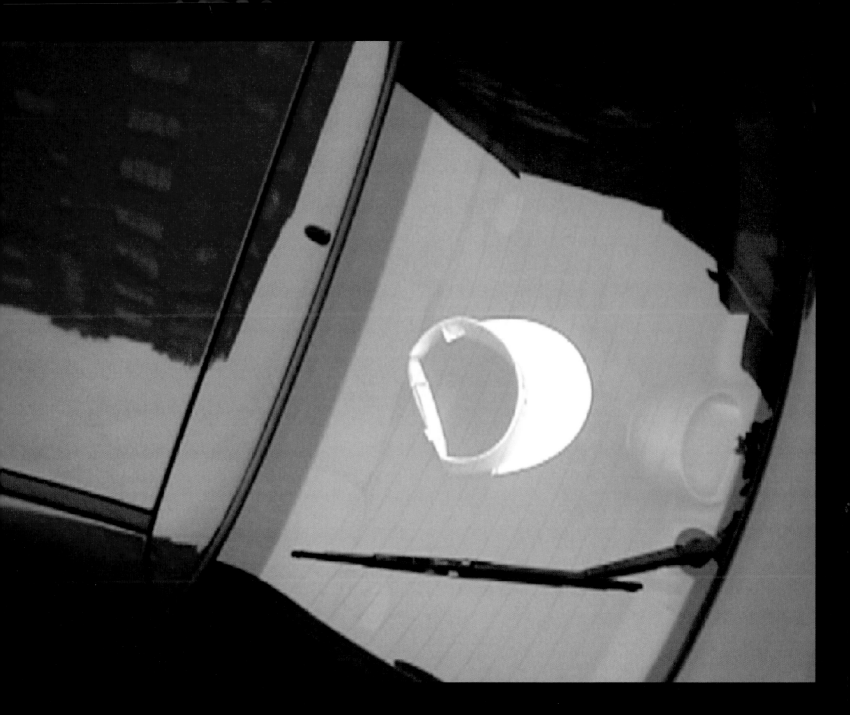

From CAP IN CAR

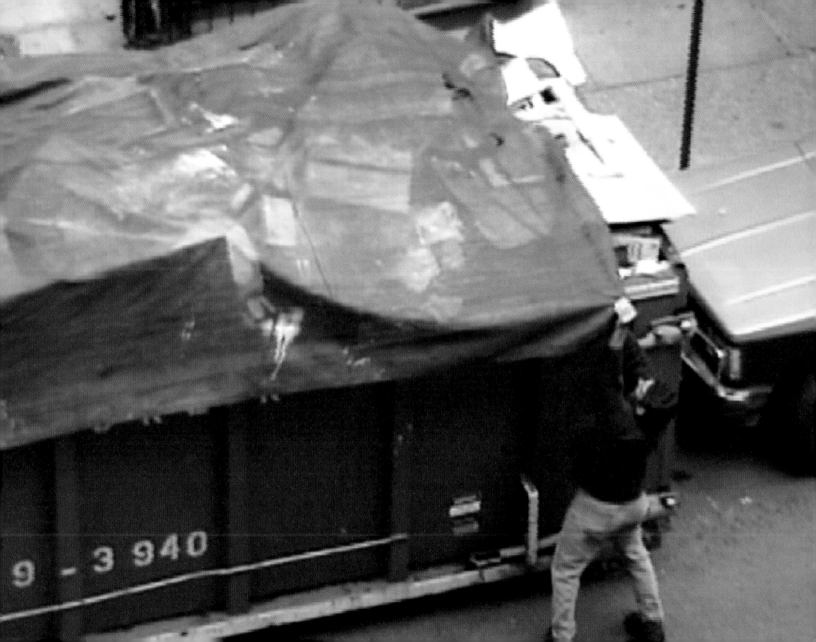

From CAP IN CAR

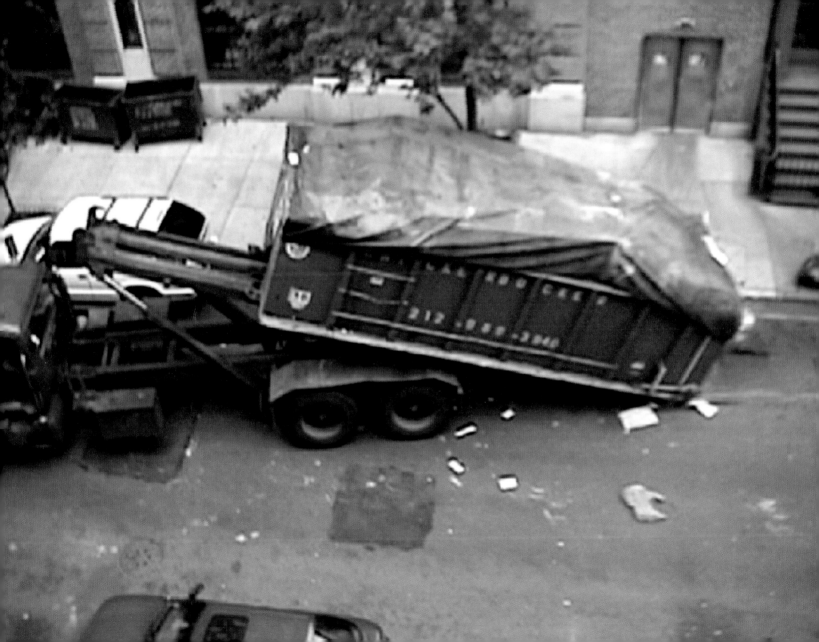

From CAP IN CAR

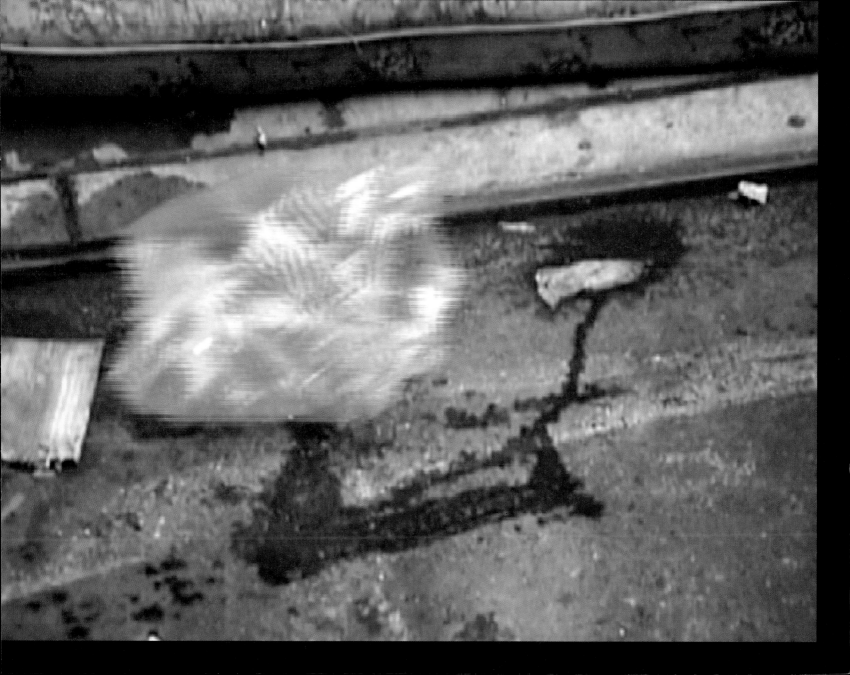

From CAP IN CAR

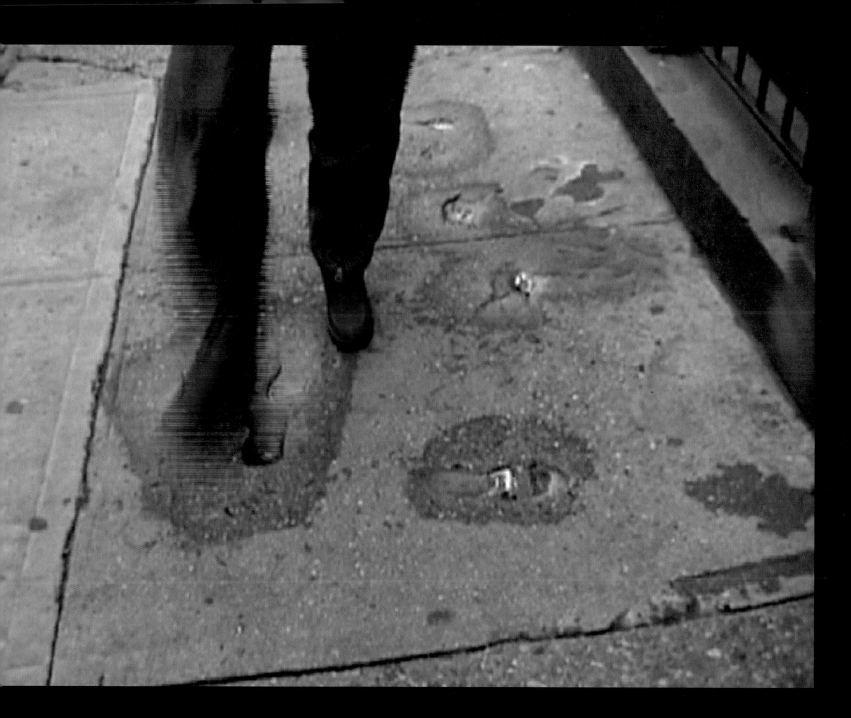

From CAP IN CAR

To ATLAS

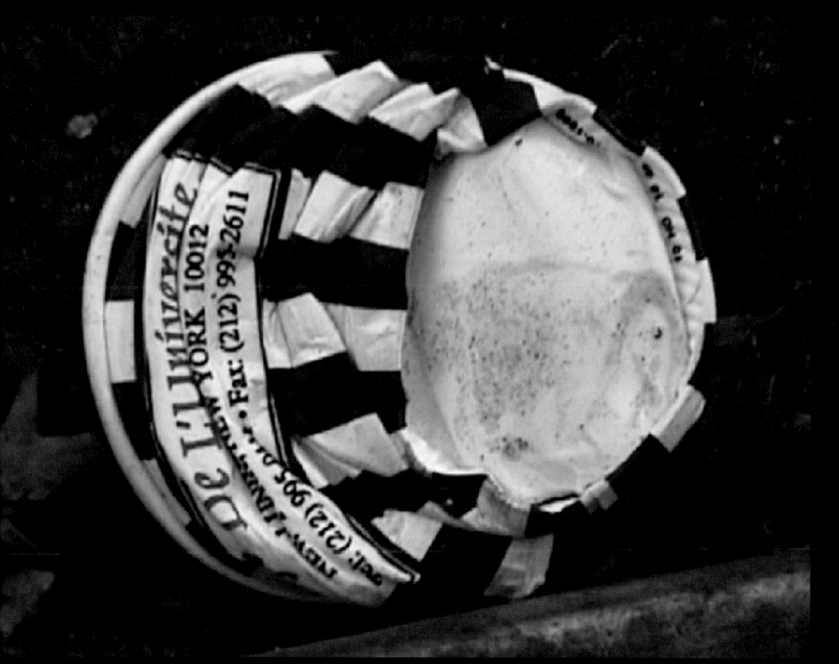

From CAP IN CAR

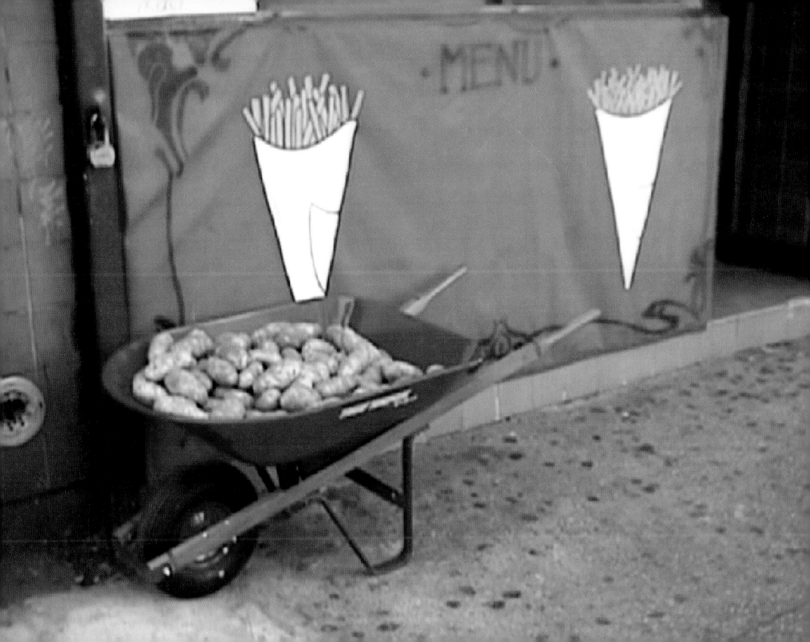

From CAP IN CAR

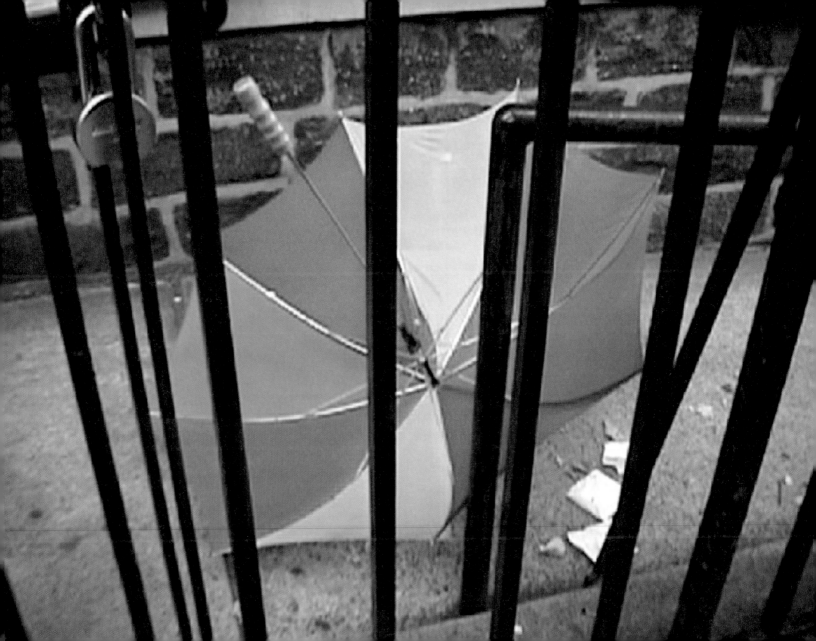

From CAP IN CAR

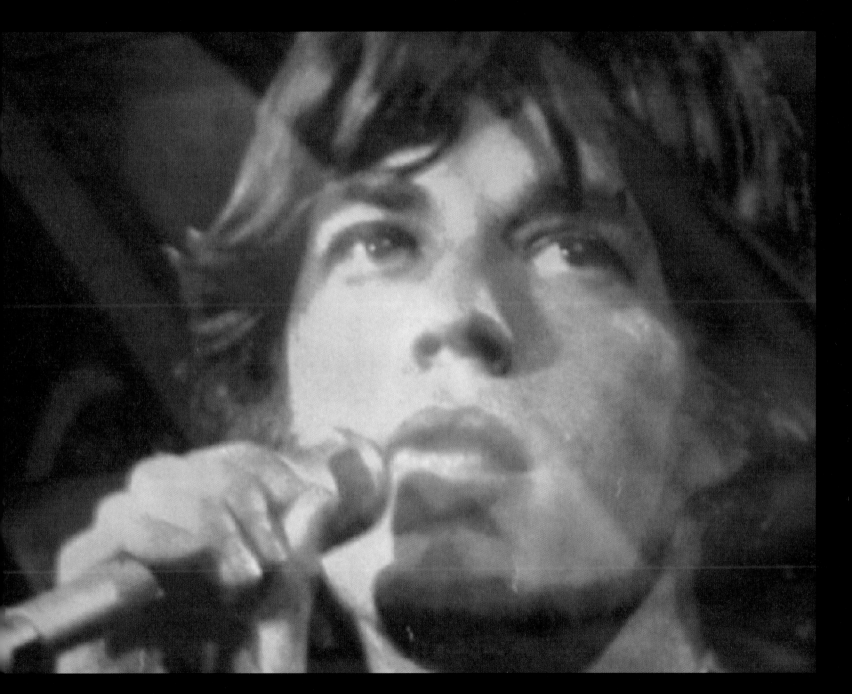

From CAP IN CAR

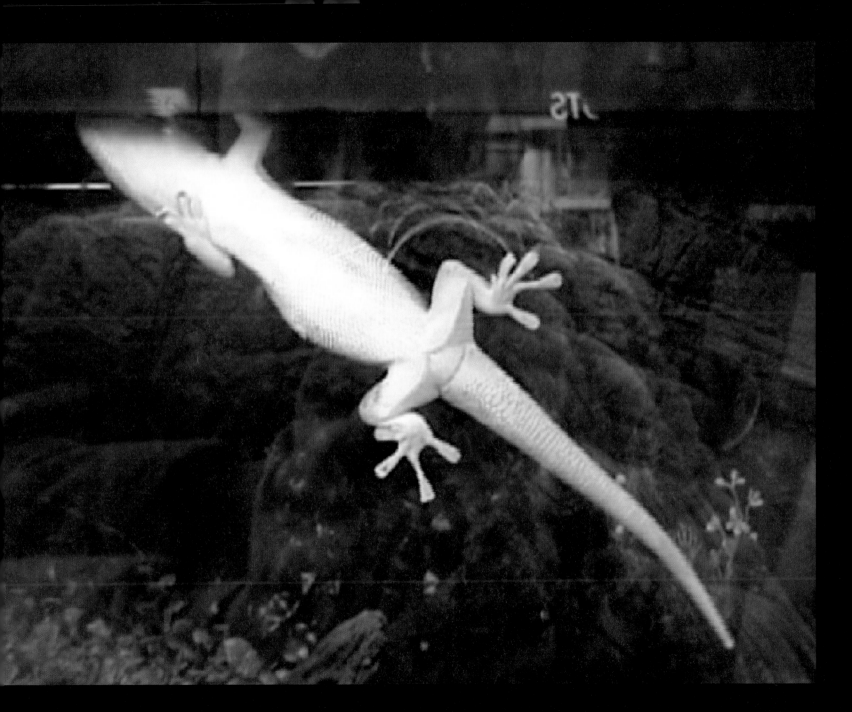

From CAP IN CAR

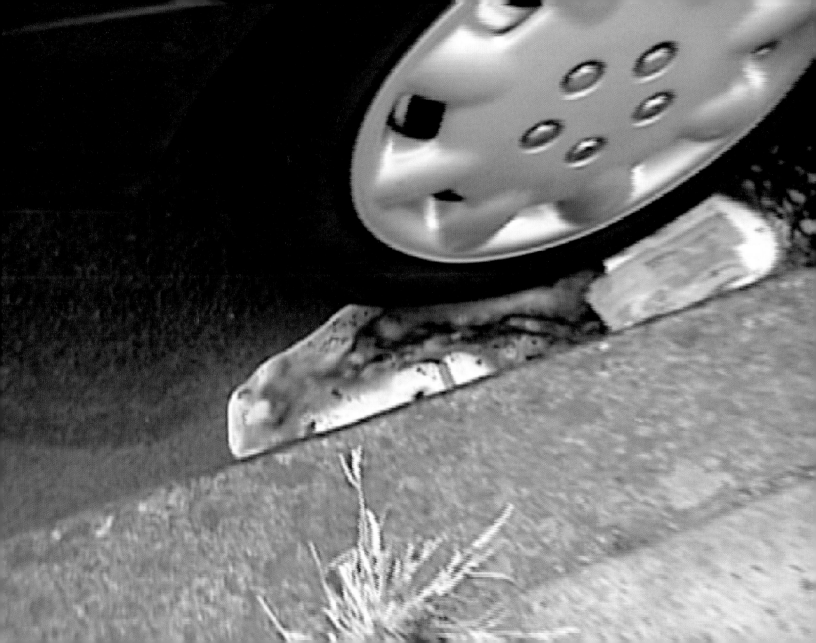

From CAP IN CAR

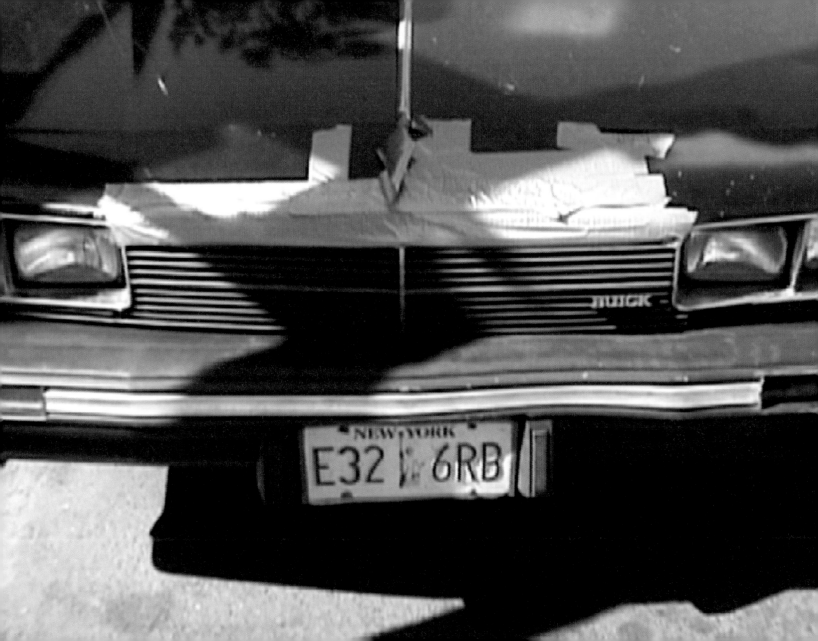

From CAP IN CAR

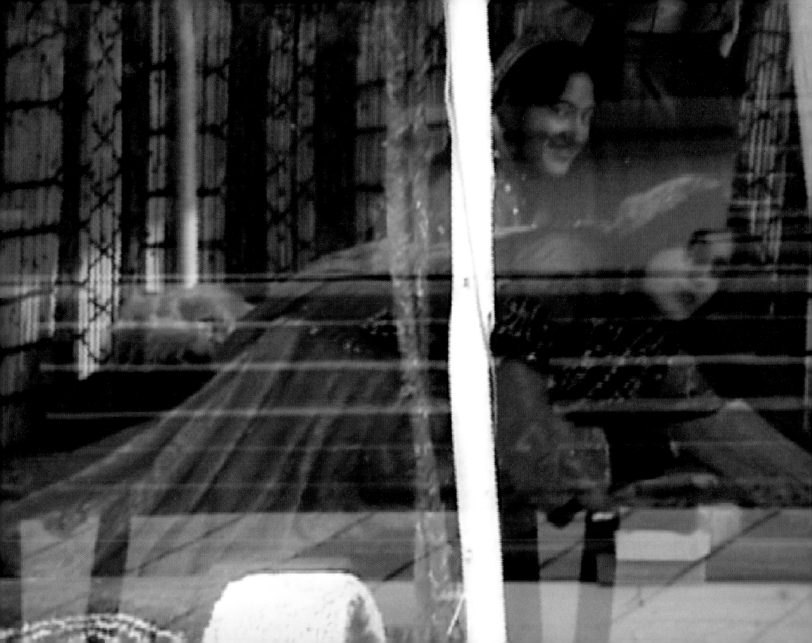

From CAP IN CAR

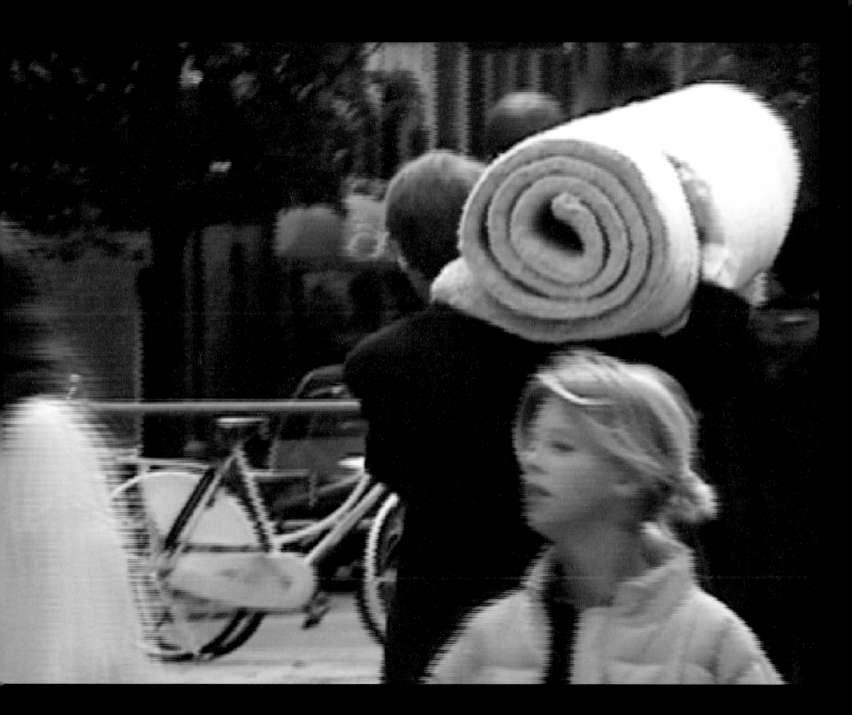

From CAP IN CAR

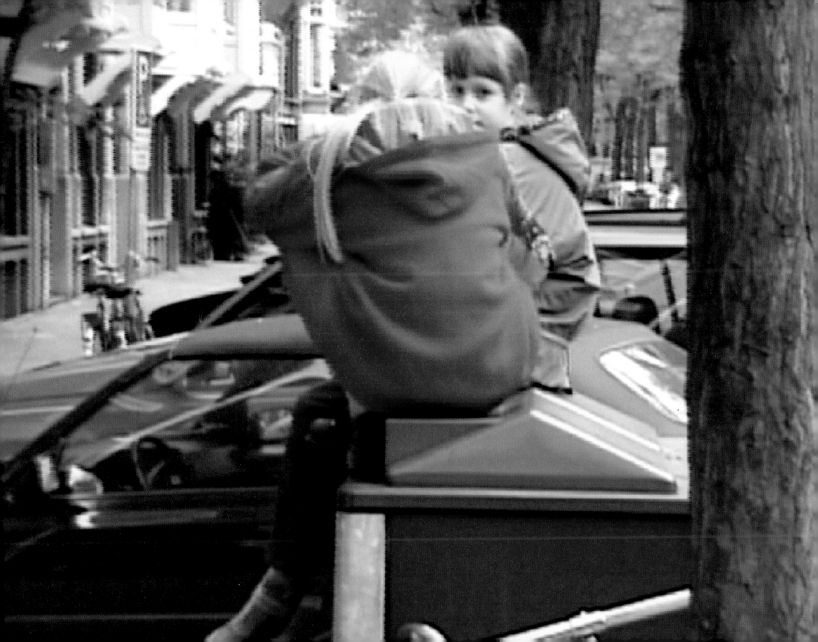

From CAP IN CAR

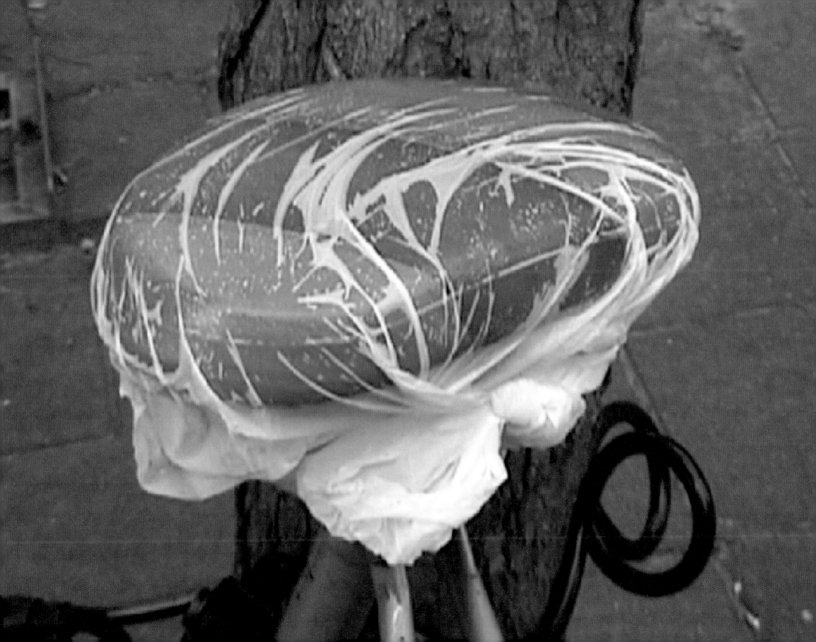

From CAP IN CAR

From CAP IN CAR

From CAP IN CAR

To ATLAS

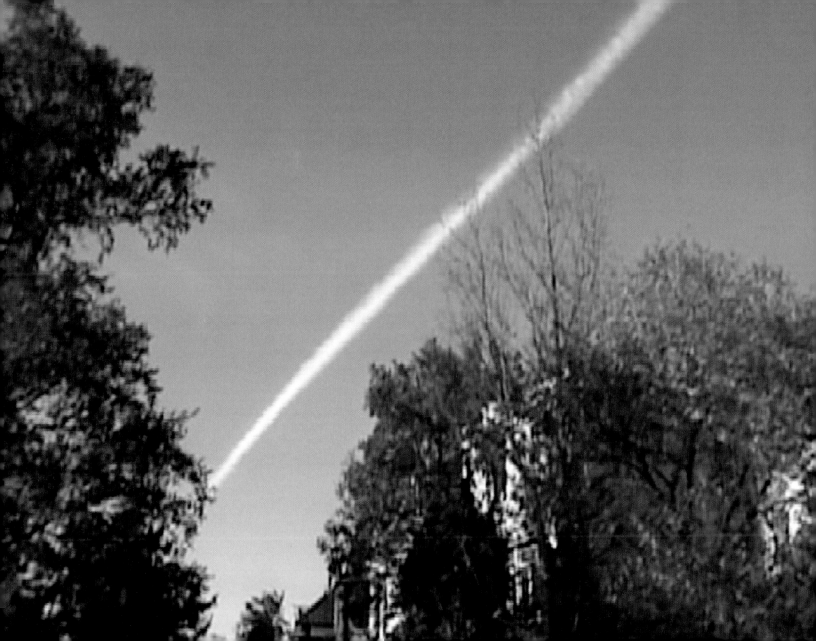

From CAP IN CAR

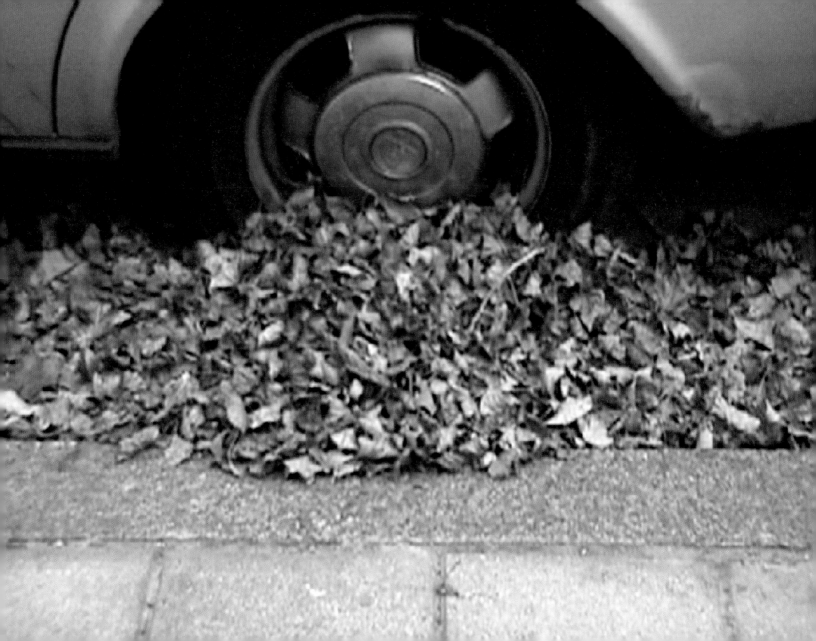

From CAP IN CAR

To ATLAS

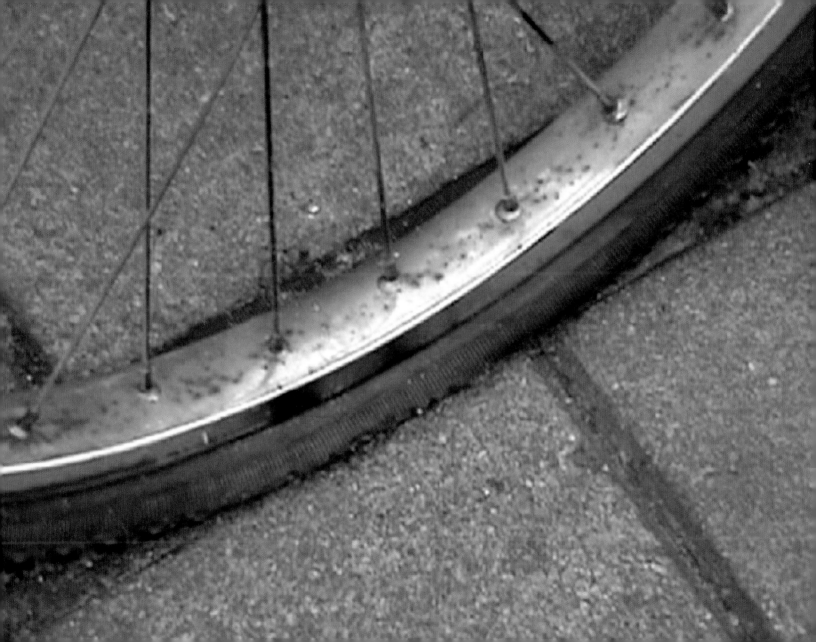

From CAP IN CAR

From CAP IN CAR

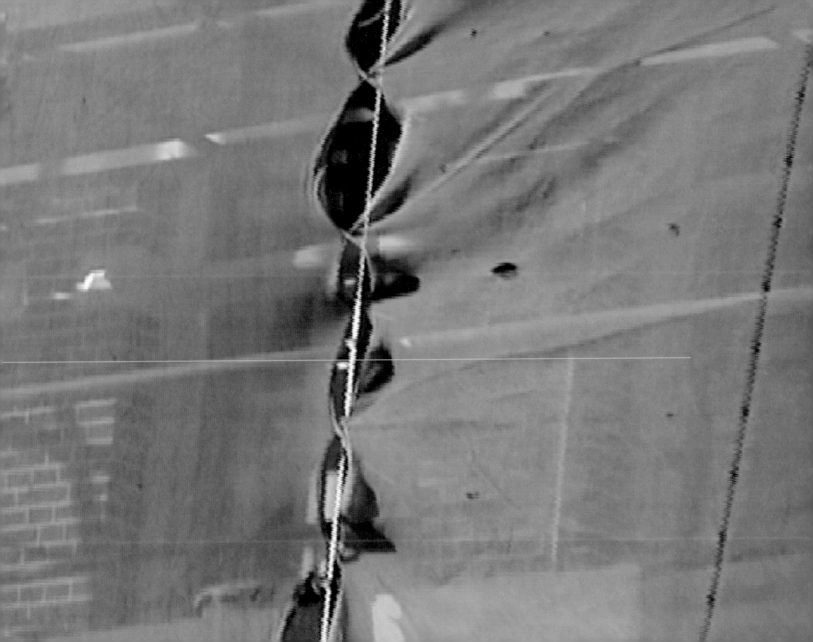

 From CAP IN CAR

To ATLAS

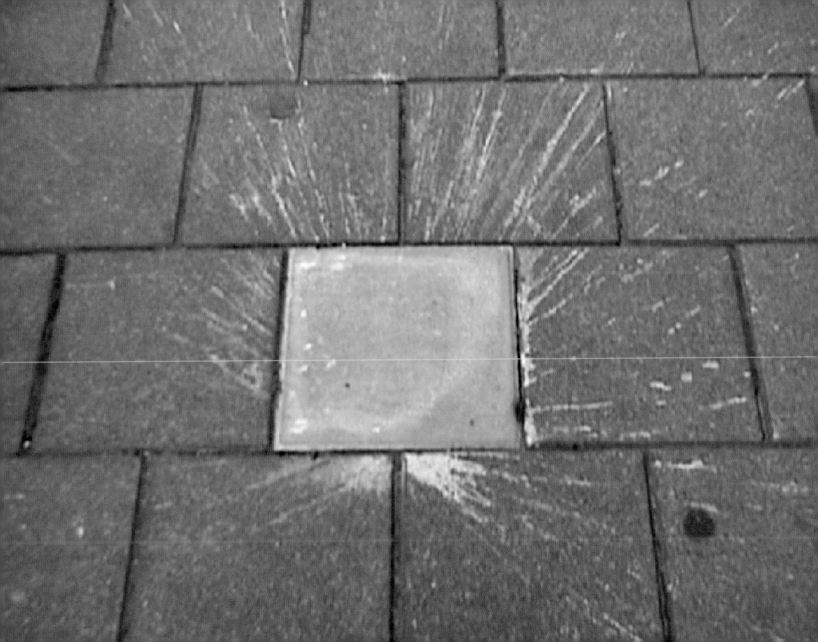

From CAP IN CAR

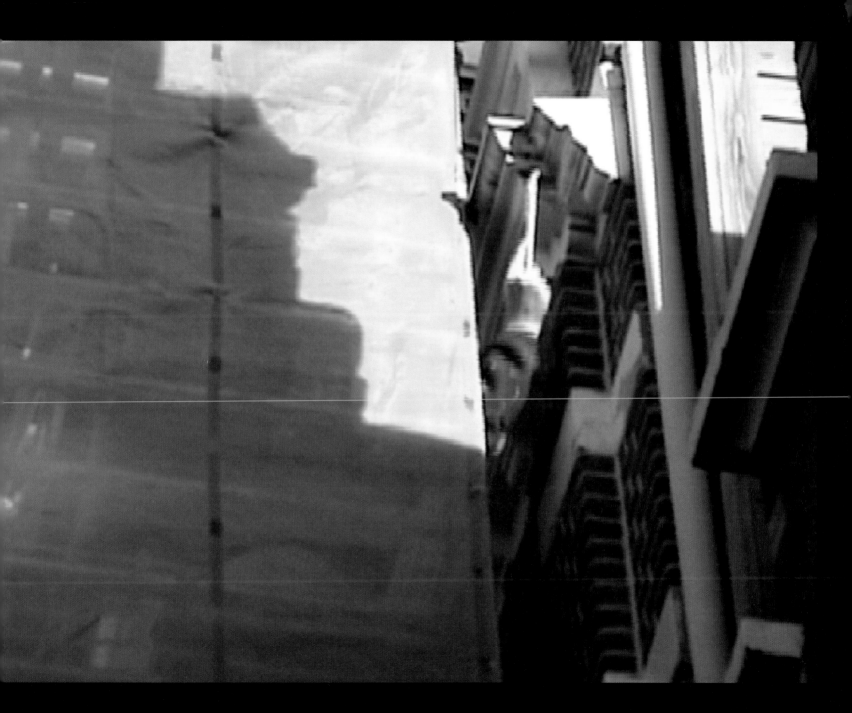

From CAP IN CAR

To ATLAS

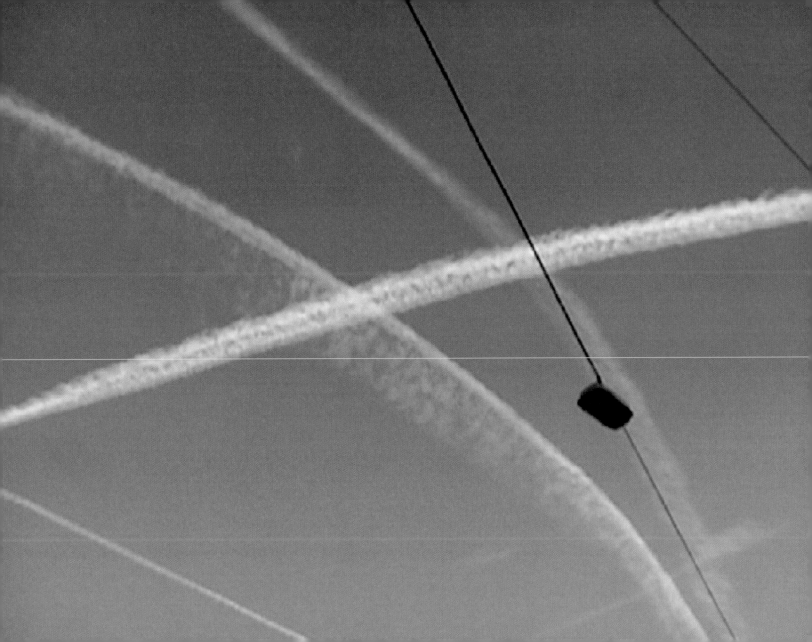

From CAP IN CAR

To ATLAS

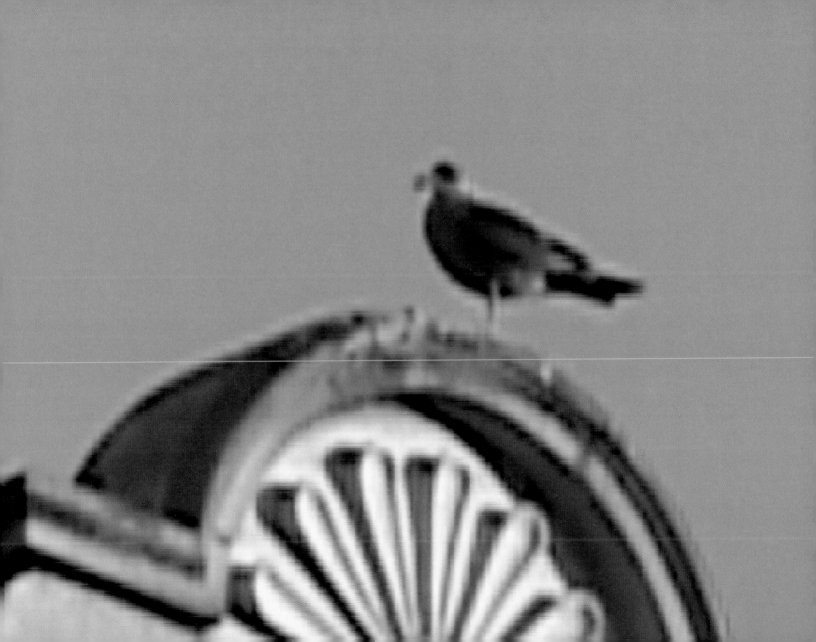

From CAP IN CAR

To ATLAS

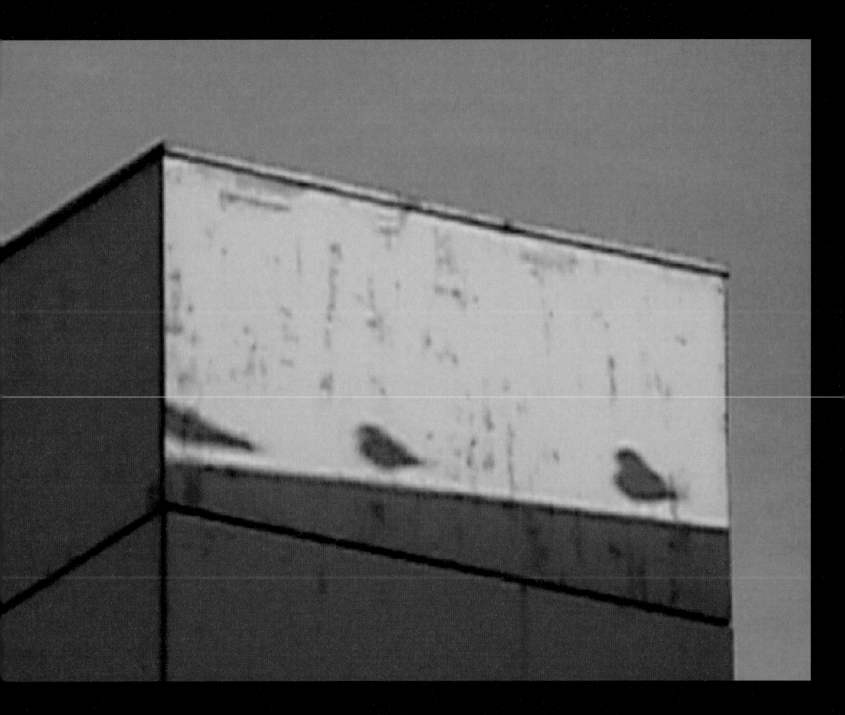

From CAP IN CAR

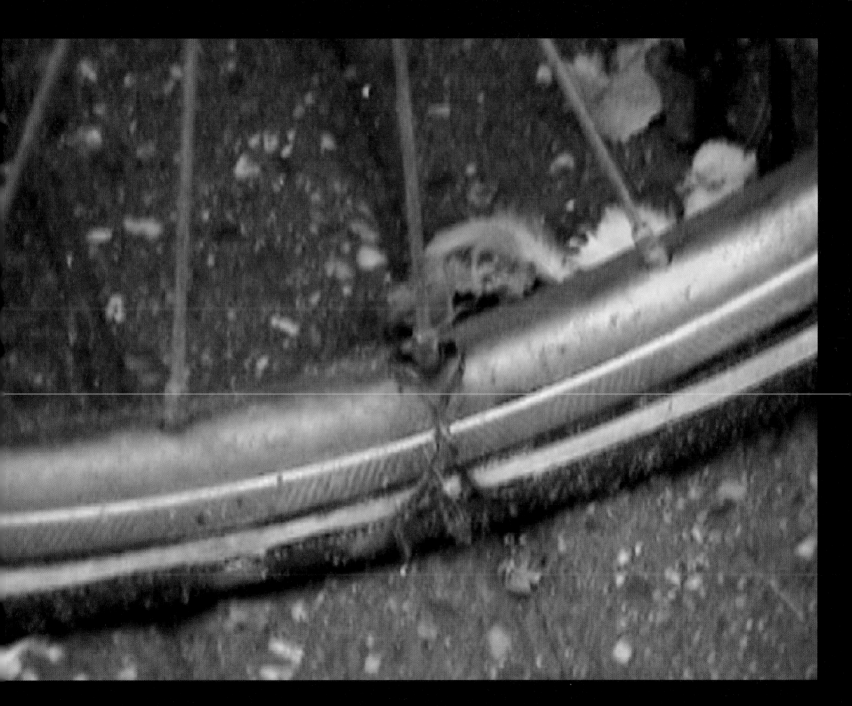

From CAP IN CAR

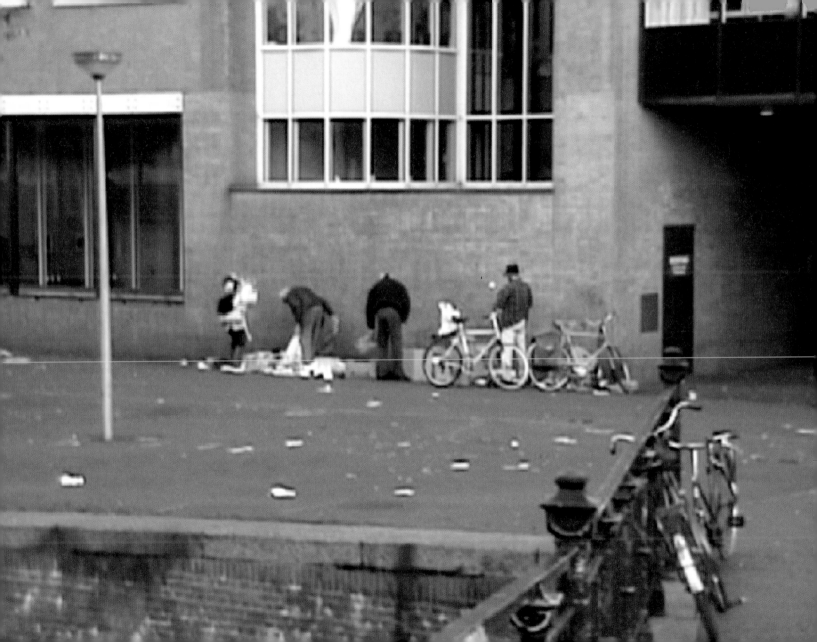

From CAP IN CAR

To ATLAS

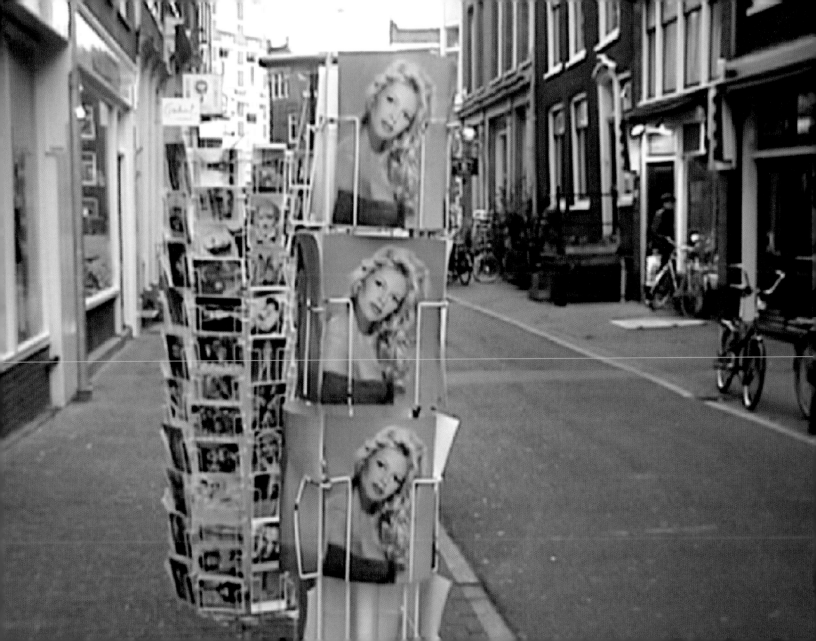

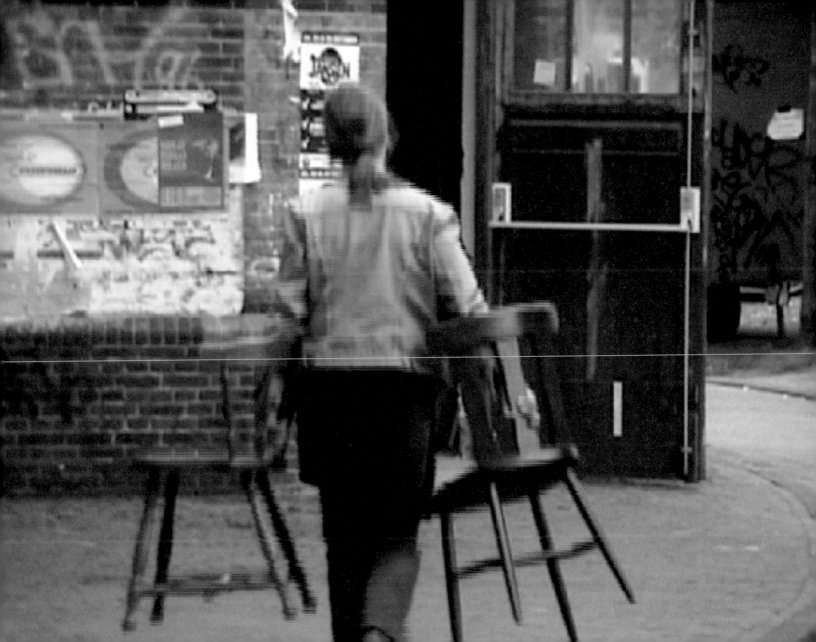

Art Center College of Design
Library
1700 Lida Street
Pasadena, Calif. 91103

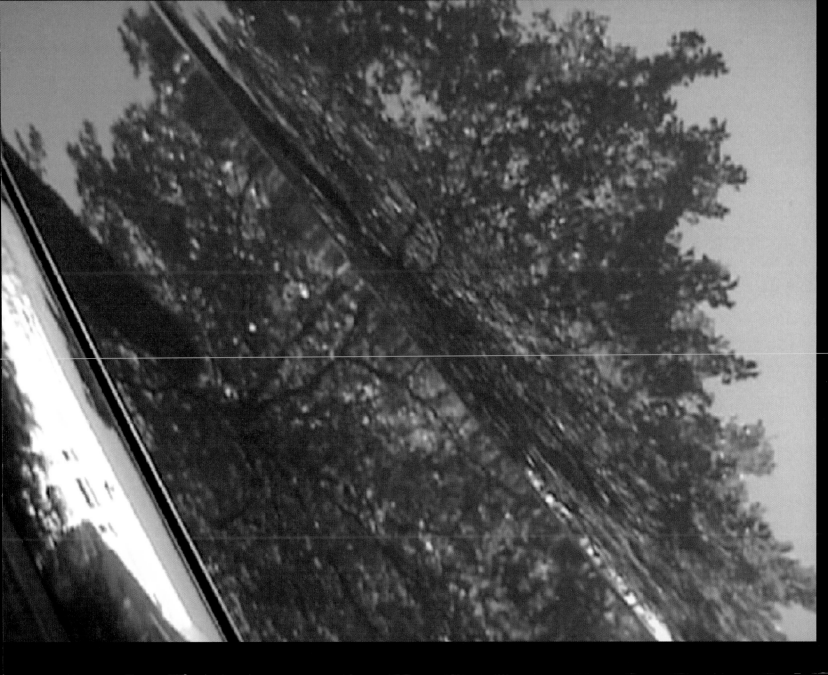

From CAP IN CAR

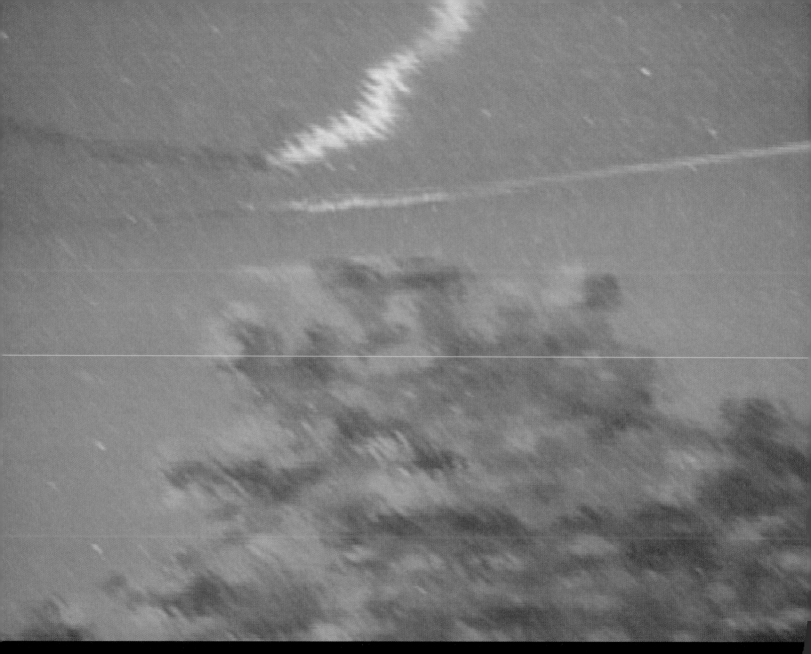

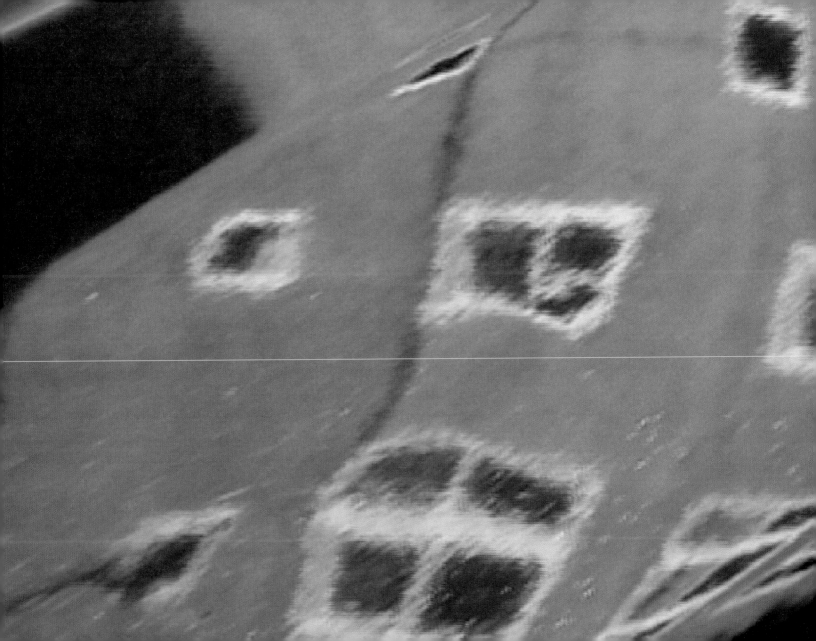

From CAP IN CAR

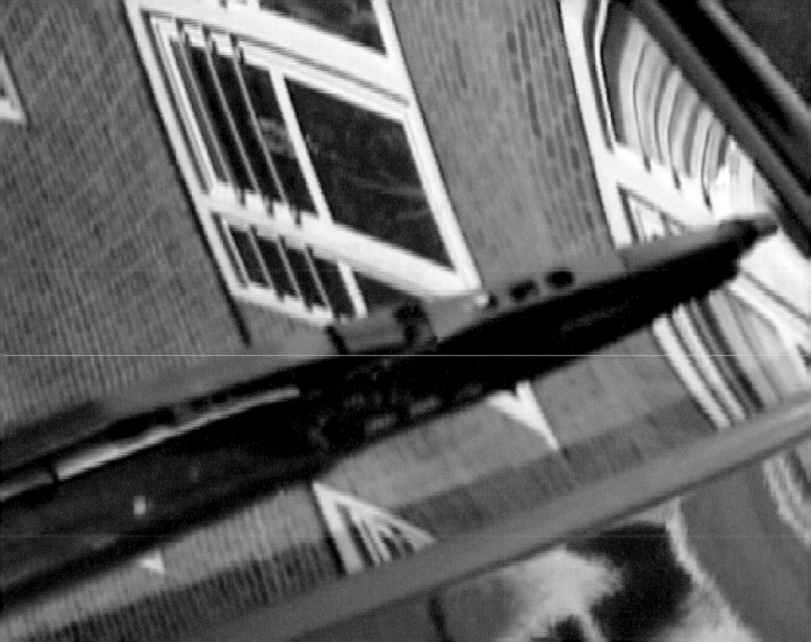

From CAP IN CAR

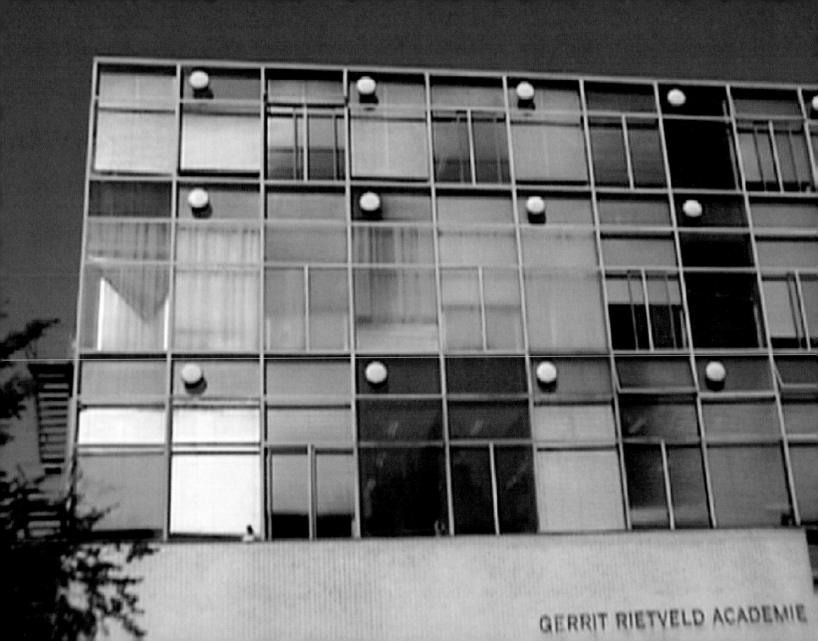

GERRIT RIETVELD ACADEMIE

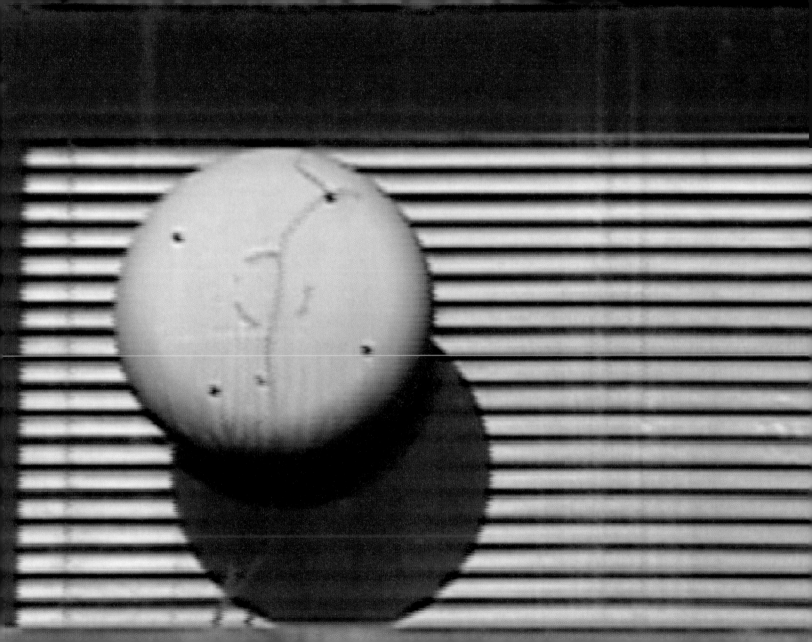

From CAP IN CAR

To ATLAS

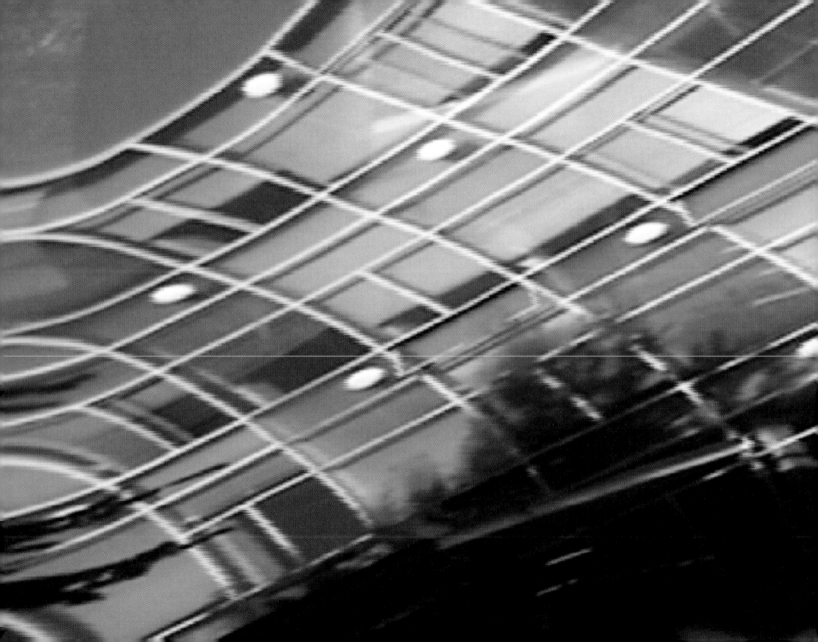

From CAP IN CAR

From CAP IN CAR

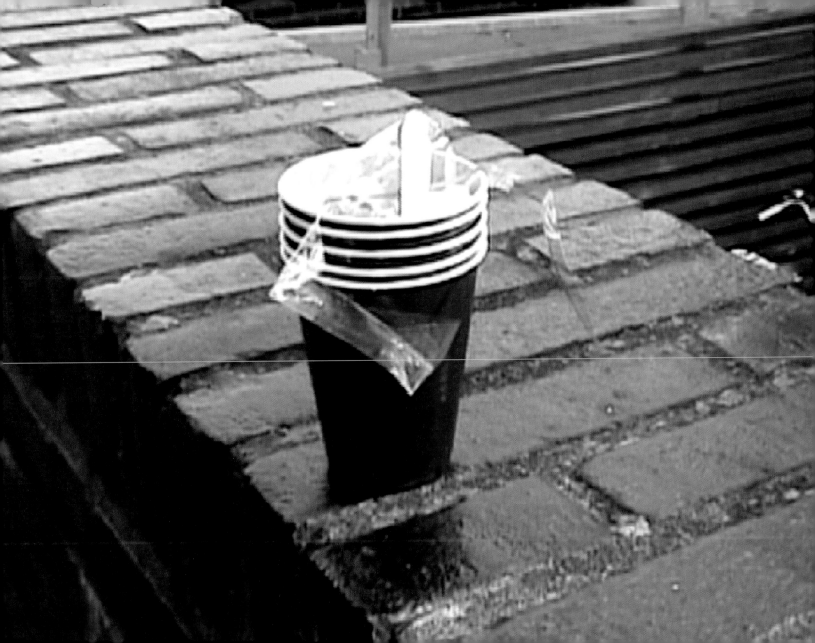

From CAP IN CAR

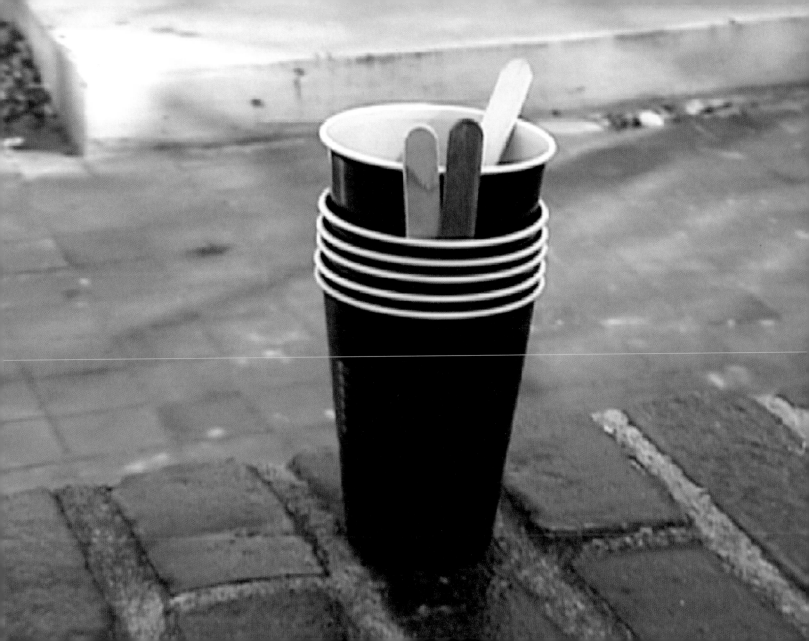

From CAP IN CAR

From CAP IN CAR

To ATLAS

From CAP IN CAR

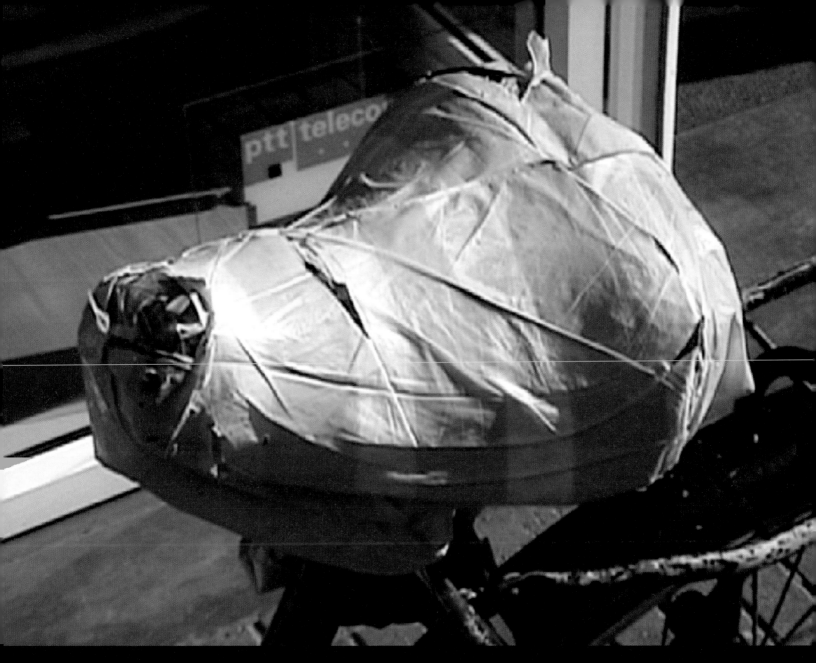

From CAP IN CAR

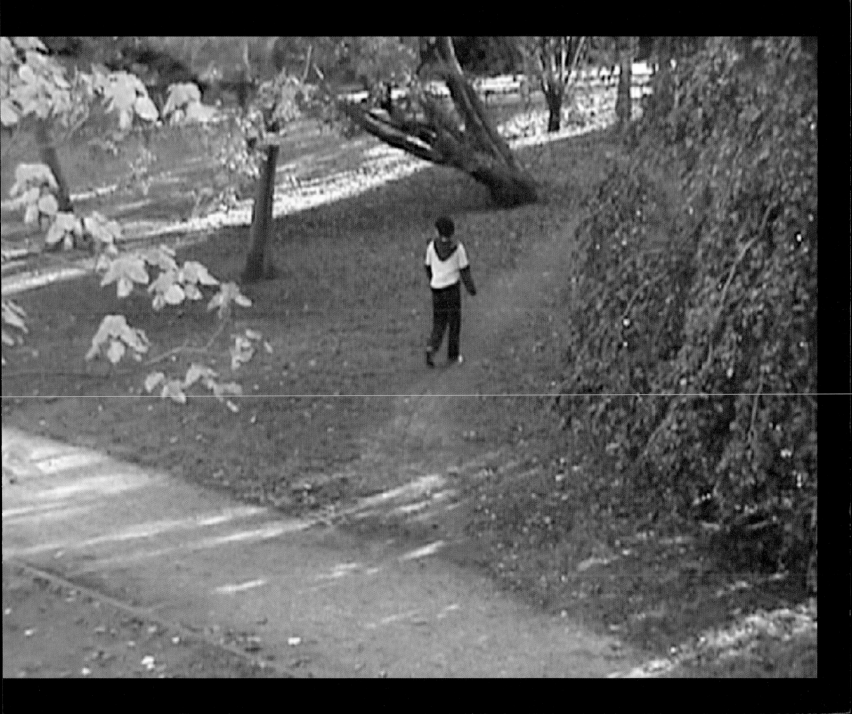

From CAP IN CAR

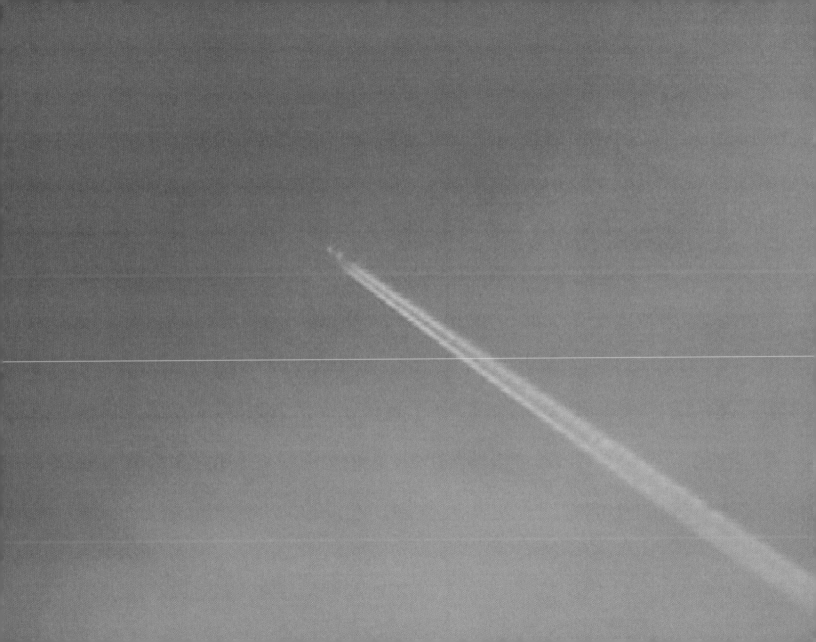

From CAP IN CAR

From CAP IN CAR

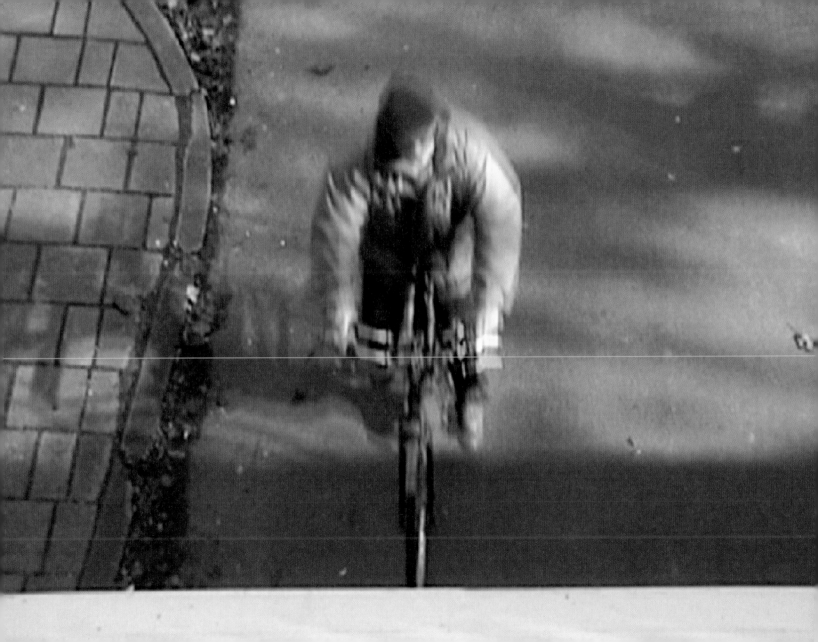

From CAP IN CAR

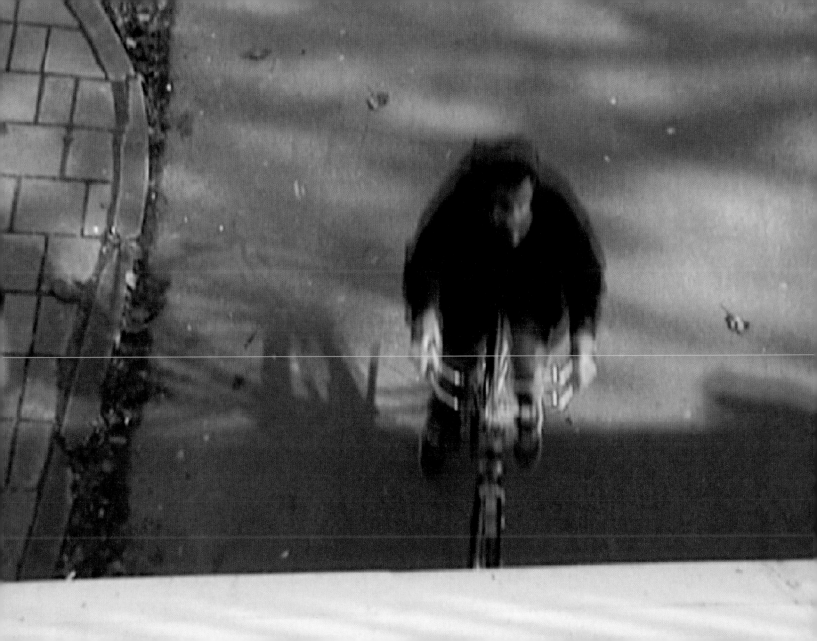

From CAP IN CAR

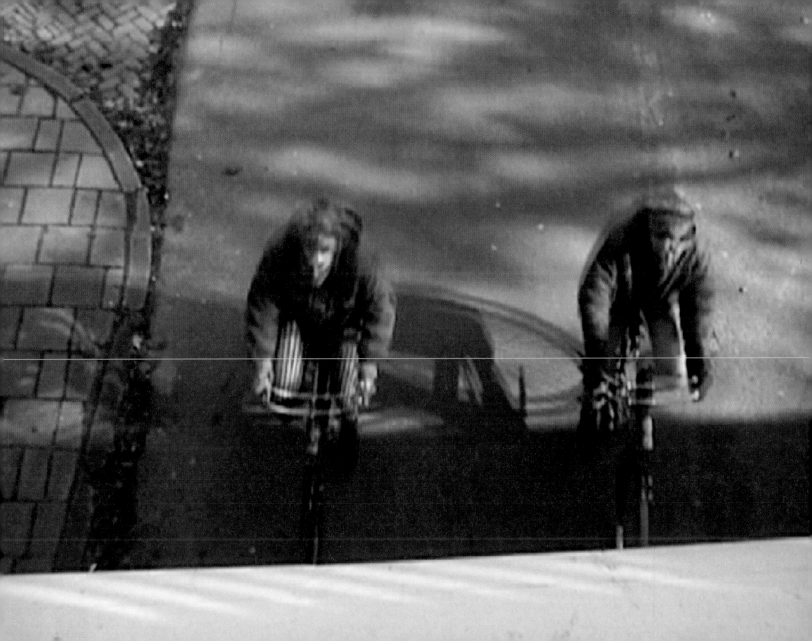

From CAP IN CAR

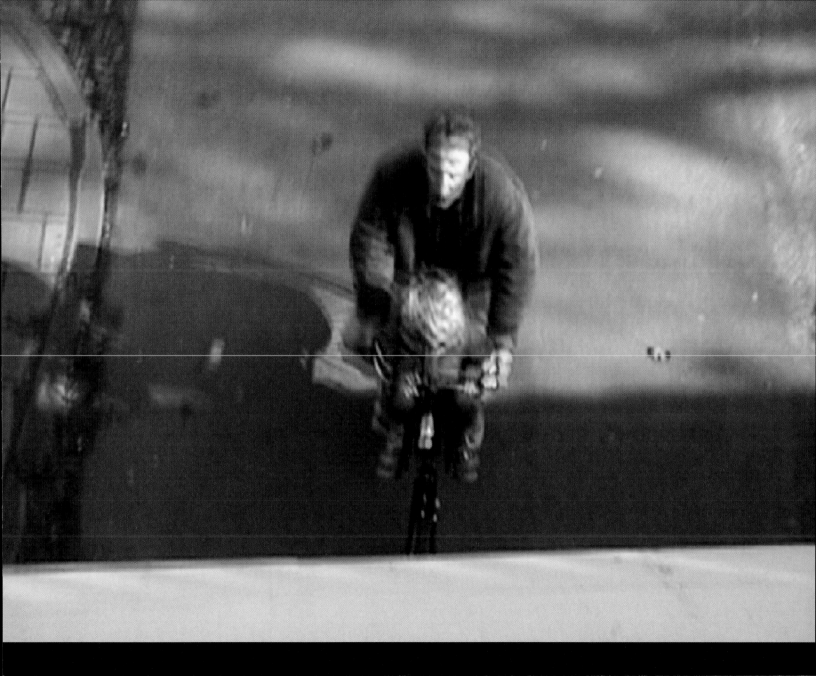

From CAP IN CAR

To ATLAS

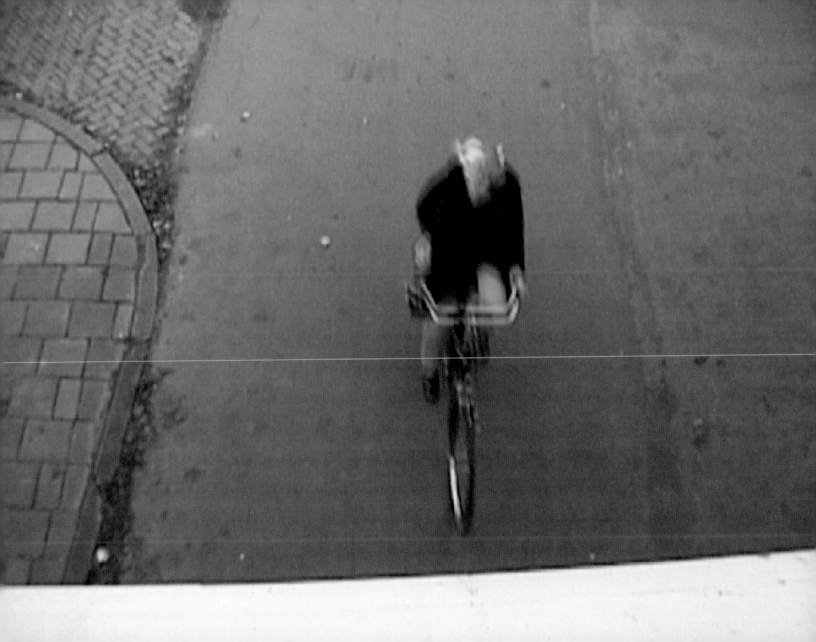

From CAP IN CAR

To ATLAS

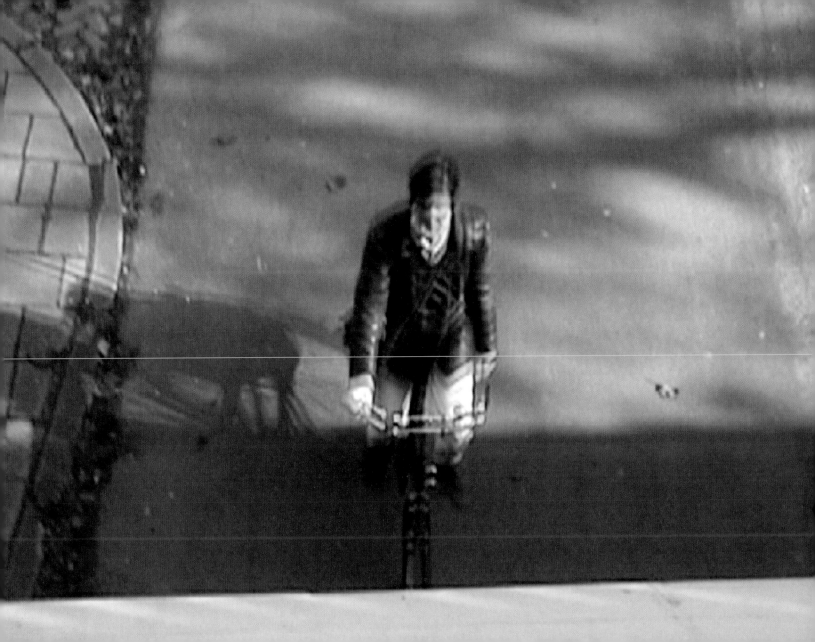

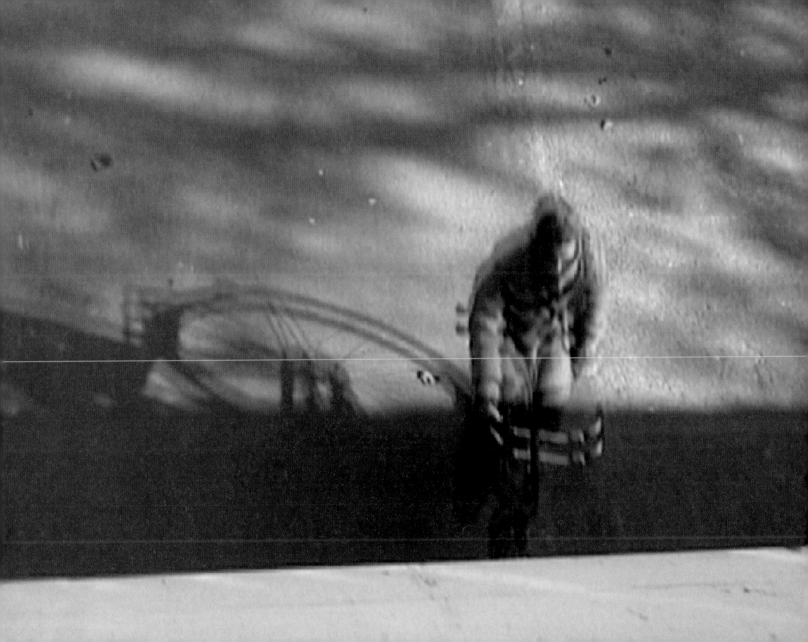

From CAP IN CAR

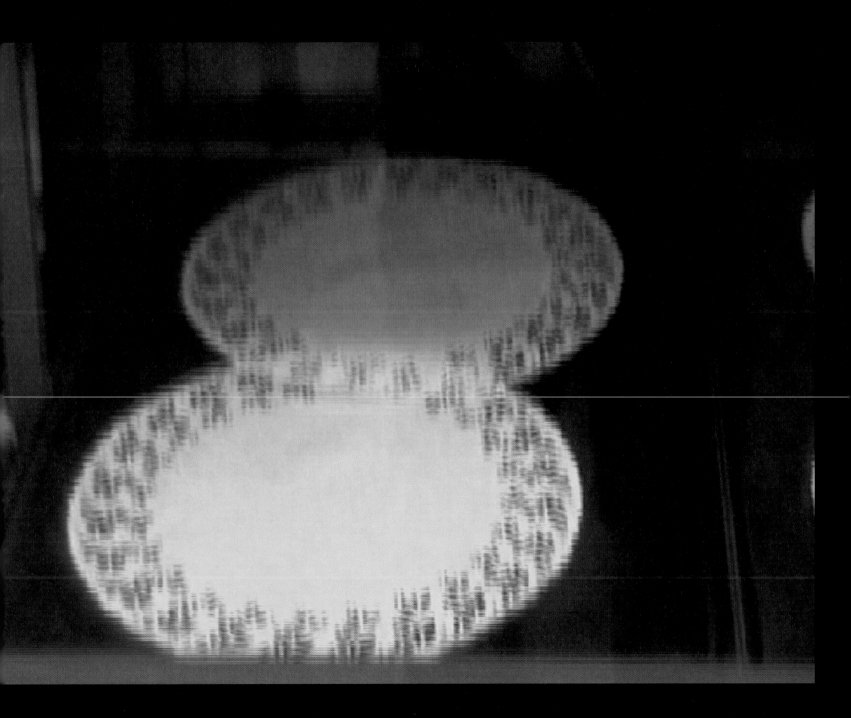

From CAP IN CAR

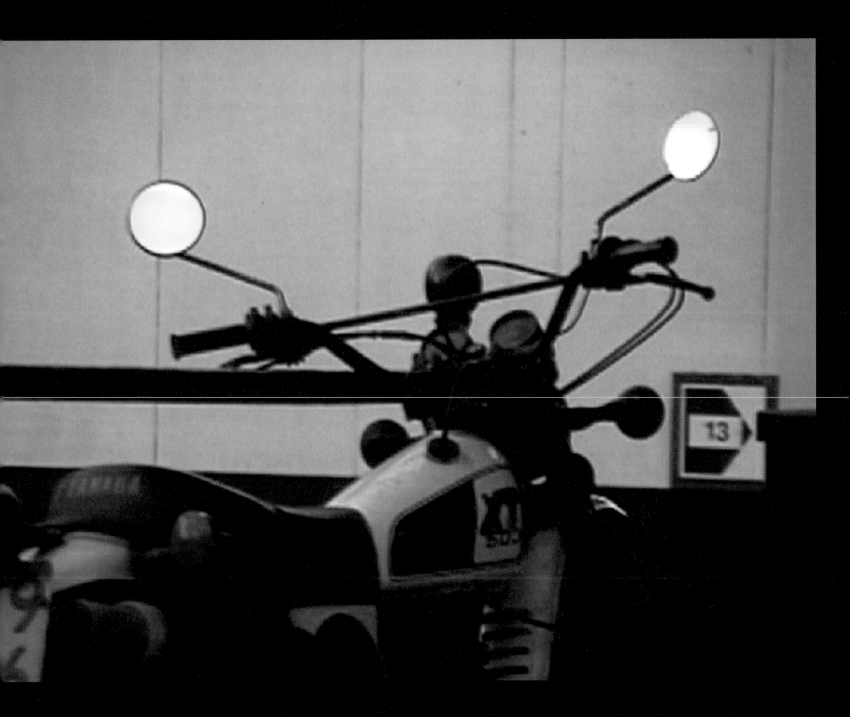

From CAP IN CAR

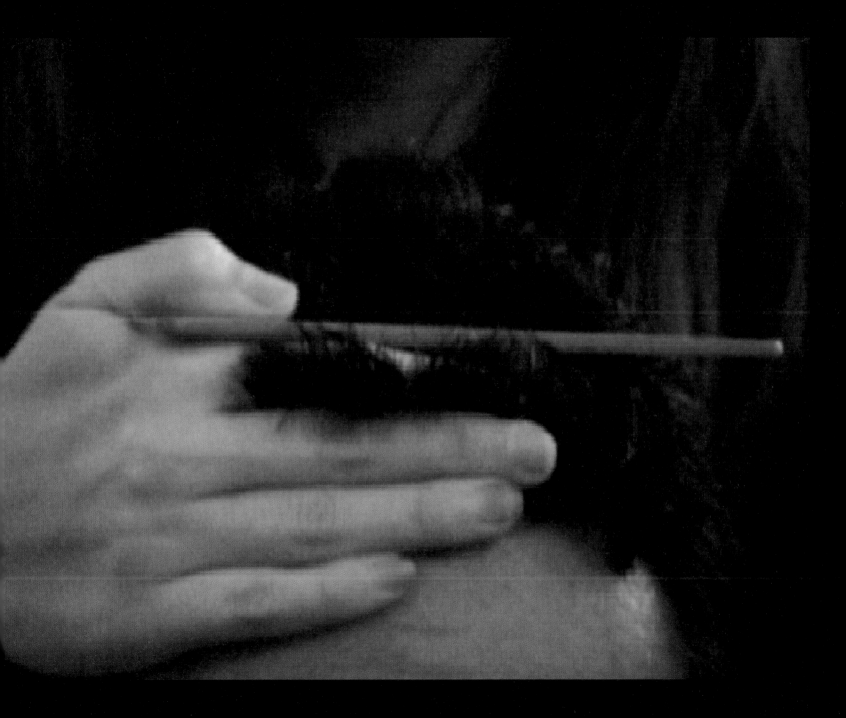

From CAP IN CAR

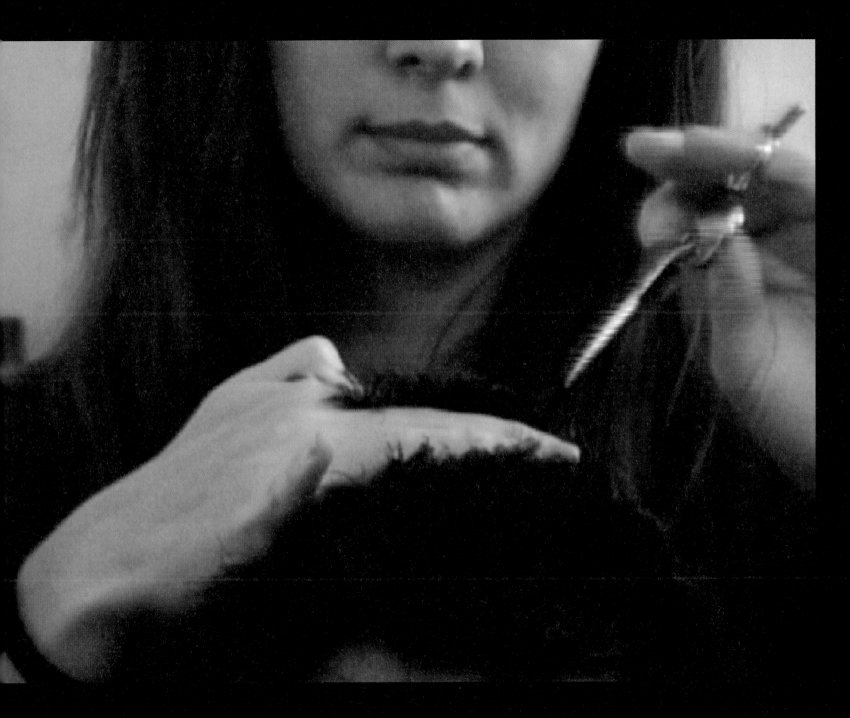

From CAP IN CAR

From CAP IN CAR

To ATLAS

From CAP IN CAR

From CAP IN CAR

RECORDING #4 40"00"
From
Dog Shit
To
IRMA VEP

Amsterdam

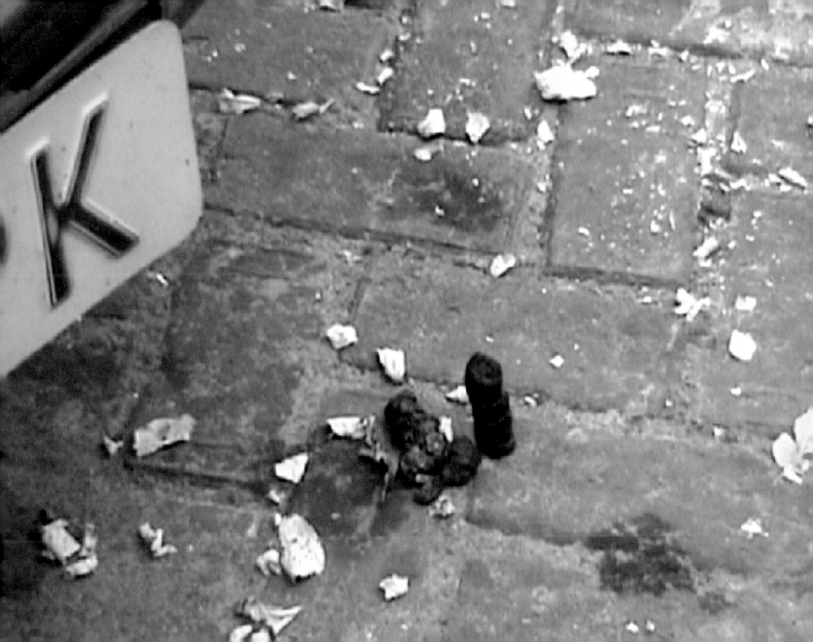

From DOG SHIT

To IRMA VEP

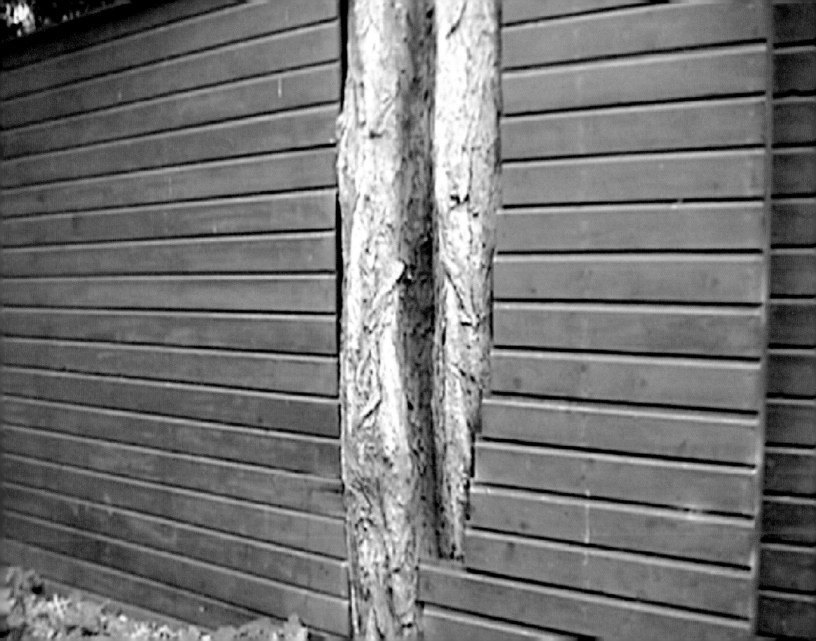

From DOG SHIT

To IRMA VEP

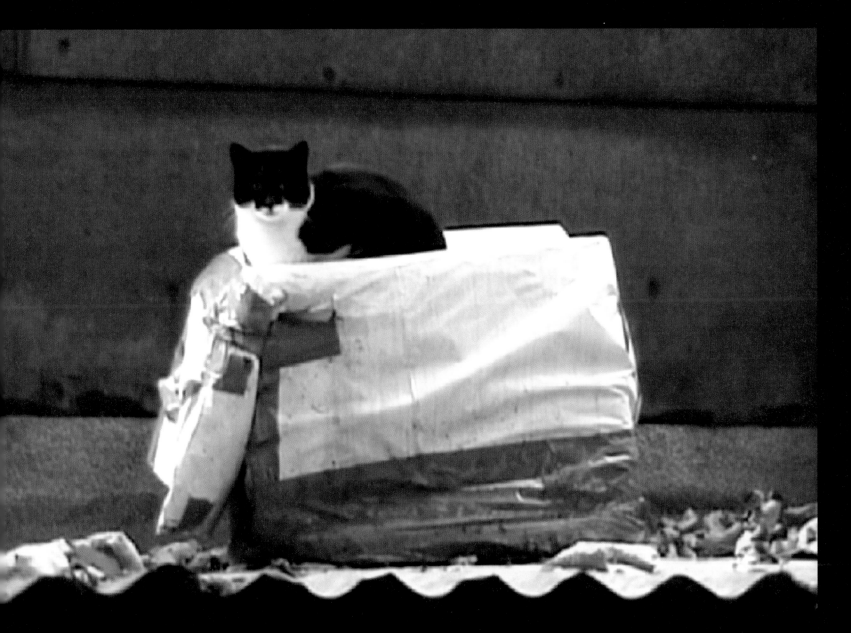

From DOG SHIT

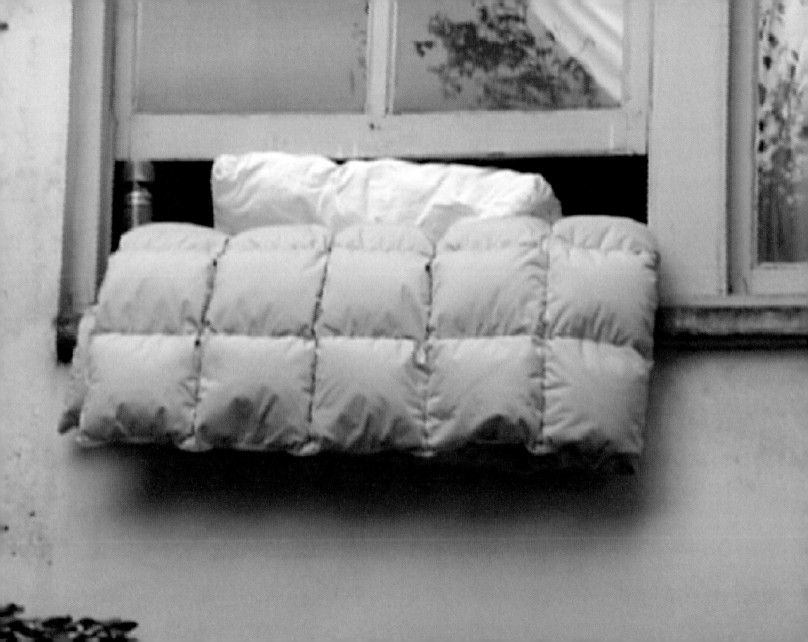

From DOG SHIT

To IRMA VEP

From DOG SHIT

From DOG SHIT

To IRMA VEP

From DOG SHIT

To IRMA VEP

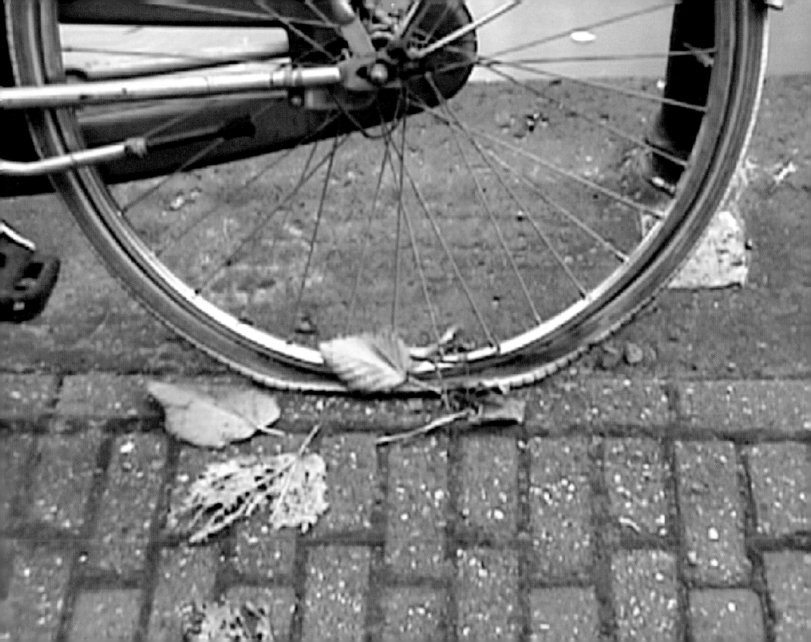

From DOG SHIT

To IRMA VEP

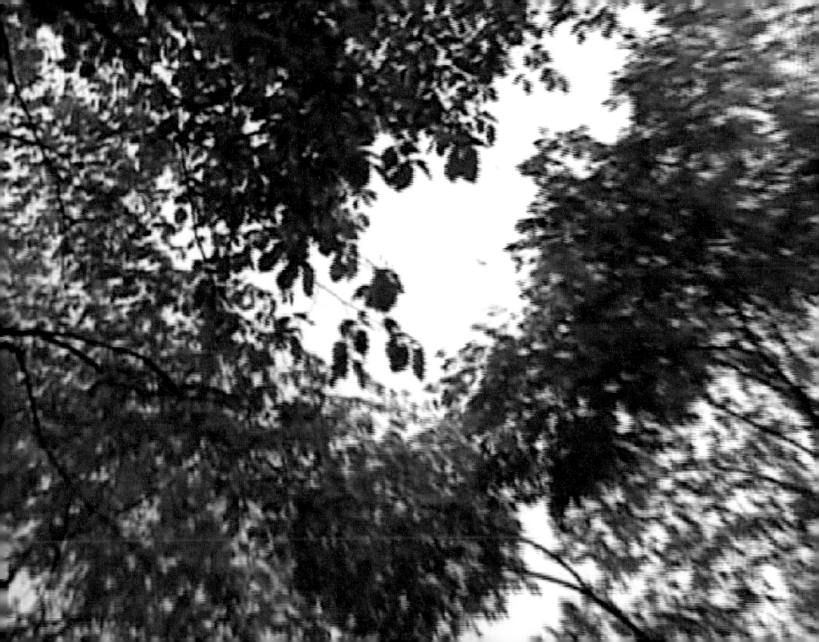

From DOG SHIT

To IRMA VEP

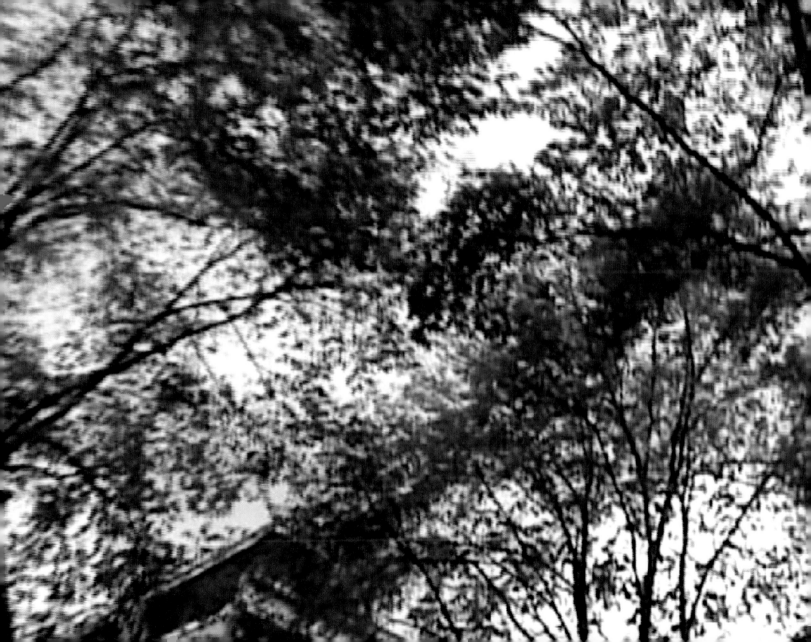

From DOG SHIT

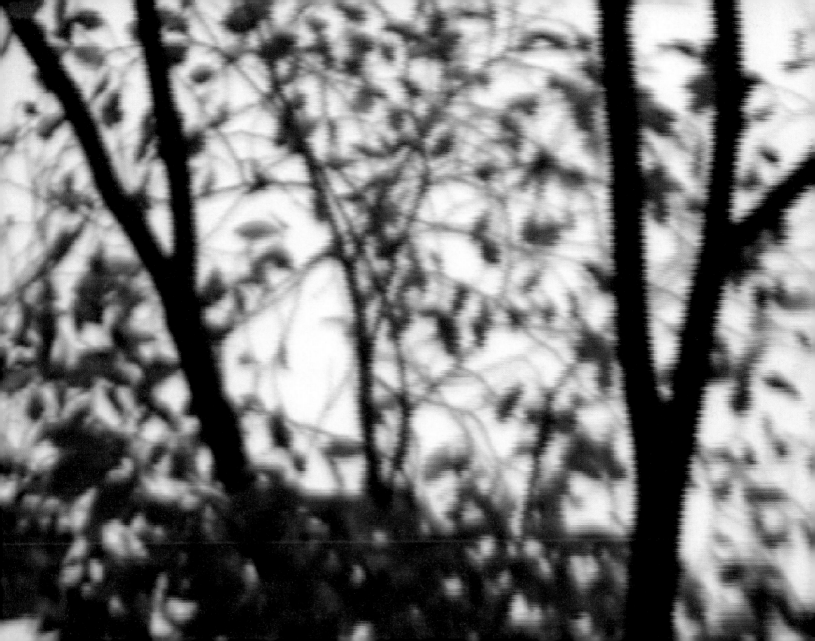

From DOG SHIT

To IRMA VEP

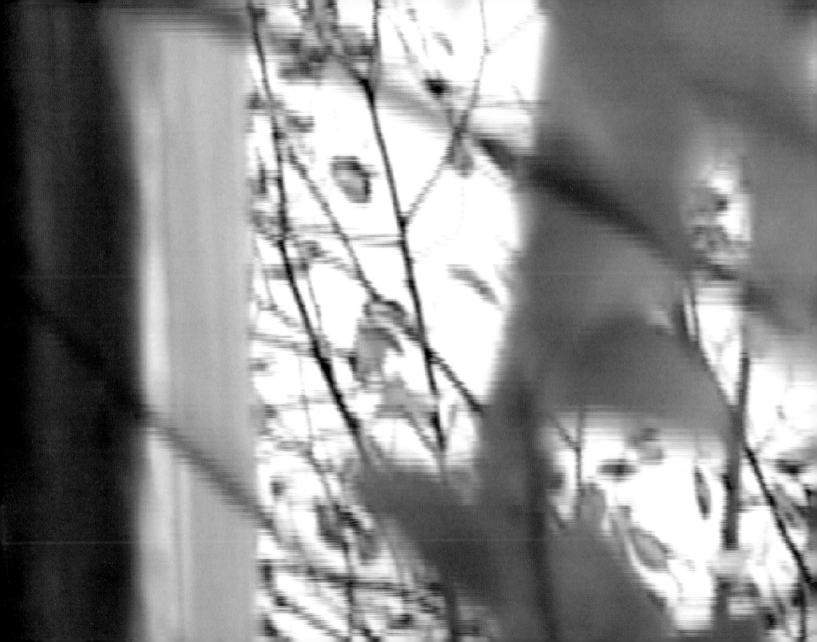

From DOG SHIT

To IRMA VEP

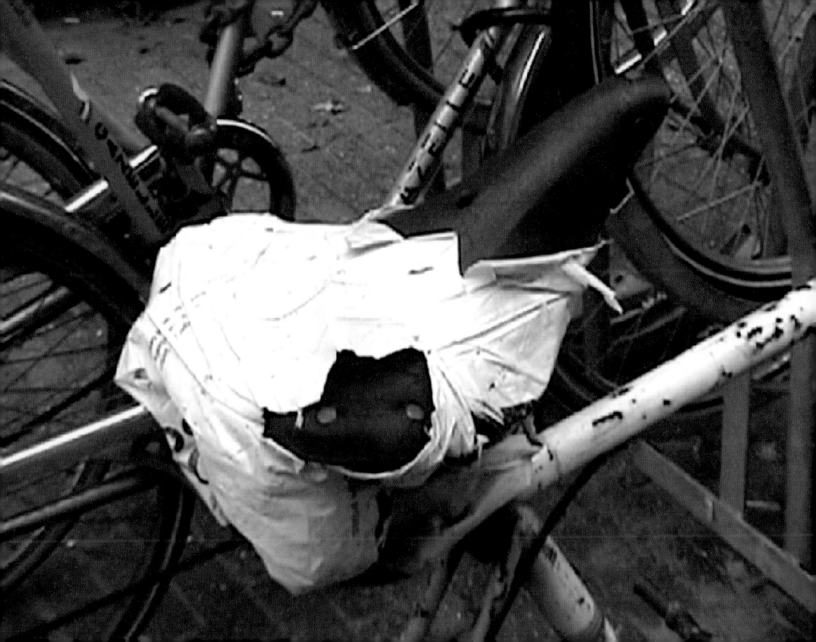

From DOG SHIT

To IRMA VEP

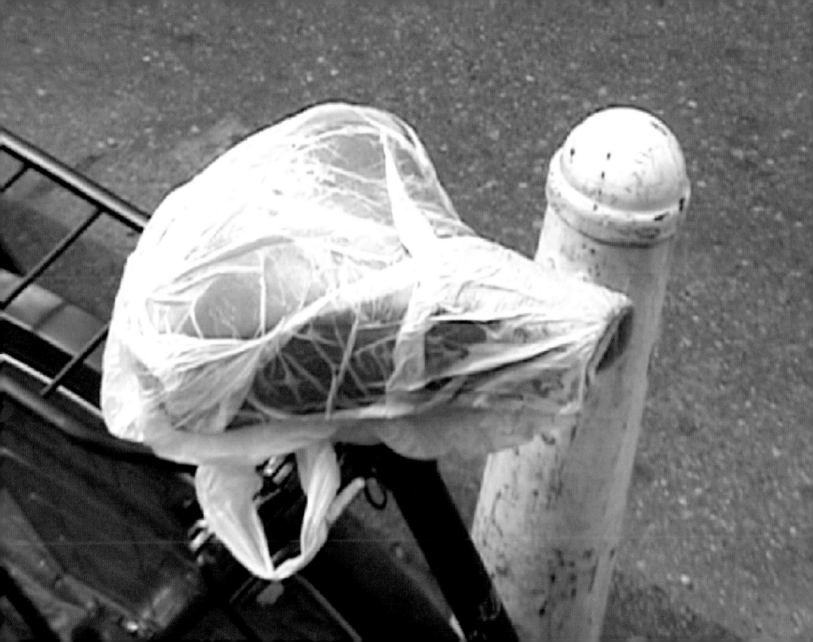

From DOG SHIT

To IRMA VEP

From DOG SHIT

To IRMA VEP

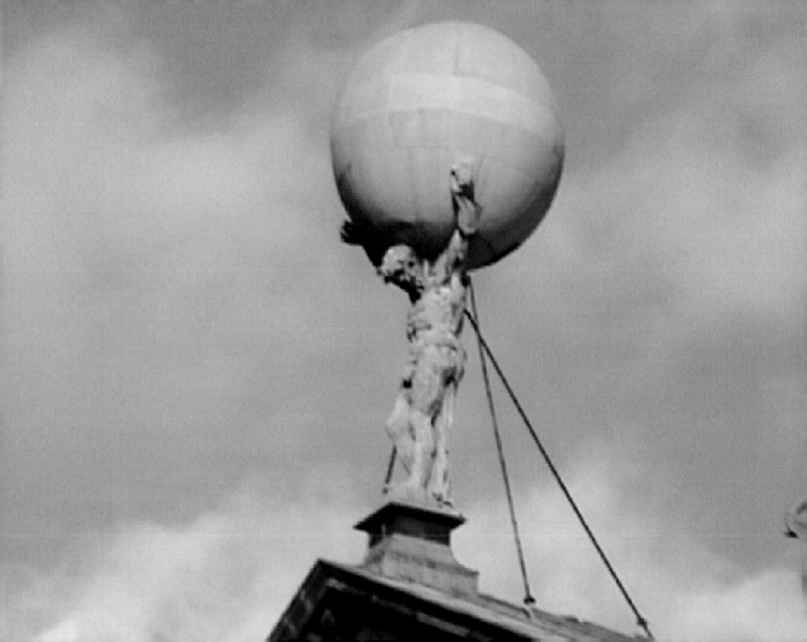

From DOG SHIT

To IRMA VEP

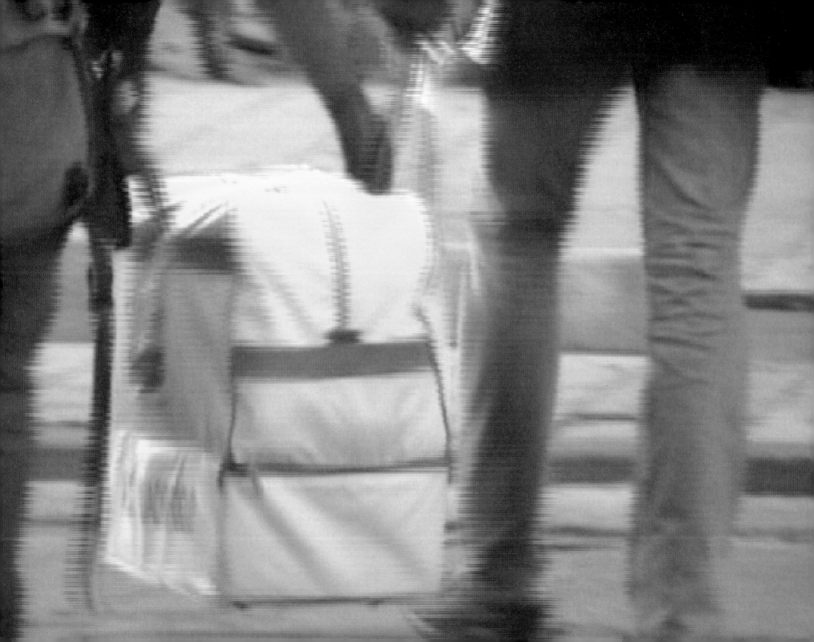

From DOG SHIT

Art Center College of Design
Library
1700 Lida Street
Pasadena, Calif. 91103

To IRMA VEP

From DOG SHIT

To IRMA VEP

From DOG SHIT

From DOG SHIT

To IRMA VEP

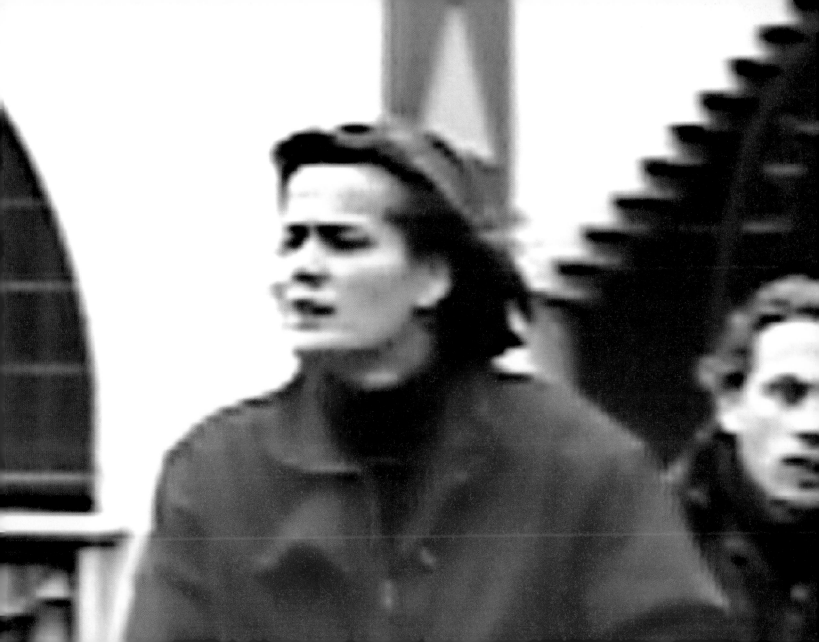

From DOG SHIT

From DOG SHIT

To IRMA VEP

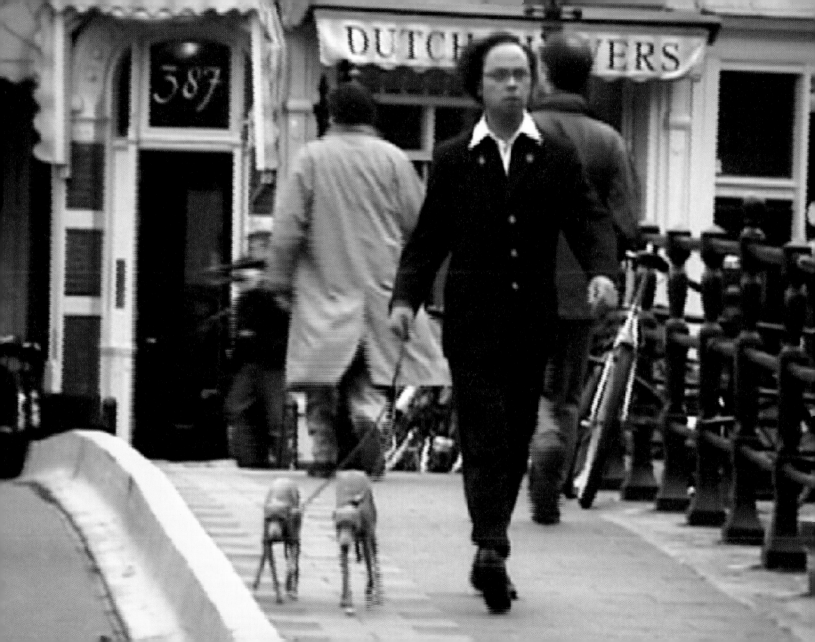

From DOG SHIT

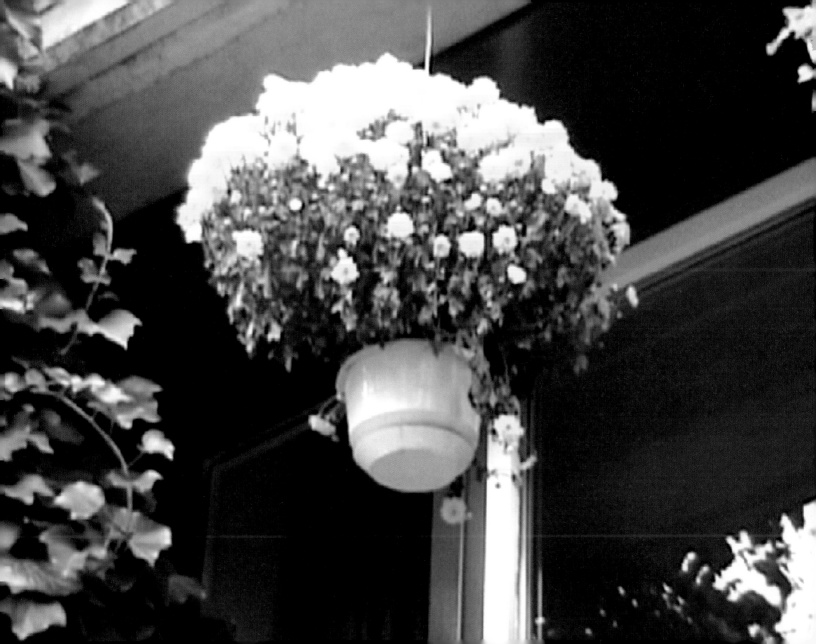

From DOG SHIT

To IRMA VEP

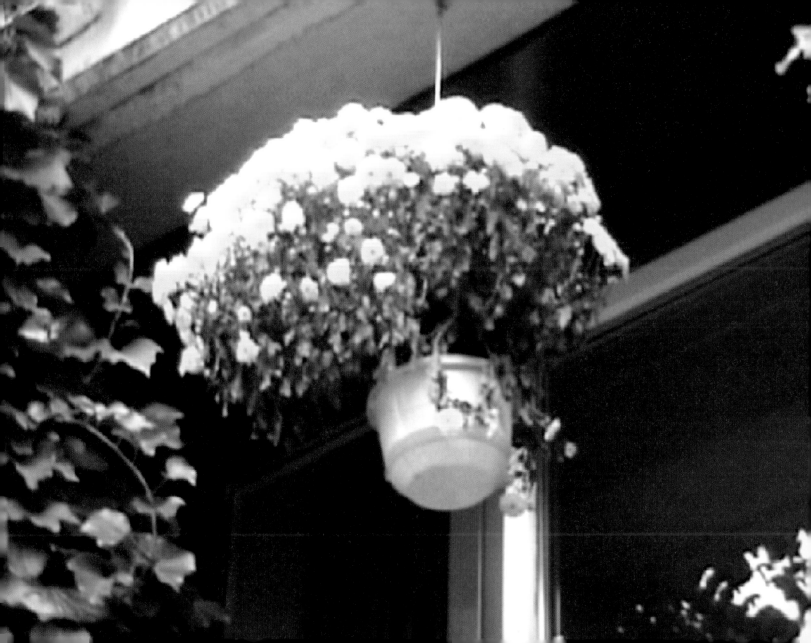

From DOG SHIT

To IRMA VEP

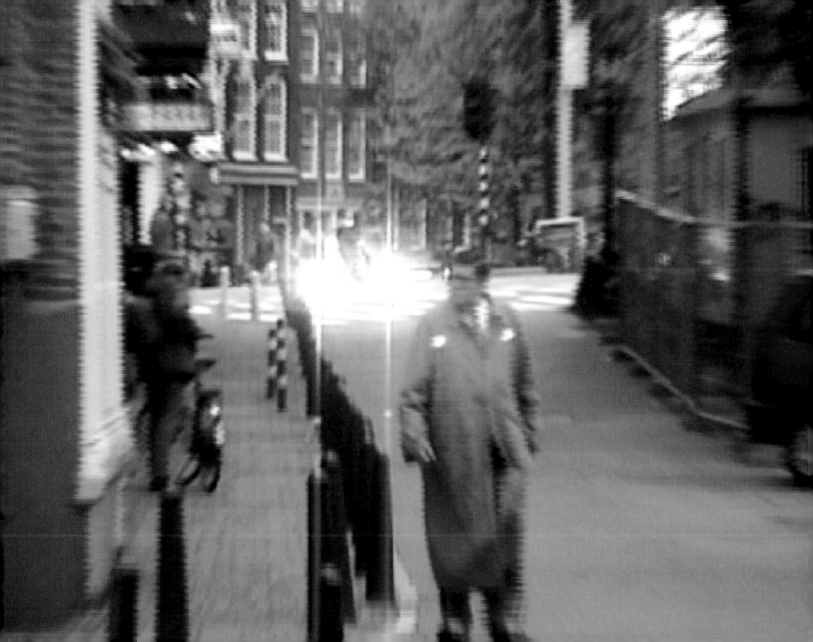

From DOG SHIT

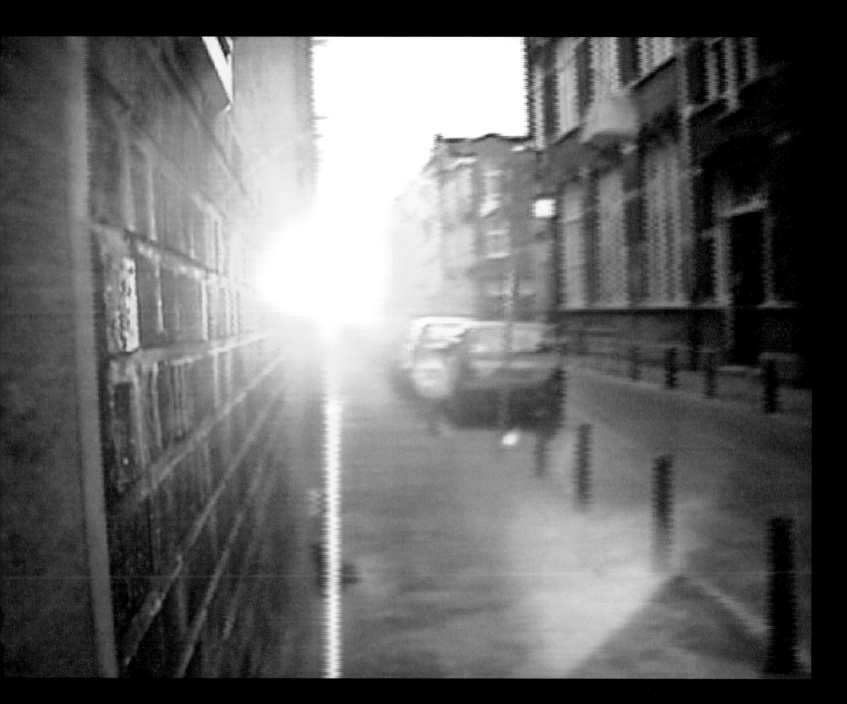

From DOG SHIT

To IRMA VEP

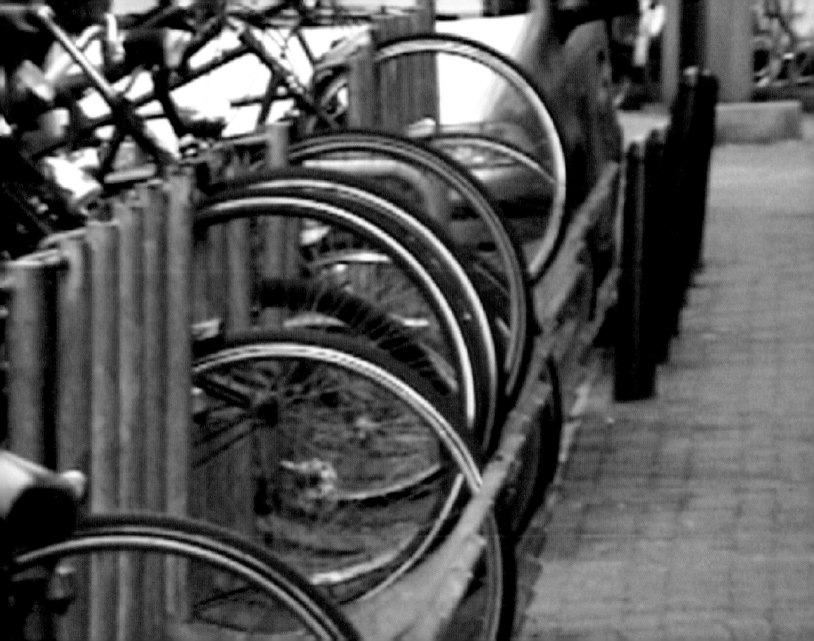

From DOG SHIT

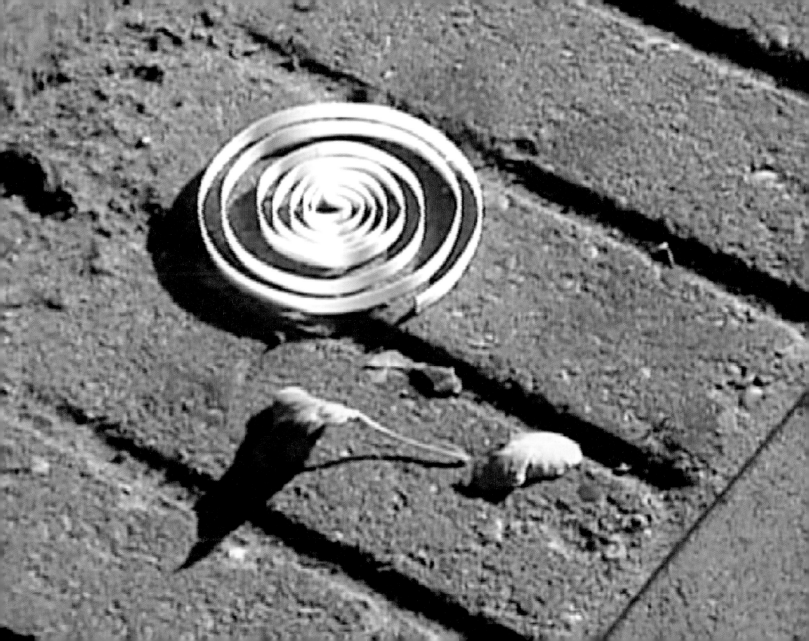

From DOG SHIT

To IRMA VEP

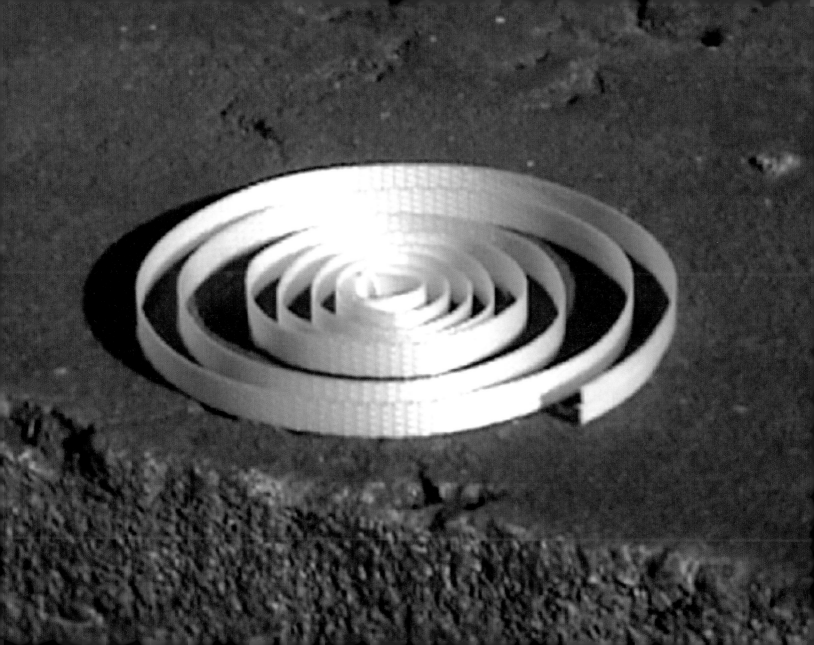

From DOG SHIT

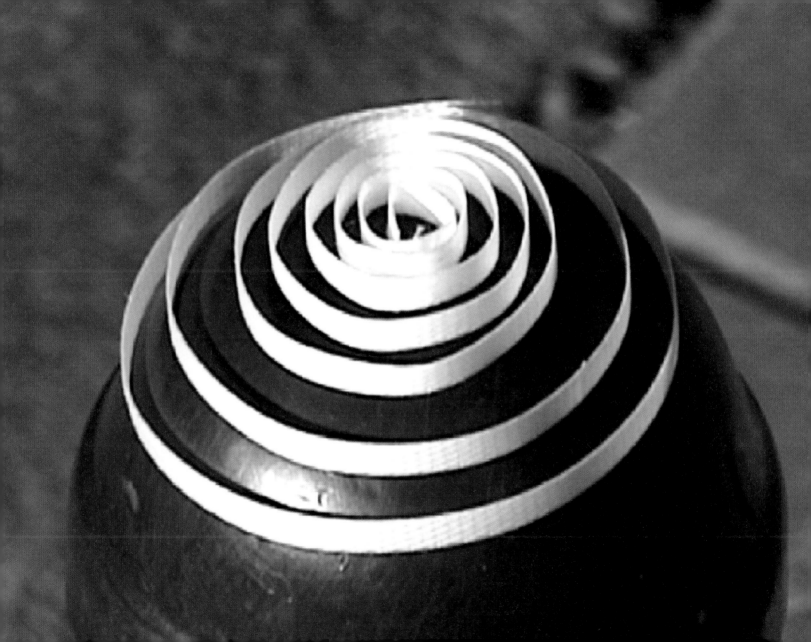

From DOG SHIT

To IRMA VEP

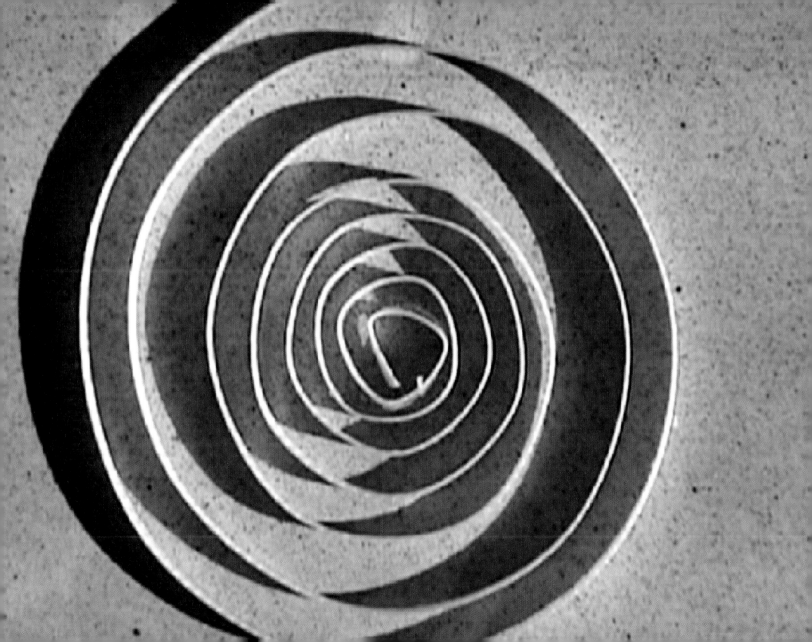

From DOG SHIT

To IRMA VEP

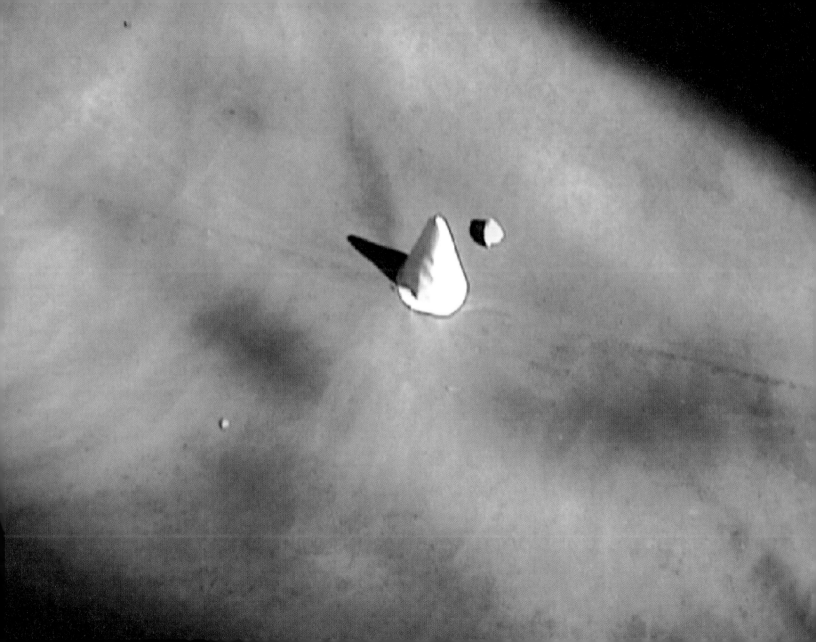

From DOG SHIT

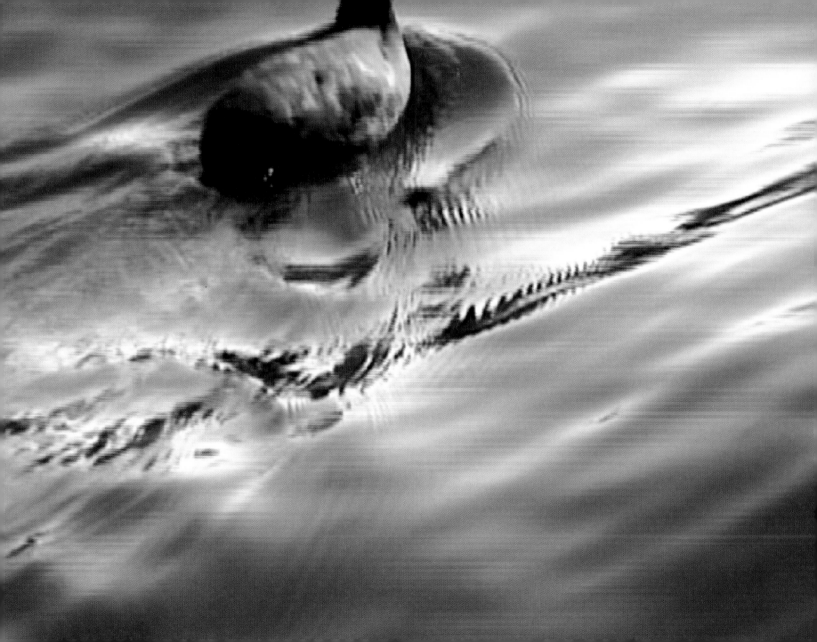

From DOG SHIT

To IRMA VEP

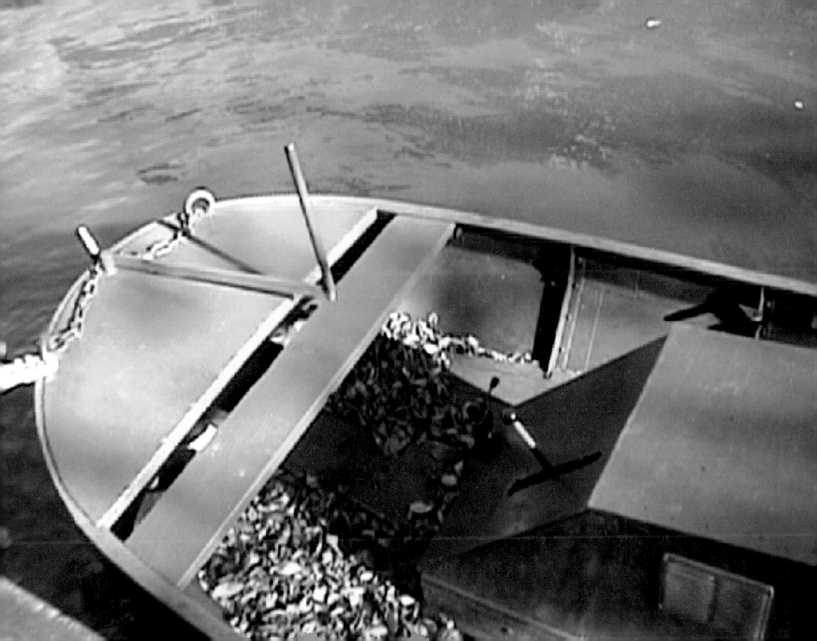

From DOG SHIT

To IRMA VEP

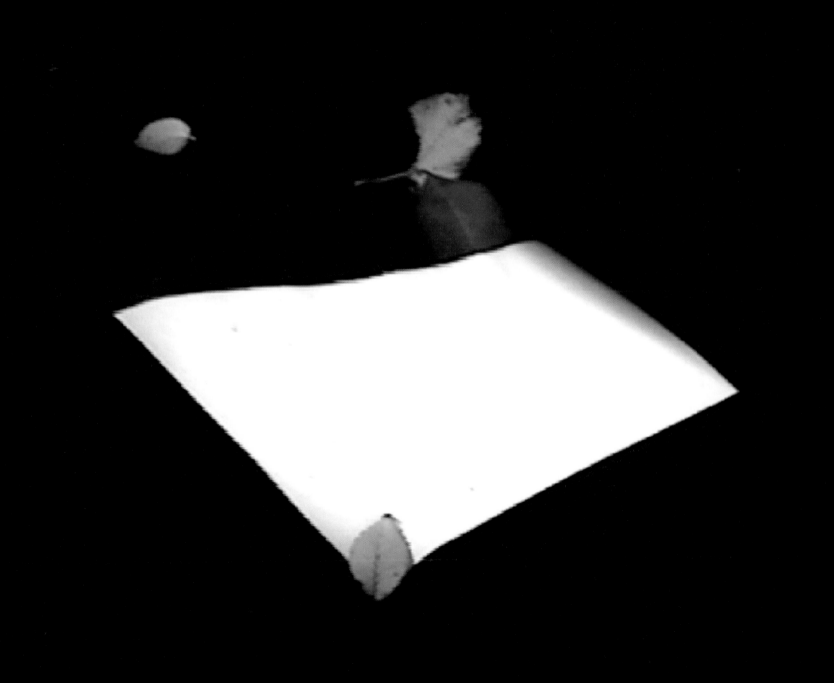

From DOG SHIT

To IRMA VEP

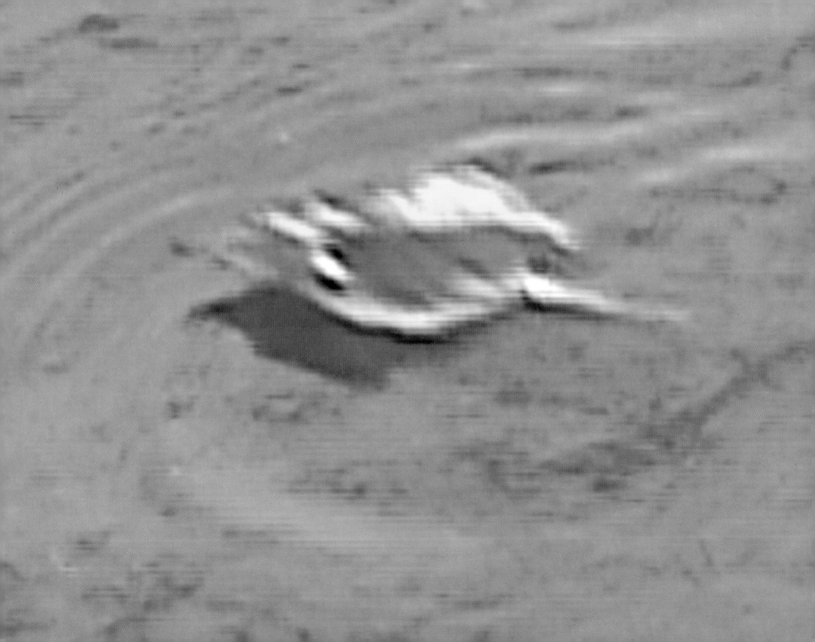

From DOG SHIT

To IRMA VEP

3.1 DIE PHILOSOPHIE HINTER DAS ERFOLGSKONZEPT

ACCOR hat sich verschiedene Ziele als Maßstab gesetzt.

1) **Förderung** der Qualität der Gruppe, der Entwicklung und der Auf... gegenüber dem Kunden.

2) **Festigung** des europäischen Maßstabes der Gruppe und des Ent... Weltweit, insbesondere die des Ostens. Die Gewinnleistungen für ent... sind gute Mitarbeiter in ein gutes Arbeitsklima, die Beste Arbeit mit... Das Persönliche Engagement von allen Mitarbeitern ist sehr wichtig... die Entwicklung des Unternehmens. Hierzu gehören die Bereitschaft... zu wagen, nachhaltes Konsequenz und Initiative. Der Erfolg einer Gru... Einsatz der Mitarbeiter.

Das Erfolgskonzept bezieht sich dann auch auf drei untrennbar...

- 1) der Kunde
- 2) der Mitarbeiter

From DOG SHIT

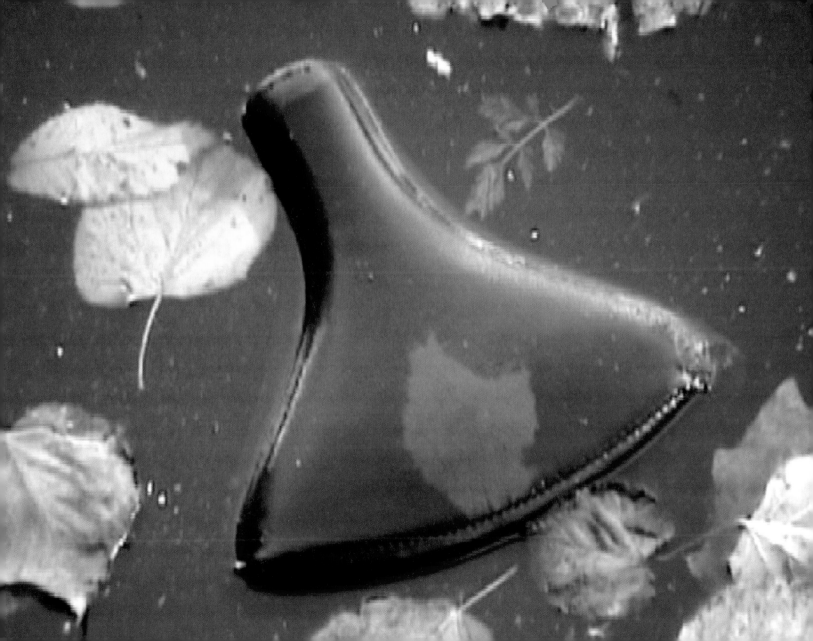

From DOG SHIT

To IRMA VEP

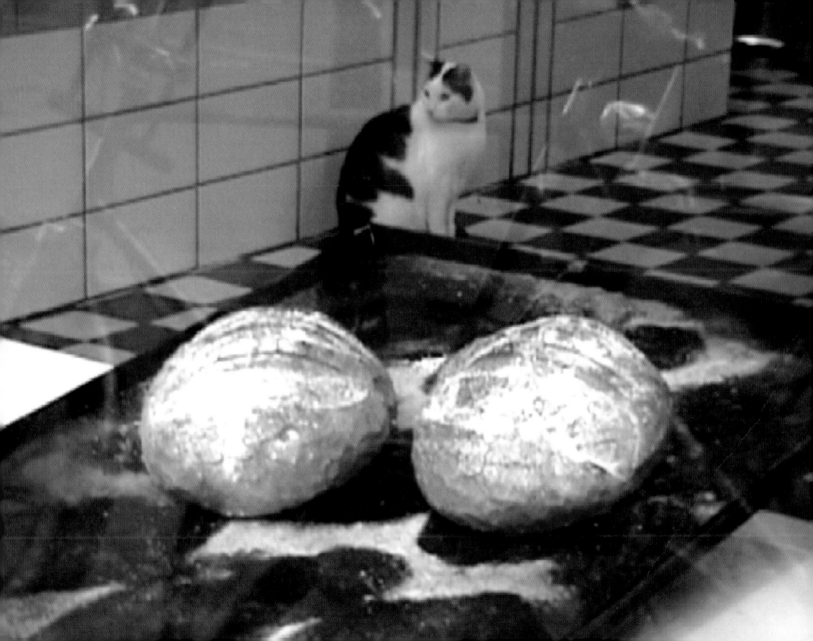

From DOG SHIT

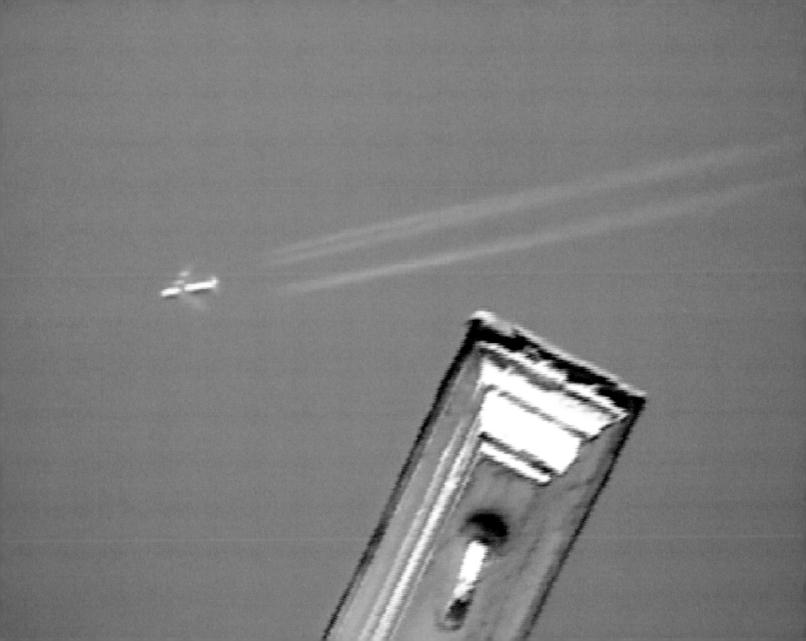

From DOG SHIT

To IRMA VEP

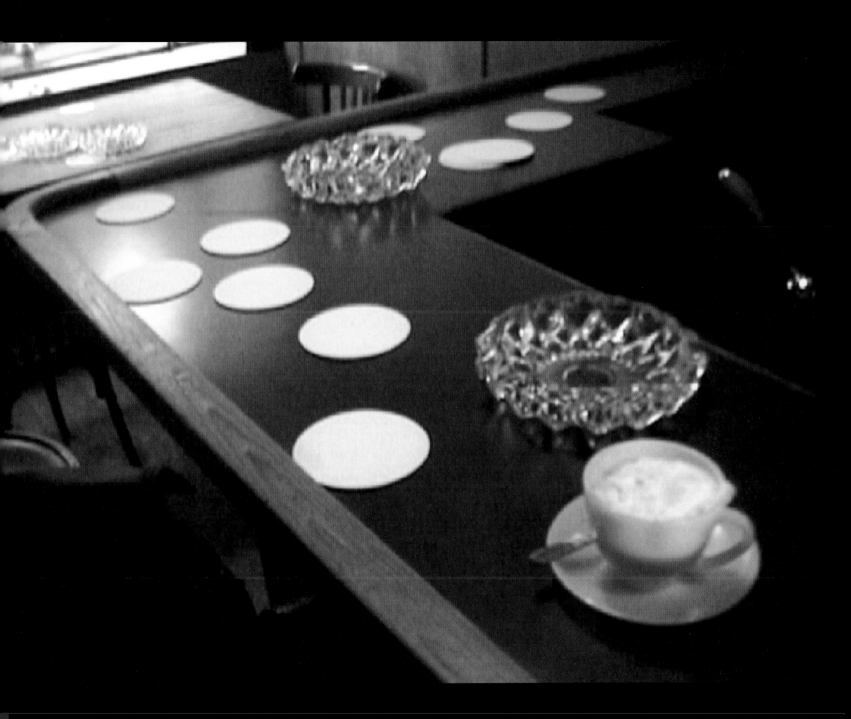

From DOG SHIT

To IRMA VEP

From DOG SHIT

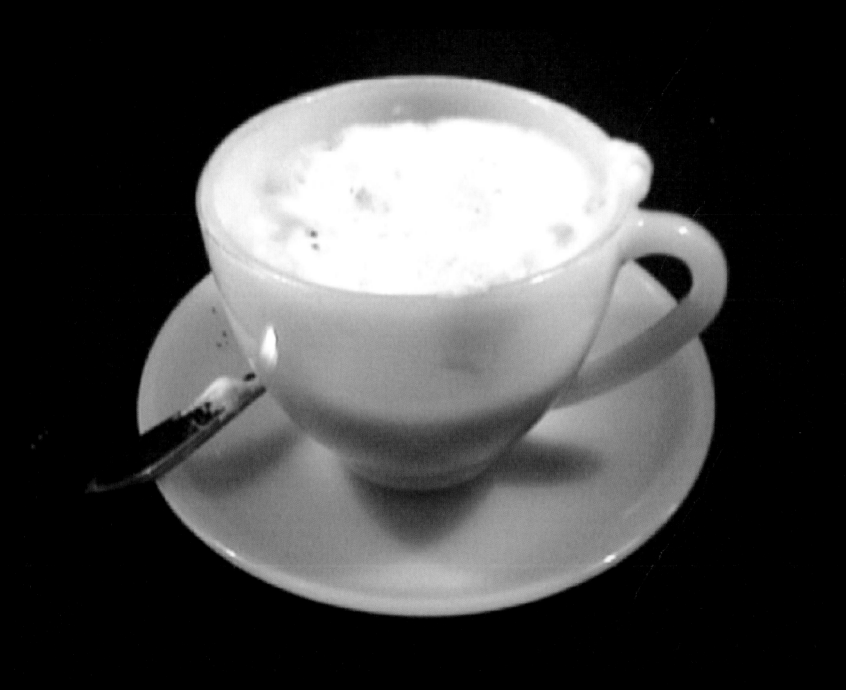

From DOG SHIT

To IRMA VEP

From DOG SHIT

To IRMA VEP

RECORDING #5 44'40"

From

Flat Tyre

To

AIRPLANE

Amsterdam

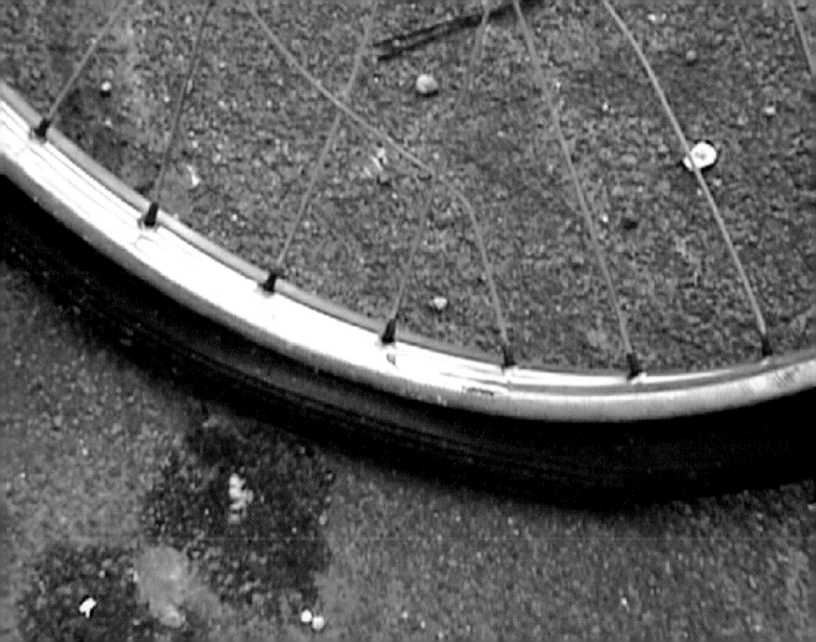

From FLAT TYRE

To AIRPLANE

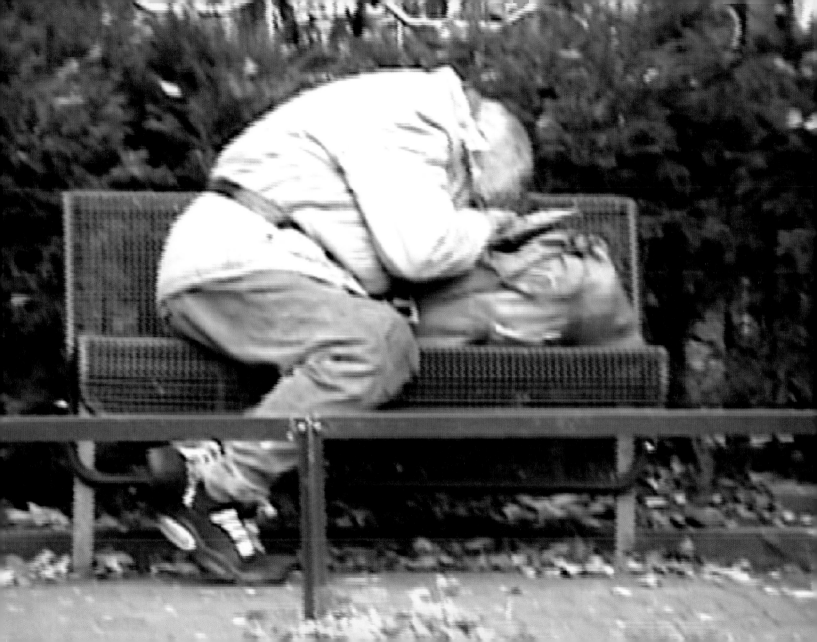

From FLAT TYRE

To AIRPLANE

From FLAT TYRE

To AIRPLANE

From FLAT TYRE

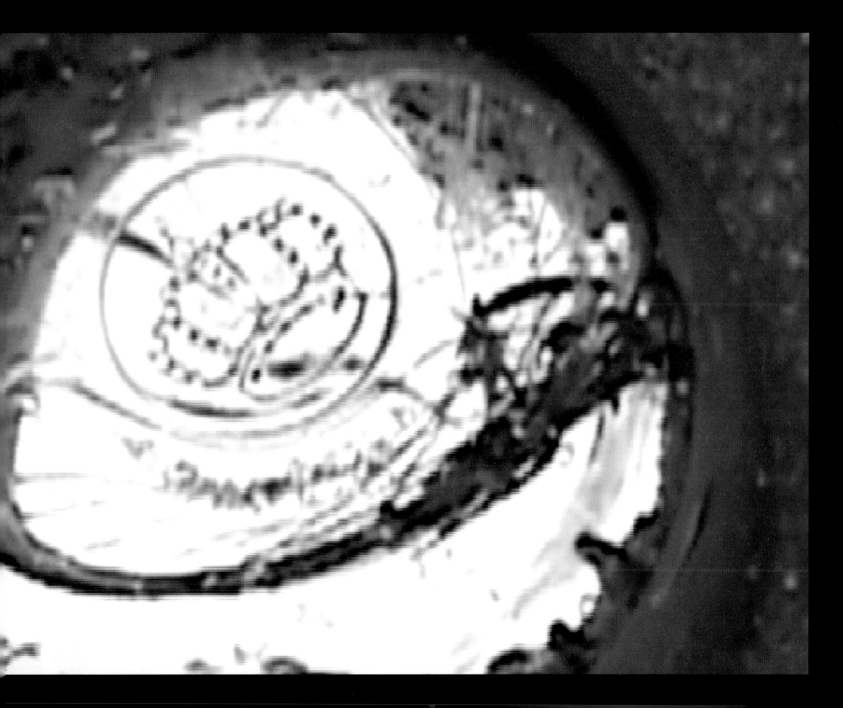

From FLAT TYRE

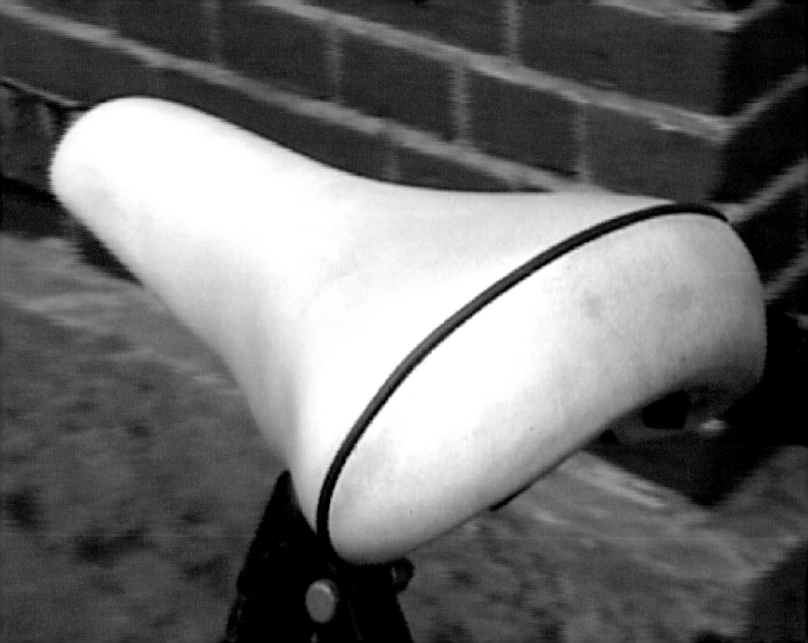

From FLAT TYRE

Art Center College of Design
Library
1700 Lida Street
Pasadena, Calif. 91103

To AIRPLANE

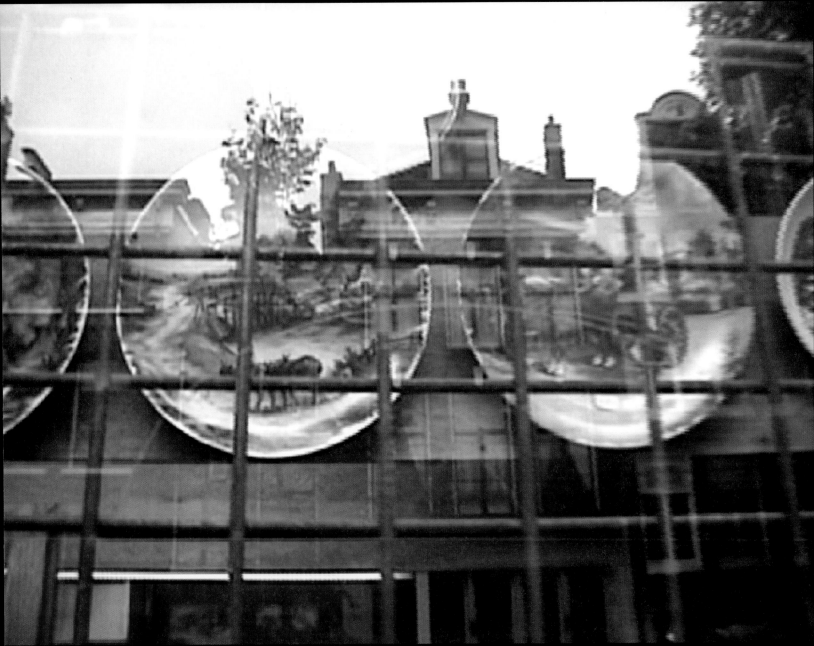

From FLAT TYRE

To AIRPLANE

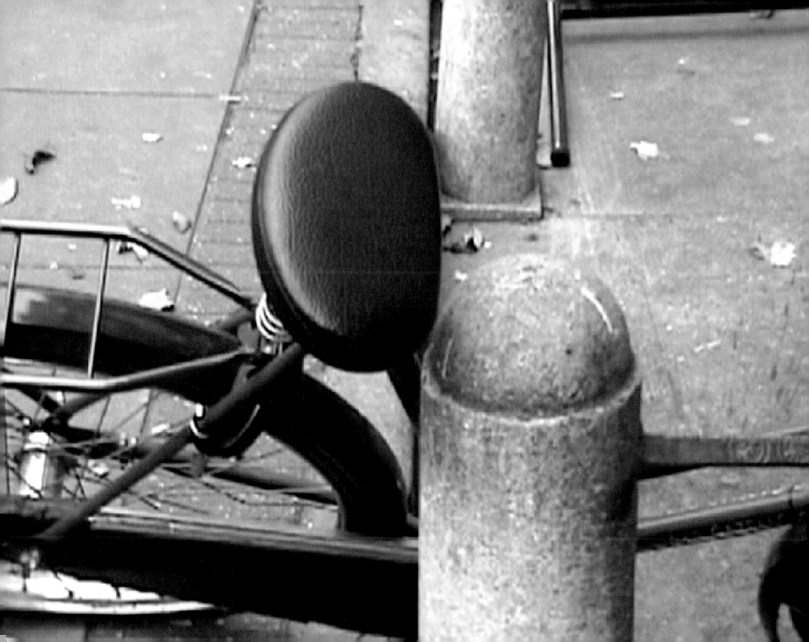

From FLAT TYRE

To AIRPLANE

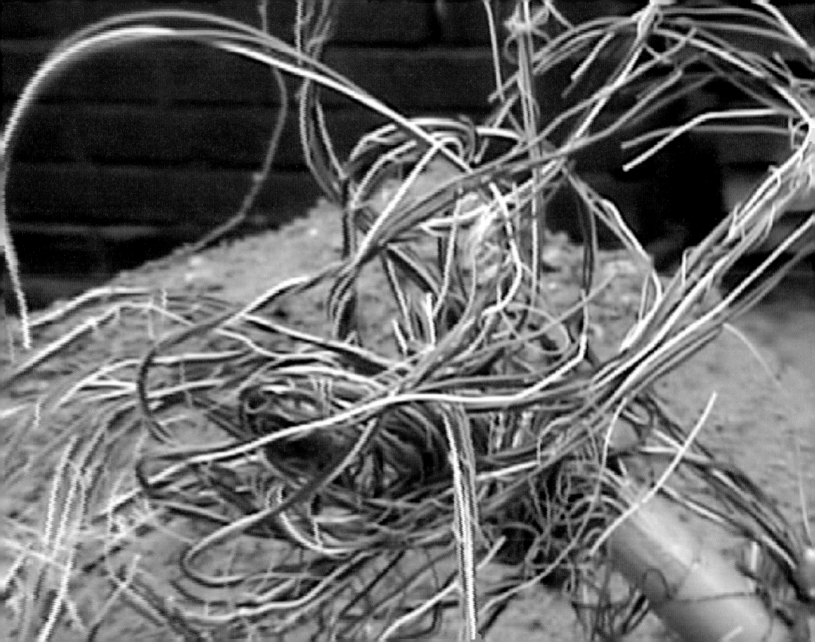

From FLAT TYRE

To AIRPLANE

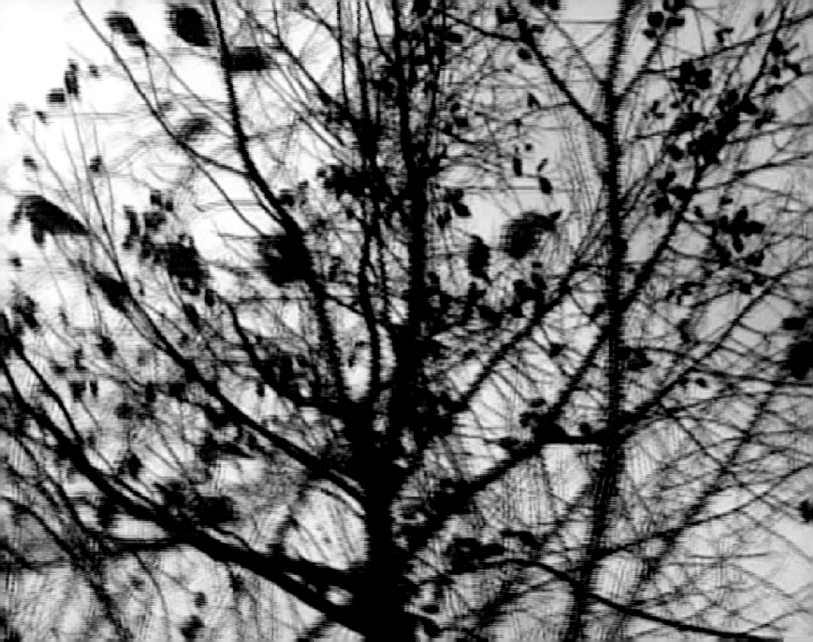

From FLAT TYRE

To AIRPLANE

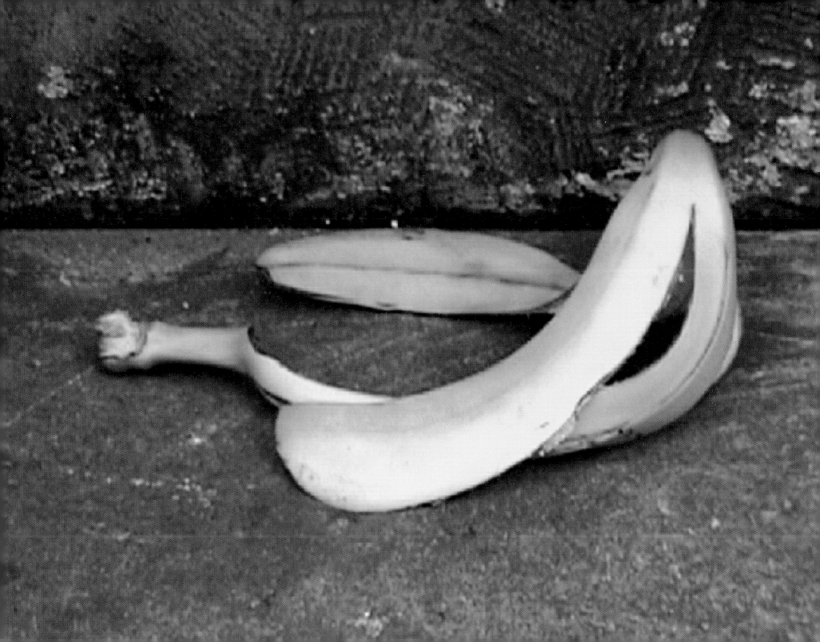

From FLAT TYRE

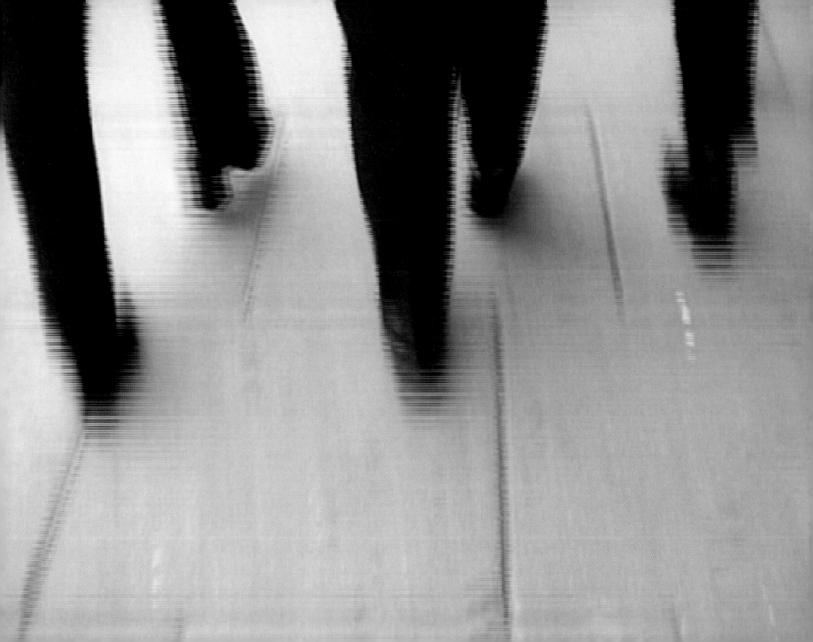

From FLAT TYRE

To AIRPLANE

From FLAT TYRE

To AIRPLANE

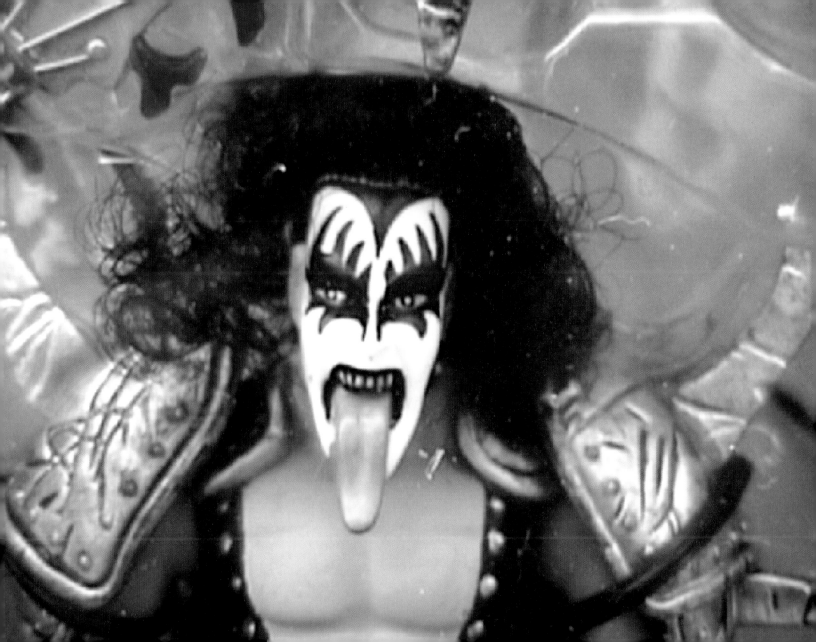

From FLAT TYRE

To AIRPLANE

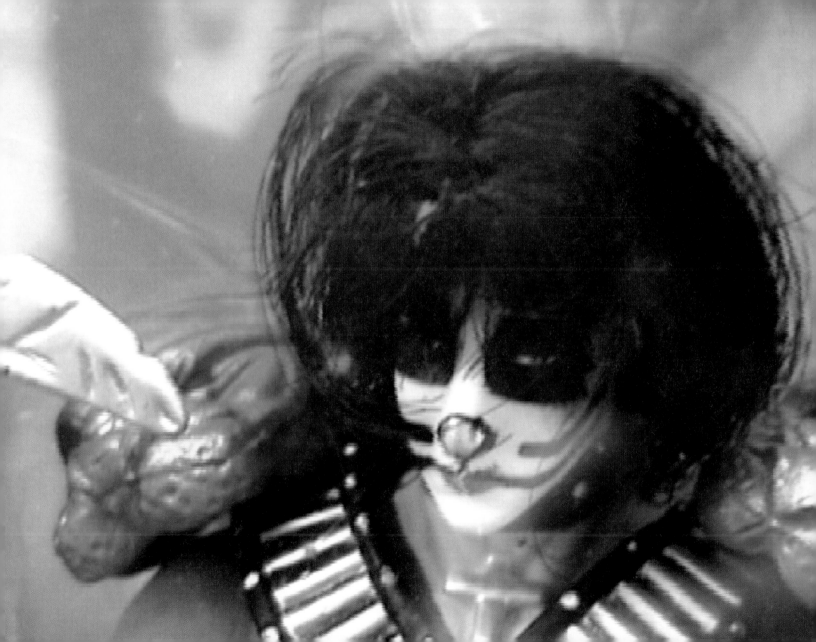

From FLAT TYRE

To AIRPLANE

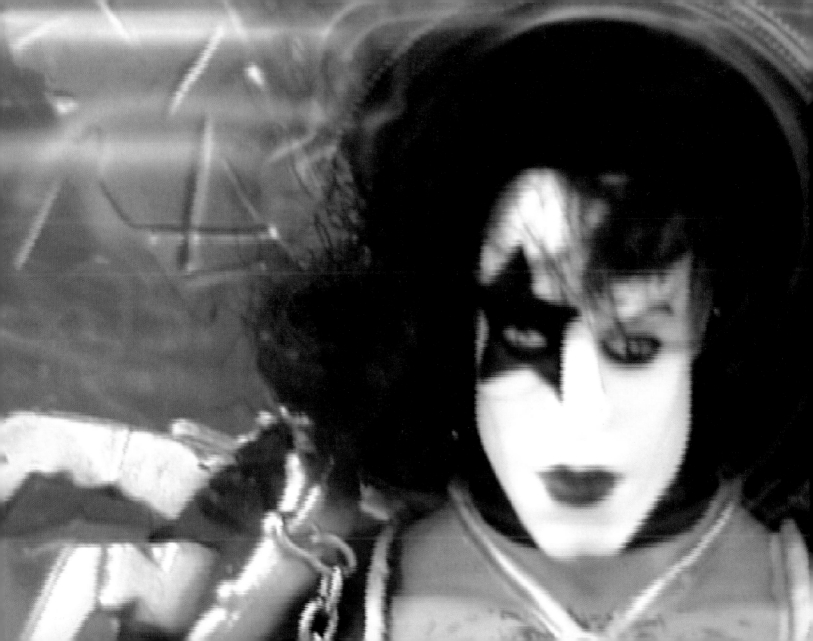

From FLAT TYRE

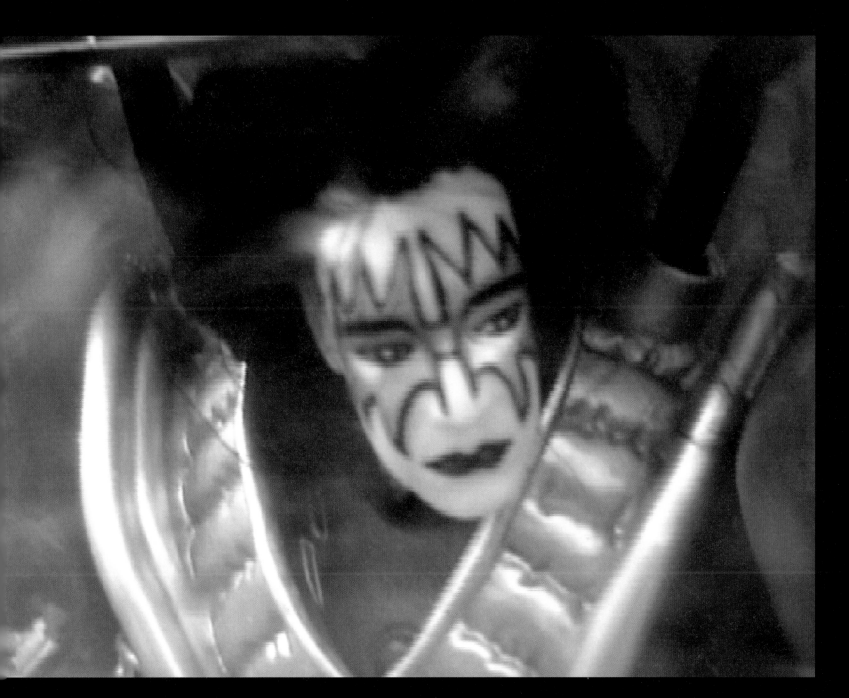

From FLAT TYRE

To AIRPLANE

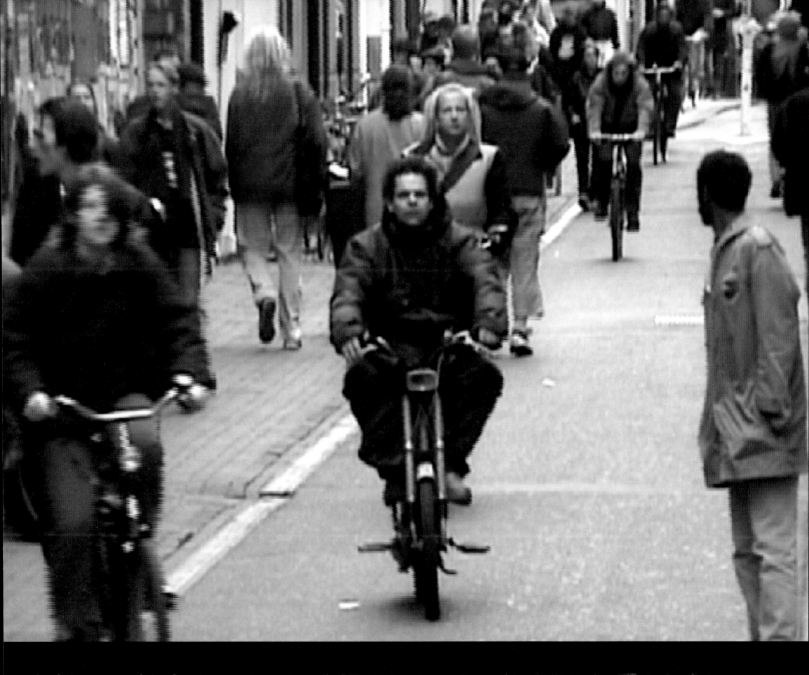

From FLAT TYRE

To AIRPLANE

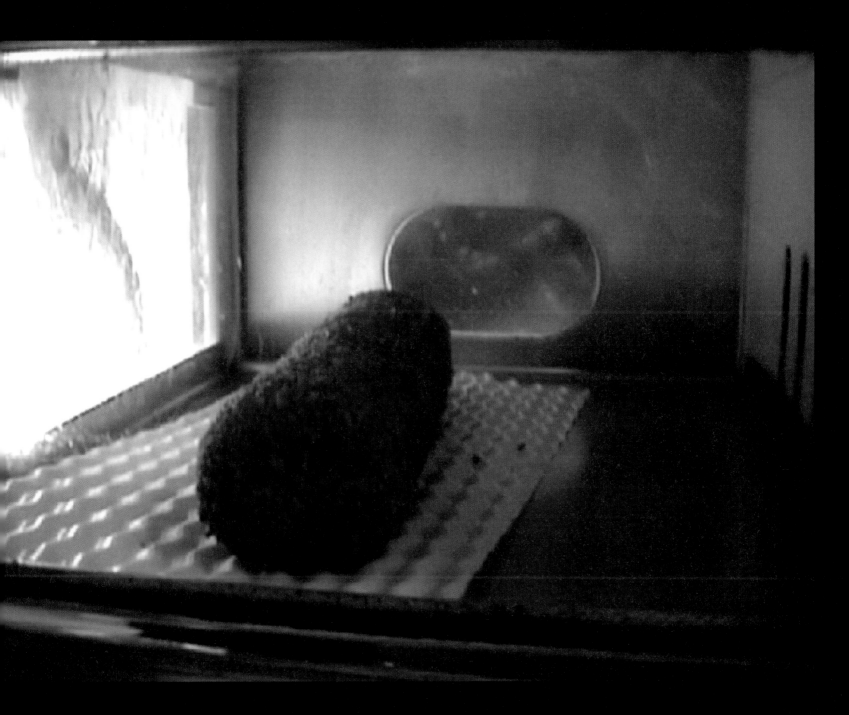

From FLAT TYRE

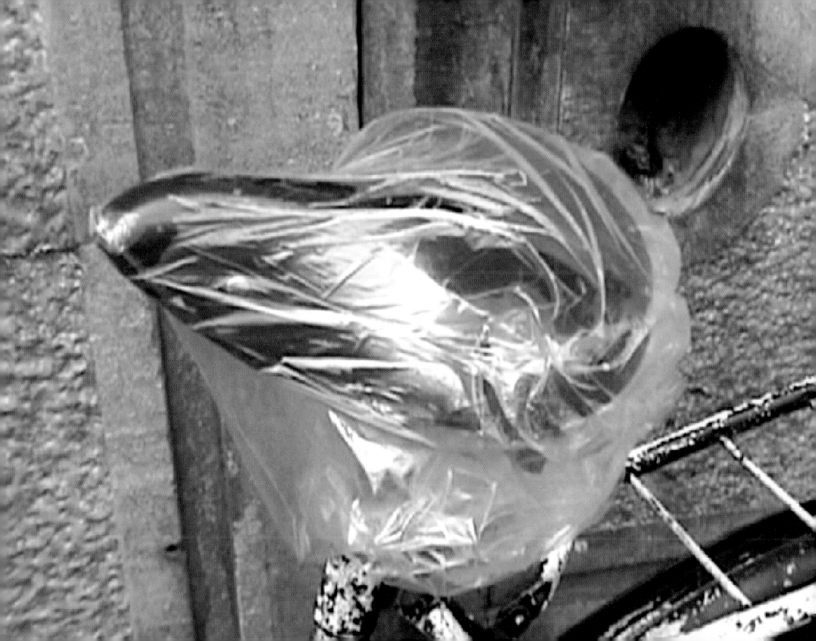

From FLAT TYRE

To AIRPLANE

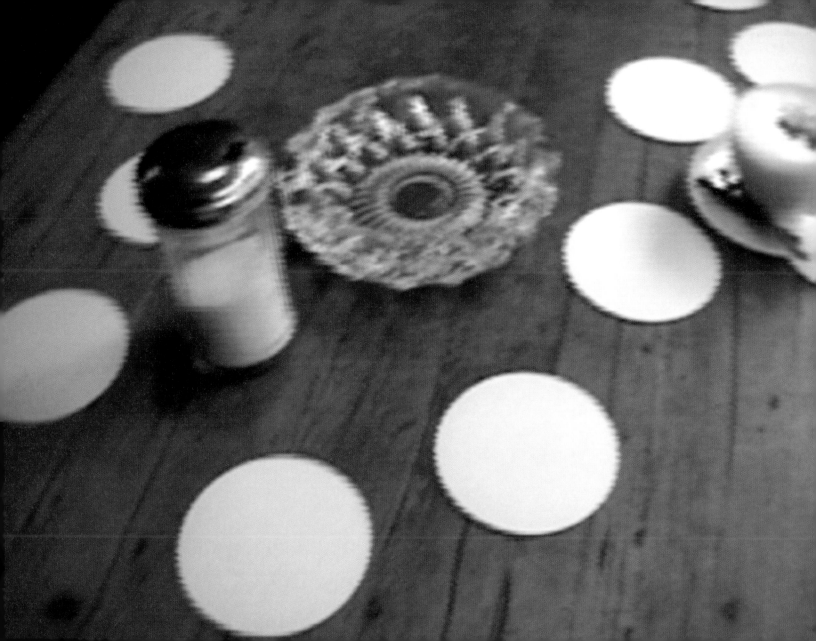

From FLAT TYRE

To AIRPLANE

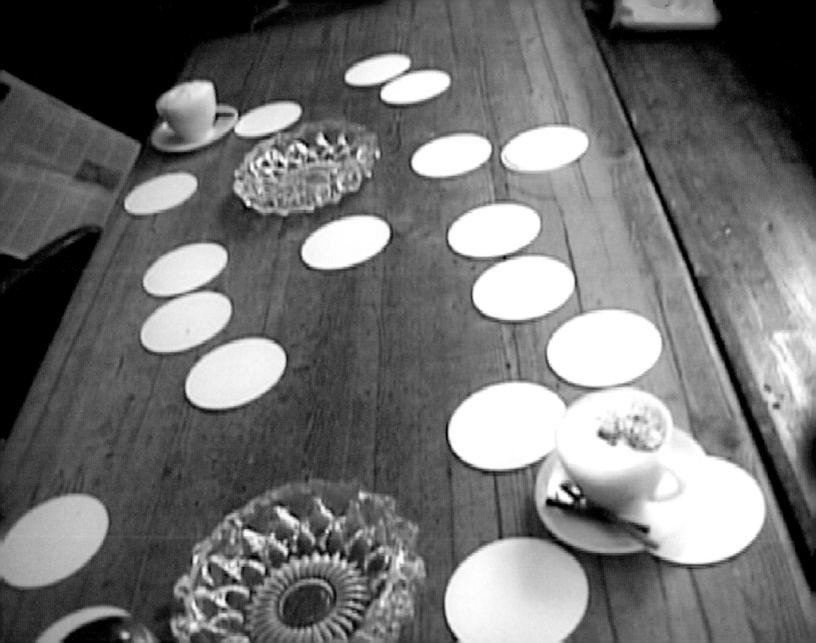

From FLAT TYRE

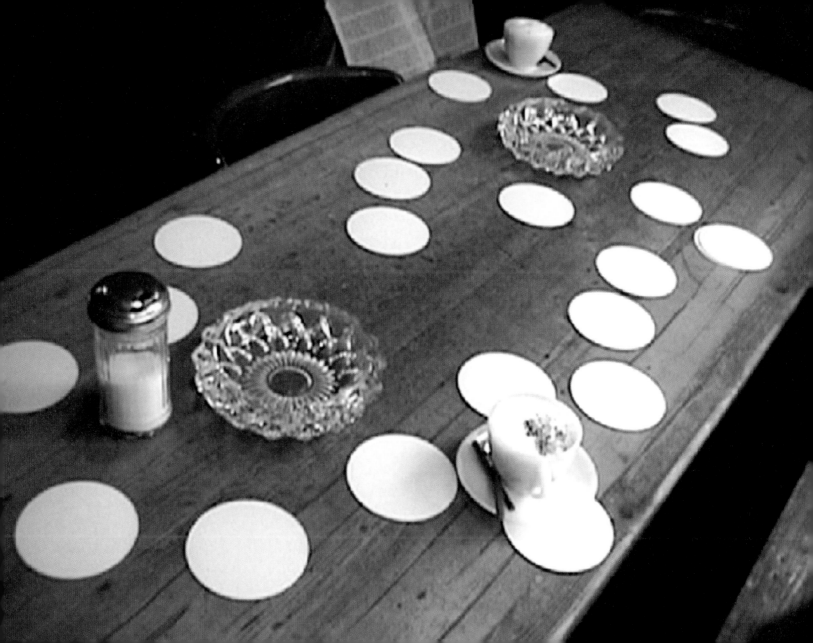

From FLAT TYRE

To AIRPLANE

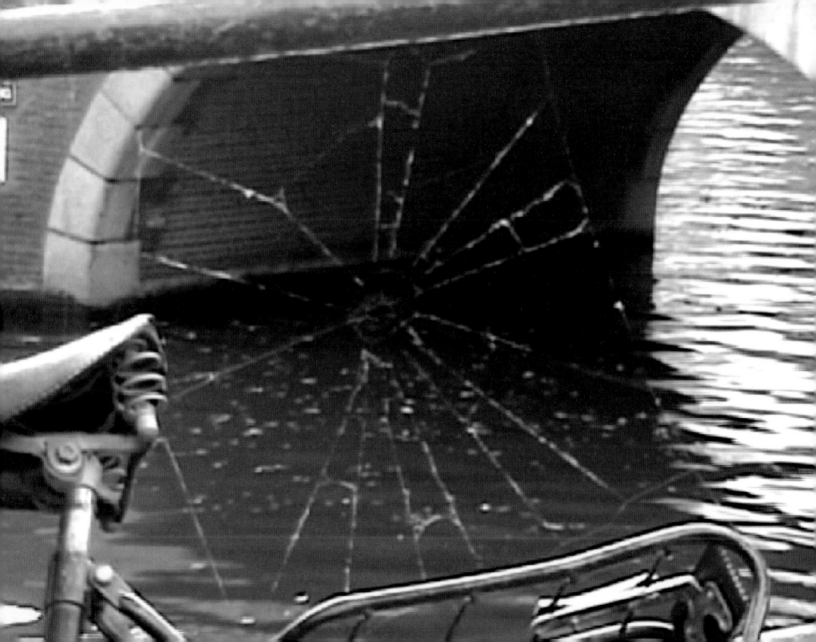

From FLAT TYRE

To AIRPLANE

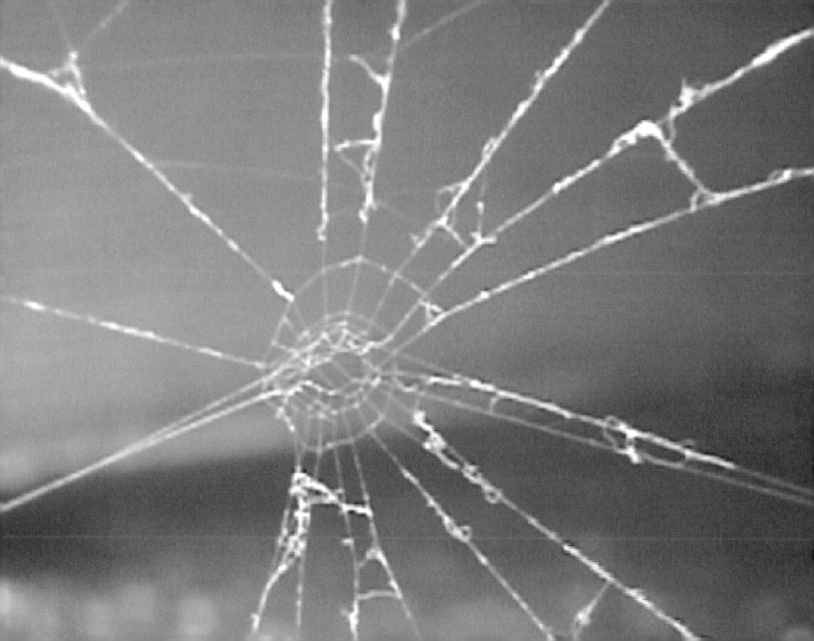

From FLAT TYRE

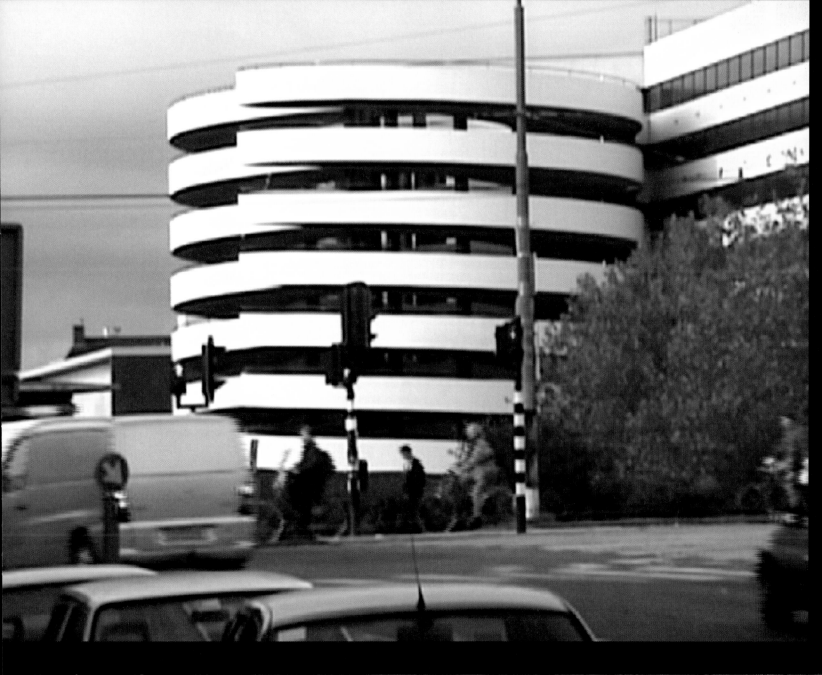

From FLAT TYRE

To AIRPLANE

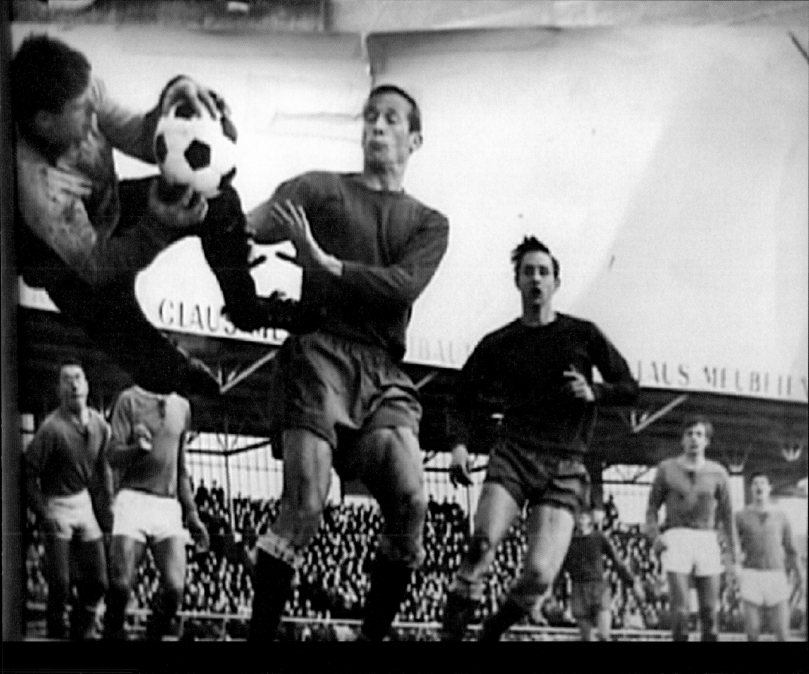

From FLAT TYRE

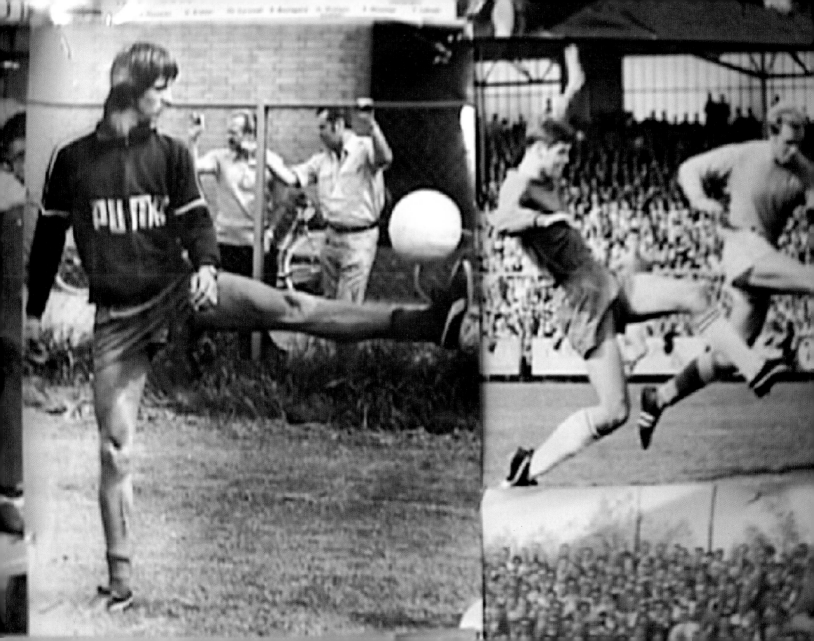

From FLAT TYRE

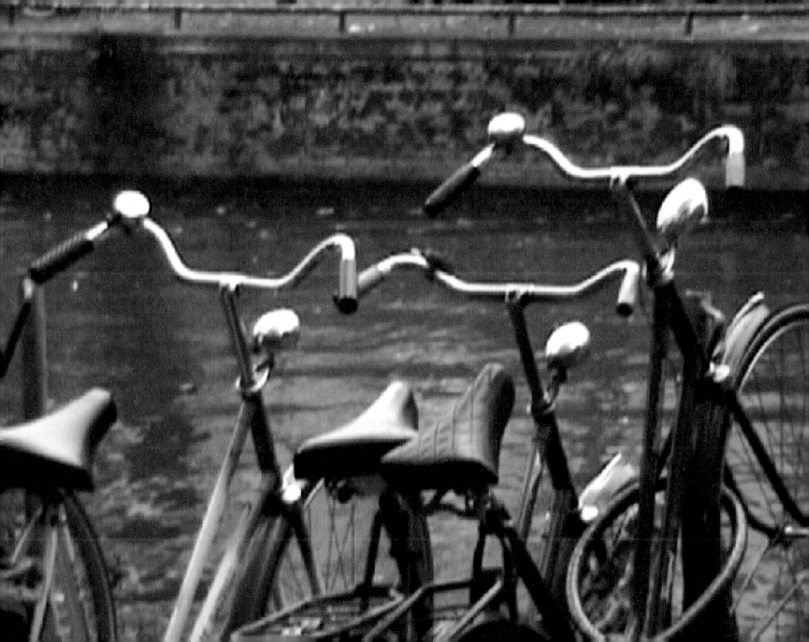

From FLAT TYRE

From FLAT TYRE

From FLAT TYRE

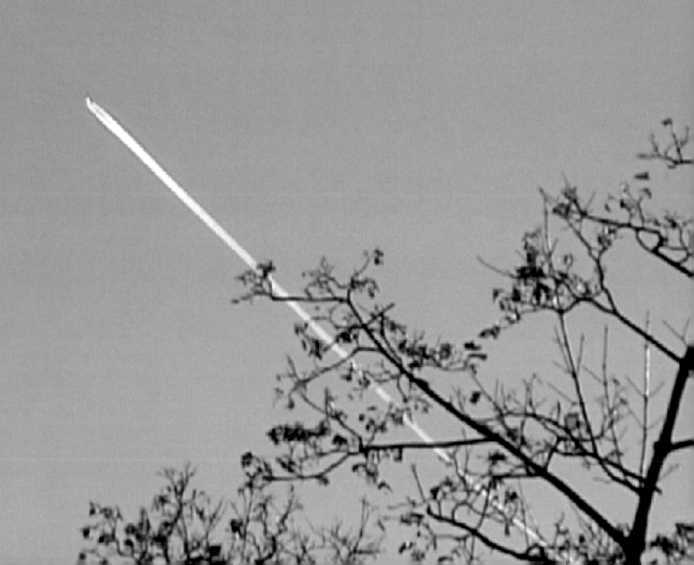

From FLAT TYRE

To AIRPLANE

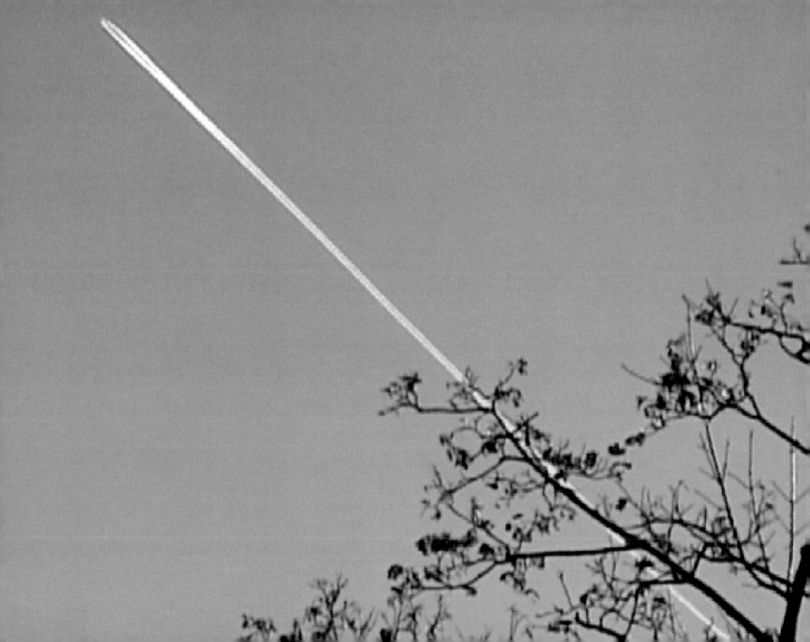

From FLAT TYRE

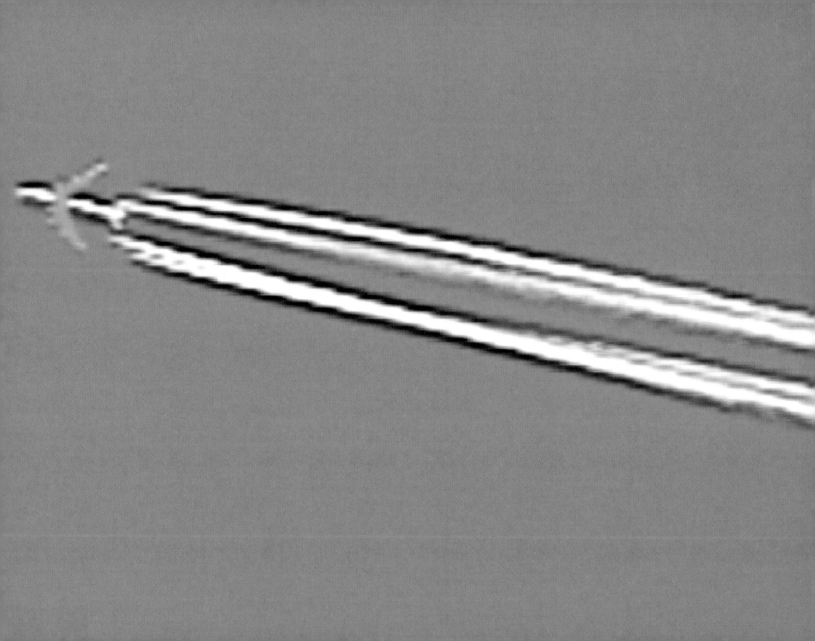

From FLAT TYRE

To AIRPLANE

From FLAT TYRE

To AIRPLANE

From FLAT TYRE

To AIRPLANE

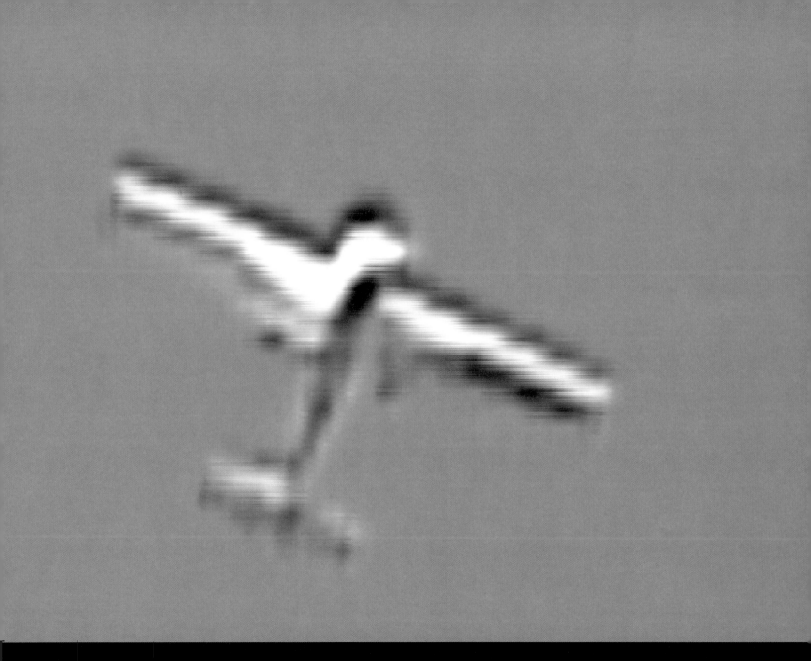

From FLAT TYRE

To AIRPLANE

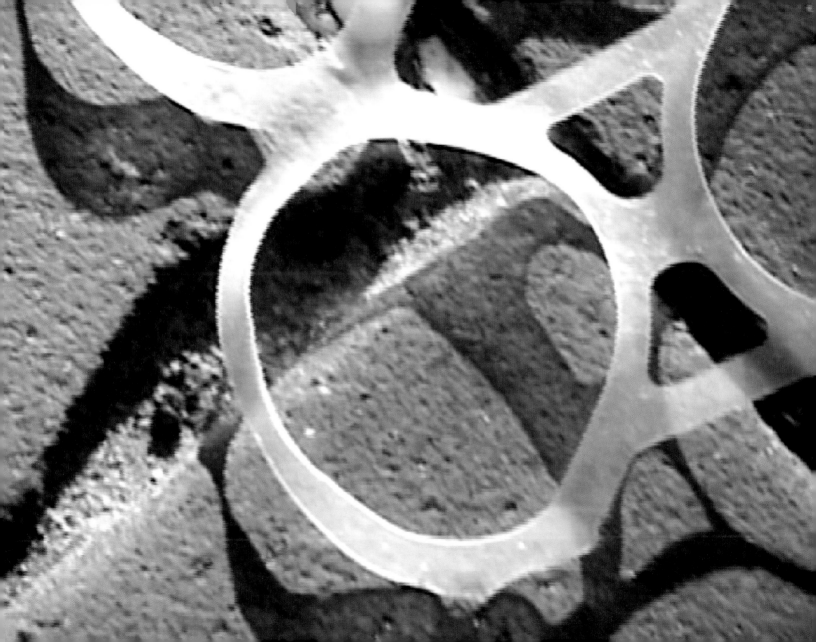

From FLAT TYRE

To AIRPLANE

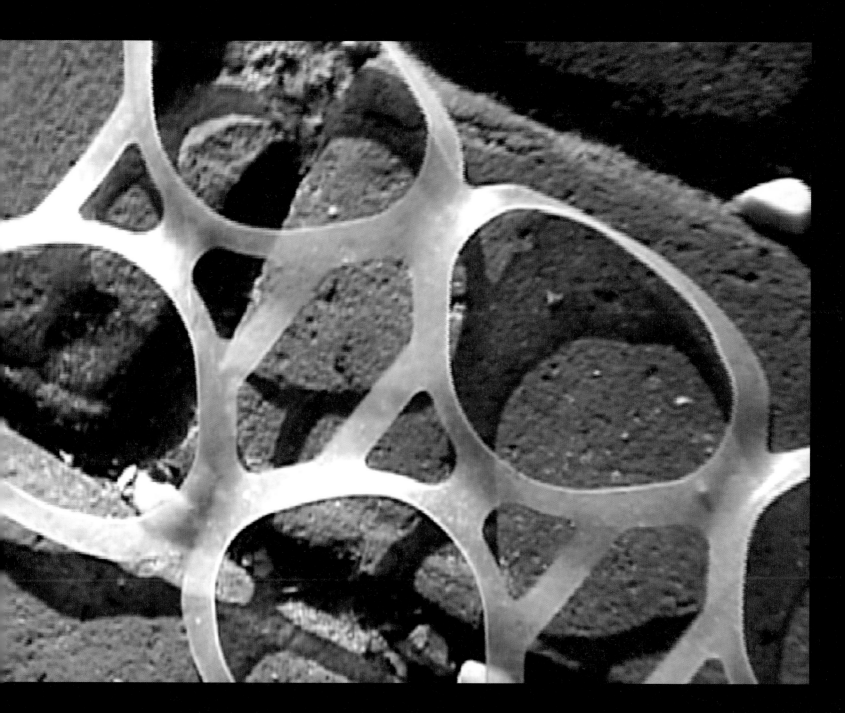

From FLAT TYRE

To AIRPLANE

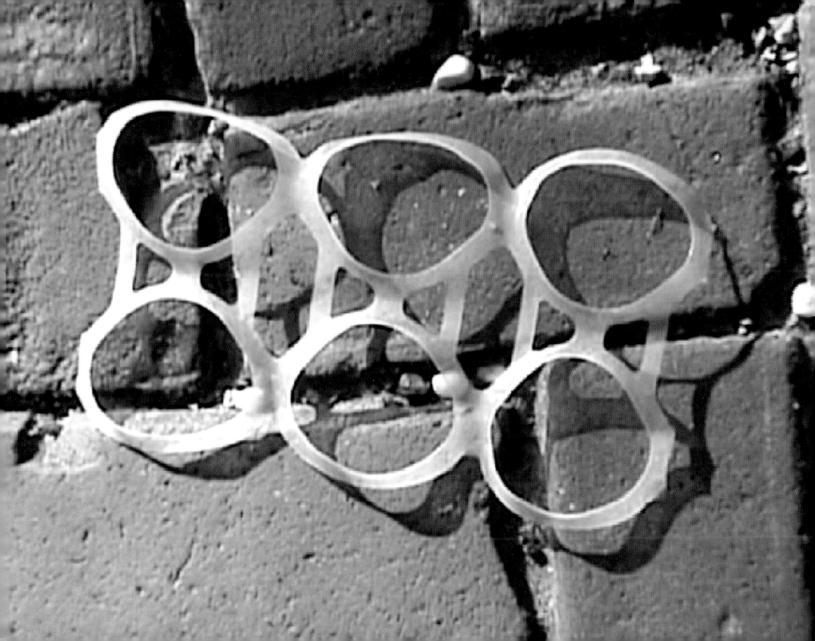

From FLAT TYRE

To AIRPLANE

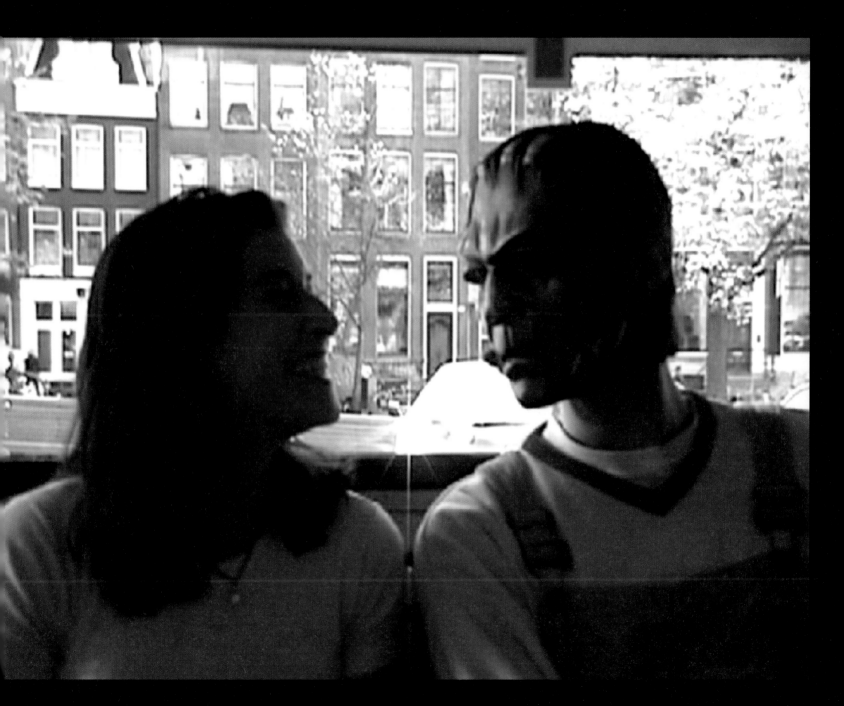

From FLAT TYRE

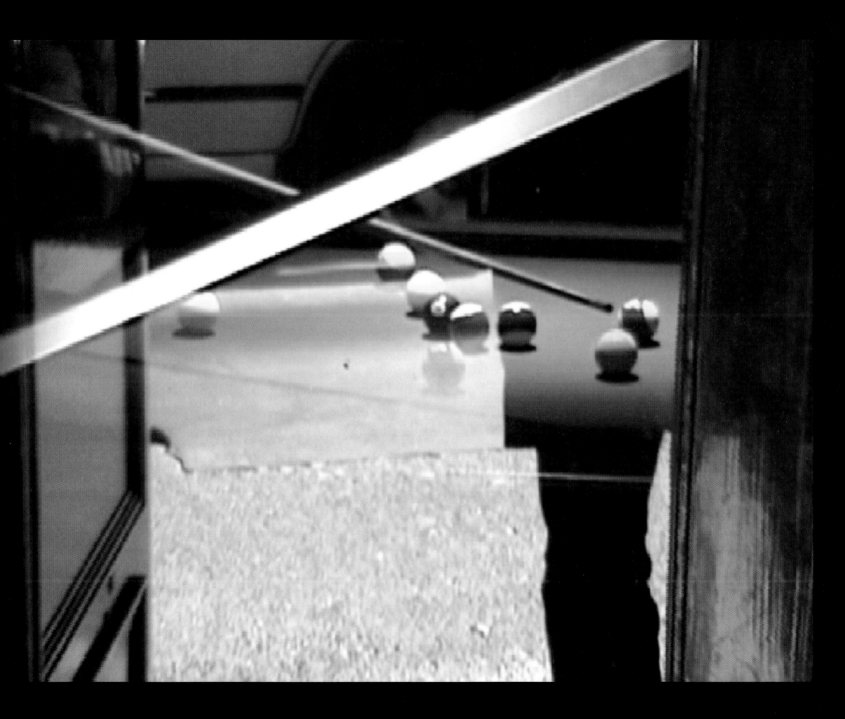

From FLAT TYRE

To AIRPLANE

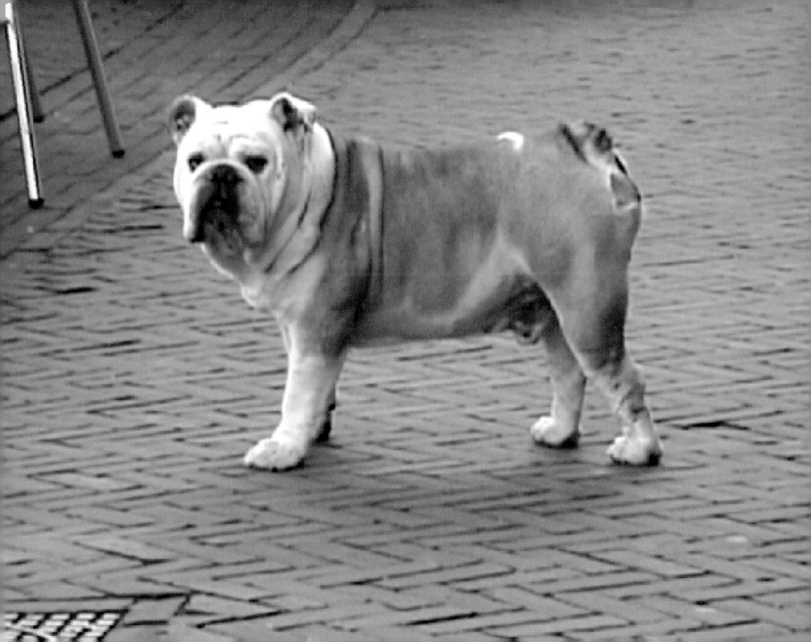

From FLAT TYRE

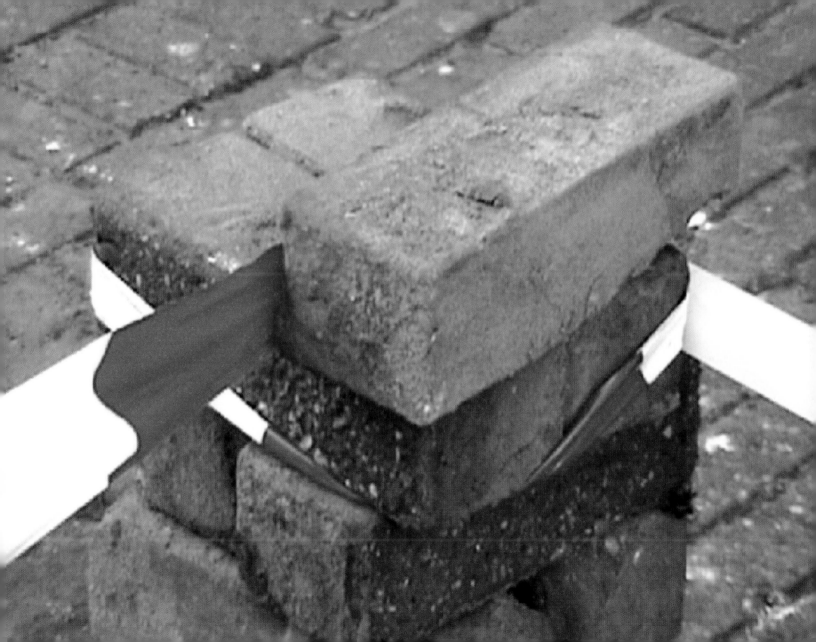

From FLAT TYRE

To AIRPLANE

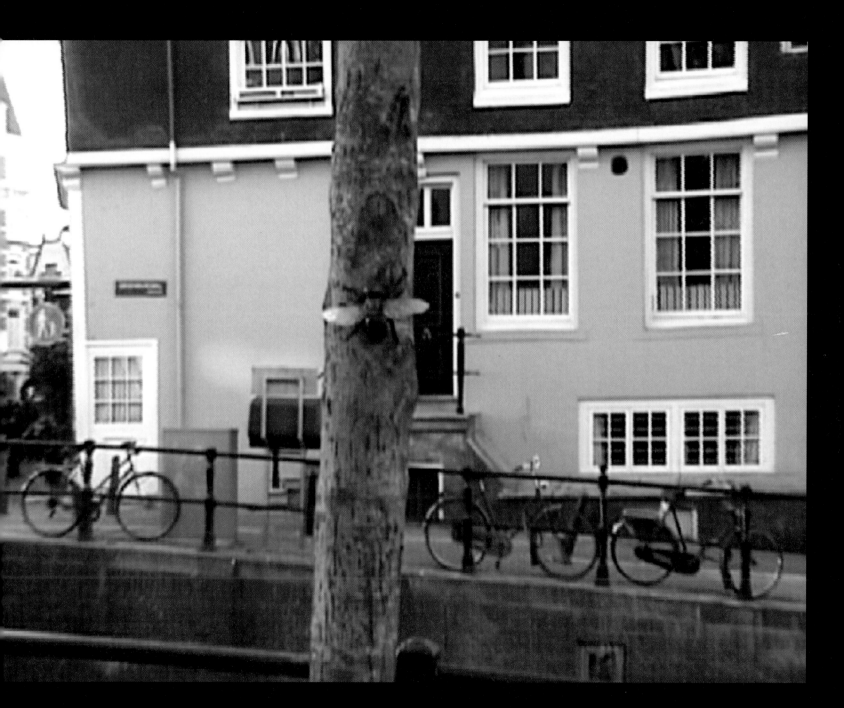

From FLAT TYRE

To AIRPLANE

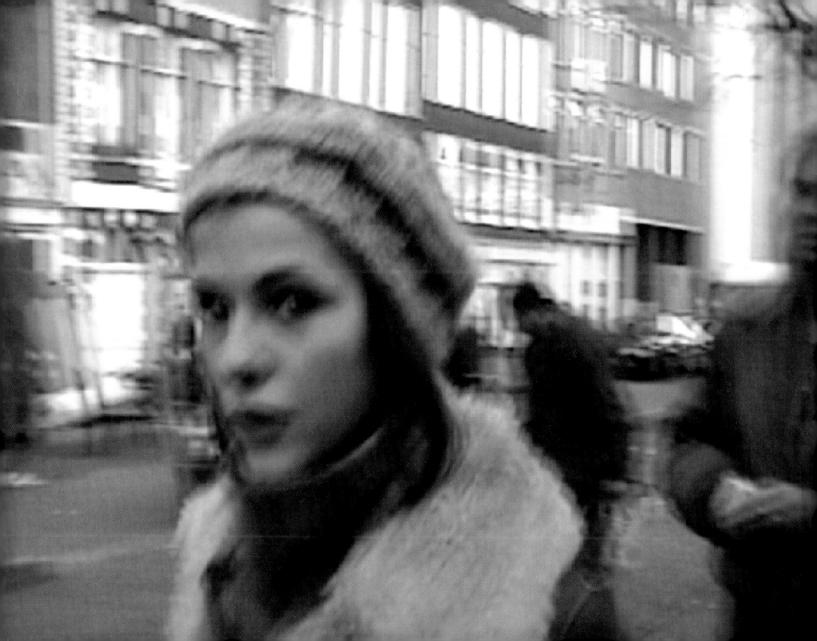

From FLAT TYRE

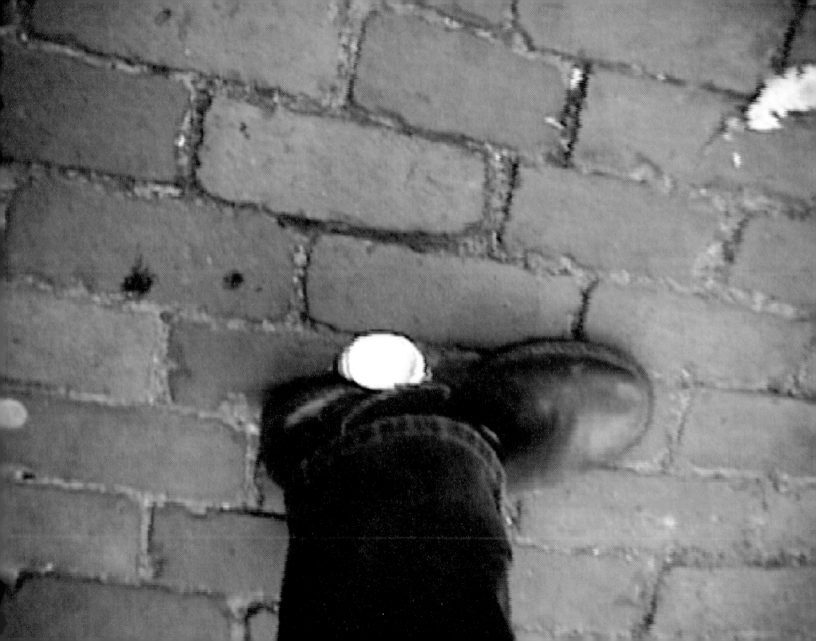

From FLAT TYRE

To AIRPLANE

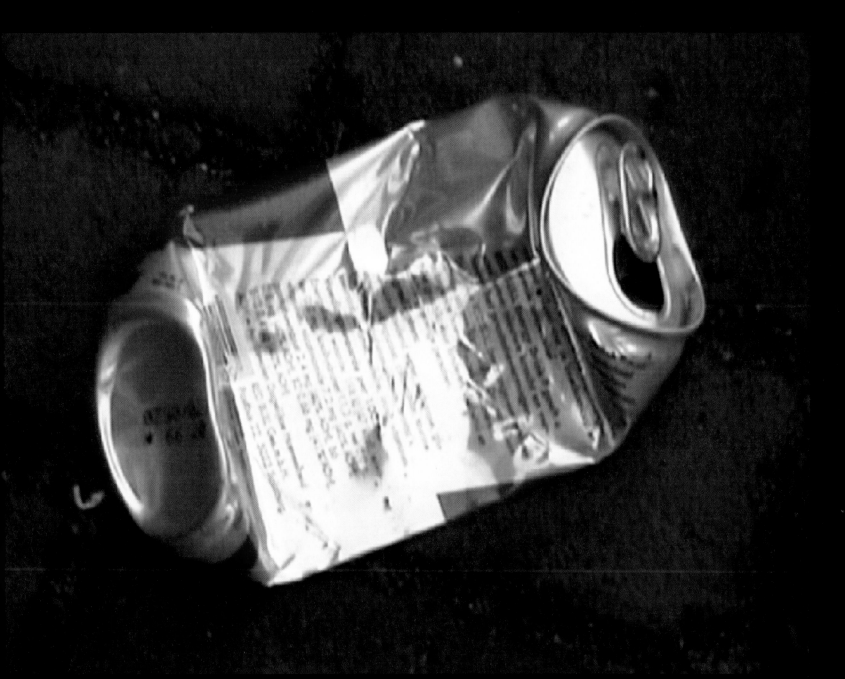

From FLAT TYRE

To AIRPLANE

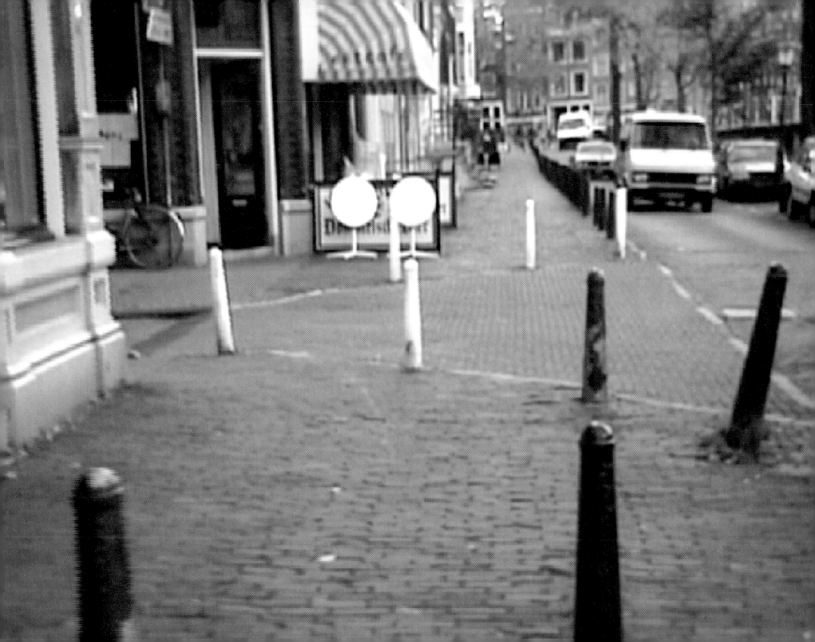

From FLAT TYRE

To AIRPLANE

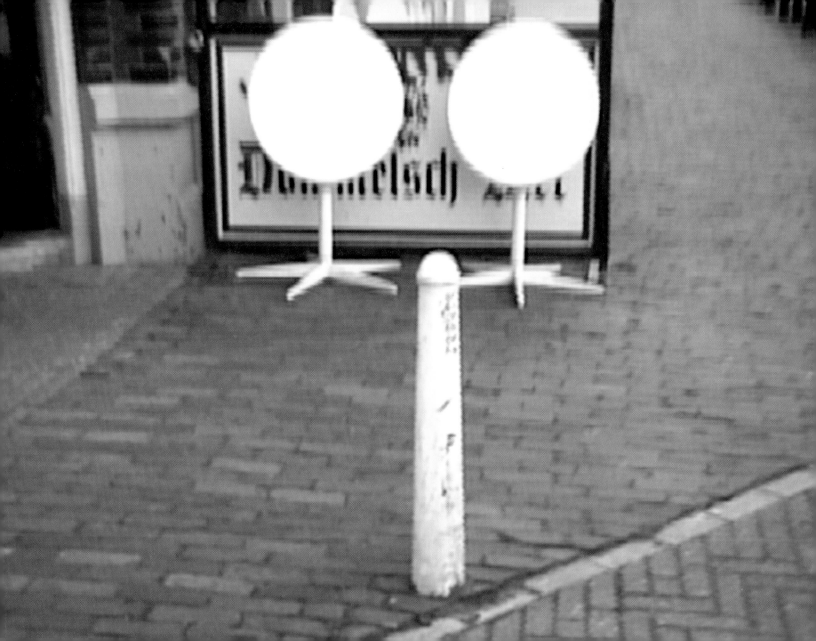

From FLAT TYRE

To AIRPLANE

From FLAT TYRE

To AIRPLANE

From FLAT TYRE

To AIRPLANE

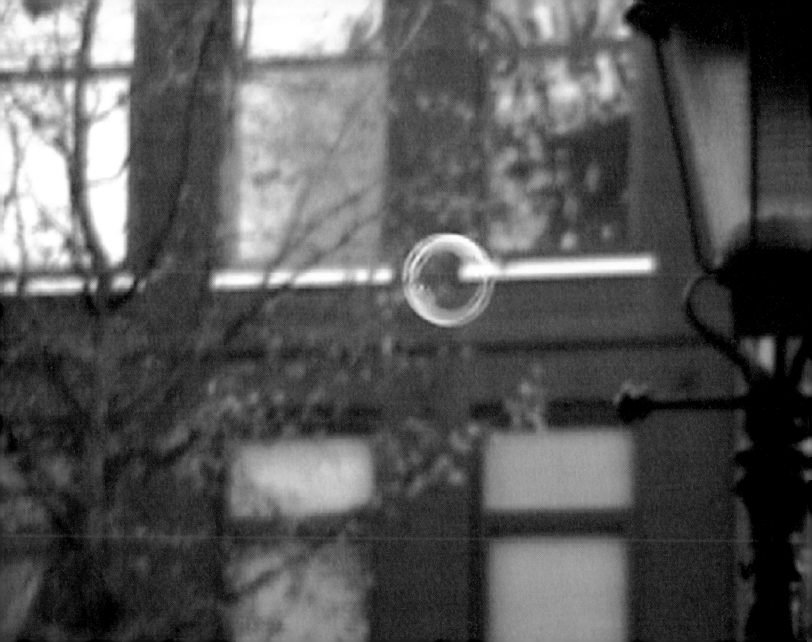

From FLAT TYRE

To AIRPLANE

From FLAT TYRE

To AIRPLANE

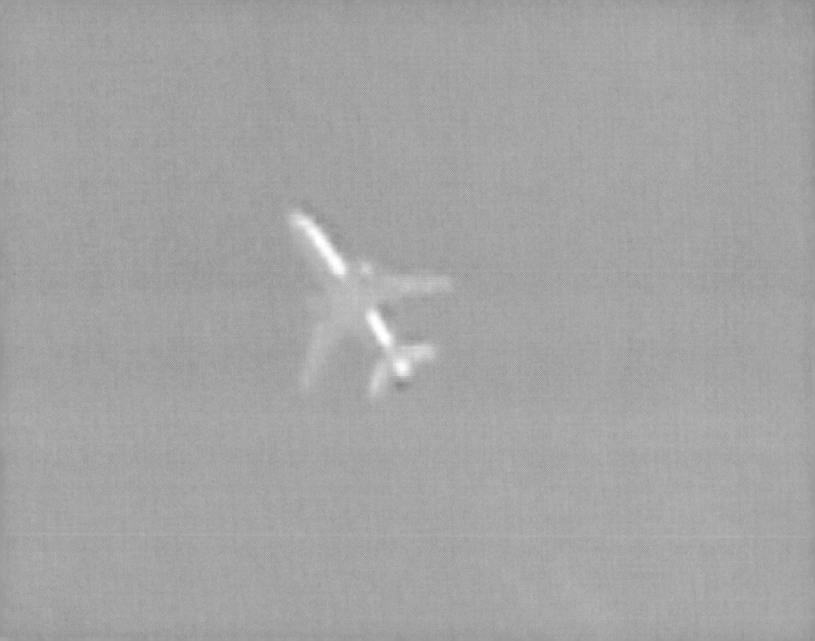

From FLAT TYRE

To AIRPLANE

Editors
Martijn van Nieuwenhuyzen
Gijs Stork

Text
Martijn van Nieuwenhuyzen

Translation
Robyn de Jong-Dalziel,
Heemstede

Design
Mevis & van Deursen

Photography
Stedelijk Museum Amsterdam,
Martijn van Nieuwenhuyzen,
Marian Goodman Gallery, NY
ICA London

Printing
Veenman drukkers, Ede

Published by
Artimo Foundation
Fokke Simonszstraat 8
NL - 1017 TG Amsterdam
artimo@lostboys.nl
www. lostart.nl

Stedelijk Museum Amsterdam
Paulus Potterstraat 13
NL - 1071 CX Amsterdam
www.stedelijk.nl
www.smba.nl

SMA Cahiers No. 10

© 2001 Gabriel Orozco, the
author, Artimo Foundation and
Stedelijk Museum Amsterdam

ISBN
90-75380-10-0

Edition
3000

Distribution
D.A.P. / Distributed Art
Publishers, Inc.
155, Sixth Avenue 2nd floor
New York, NY 10013-1507,
USA
tel +1 212 627 1999
fax +1 212 627 9484
www.artbook.com

Idea Books
Nieuwe Herengracht 11
1011 RK Amsterdam
The Netherlands
tel +31 20 622 61 54
fax + 31 20 620 92 99
idea@ideabooks.nl

Special thanks to
Rosalie Basten, Jan Mol,
Michiel Mol, Kyra Müller,
Xander Karskens, Anne Marie
Nuss, Eefje Mol-Vanderoel,
Tanja Wallroth, Manon de Boer,
World Wide Video Festival

9 April 02 HAI 45.00 (50.00) 84516